Briggs
Megan Pd#1

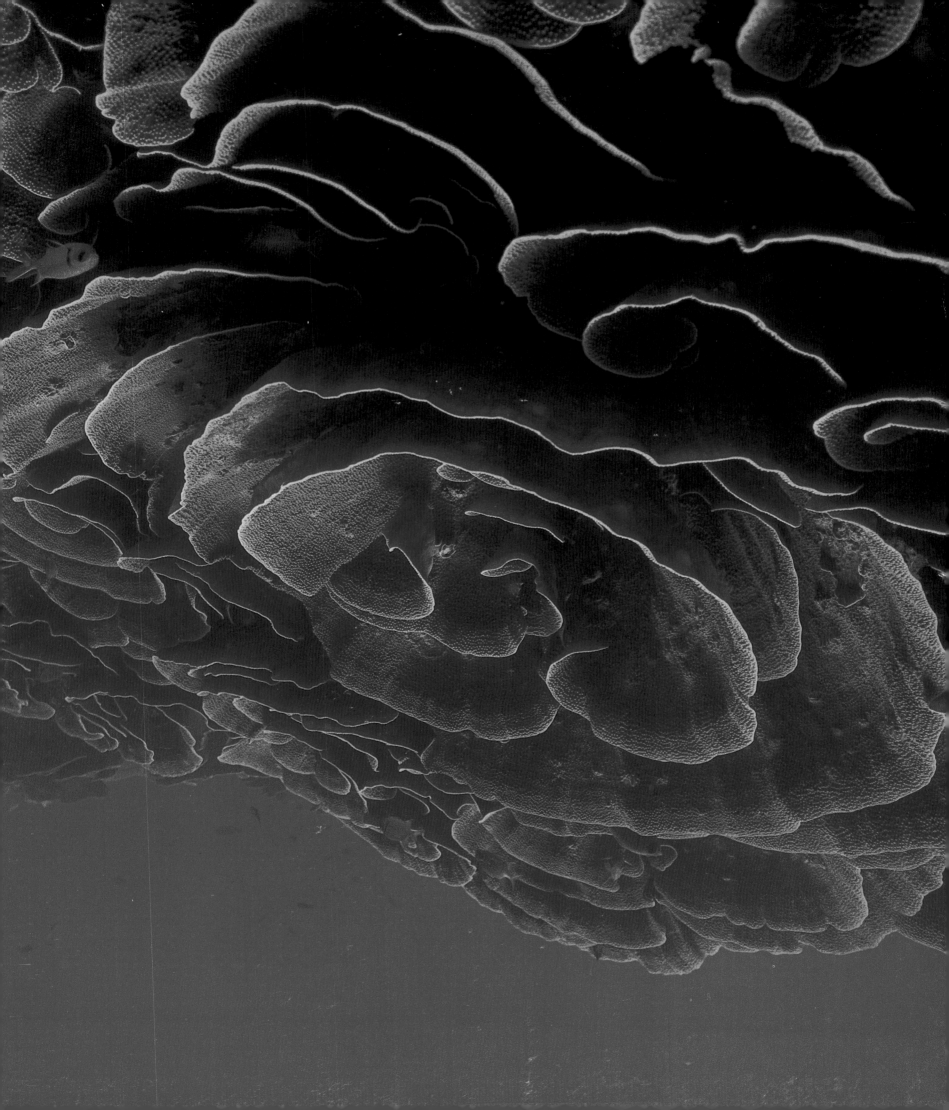

Hidden Seascapes

Hidden Seascapes

Photographs by
Feodor Pitcairn

Text by
Kirstin Pitcairn and Feodor Pitcairn

A New York Graphic Society Book
Little, Brown and Company
Boston

Frontispiece:
Bank of chalice corals,
Rainbow Reef,
off Vanua Levu, Fiji

New York Graphic Society books are published by
Little, Brown and Company. Published in Canada
by Little, Brown and Company (Canada) Limited.

First edition

Library of Congress Cataloging in Publication Data

Pitcairn, Feodor.
 Hidden seascapes.

 "A New York Graphic Society book."
 1. Photography, Submarine. I. Pitcairn, Kirstin.
II. Title.
TR800.P58 1984 778.7'3 84–17128
ISBN 08212–1577–9

Printed in the United States of America

To all who love and defend the ocean wilderness

Contents

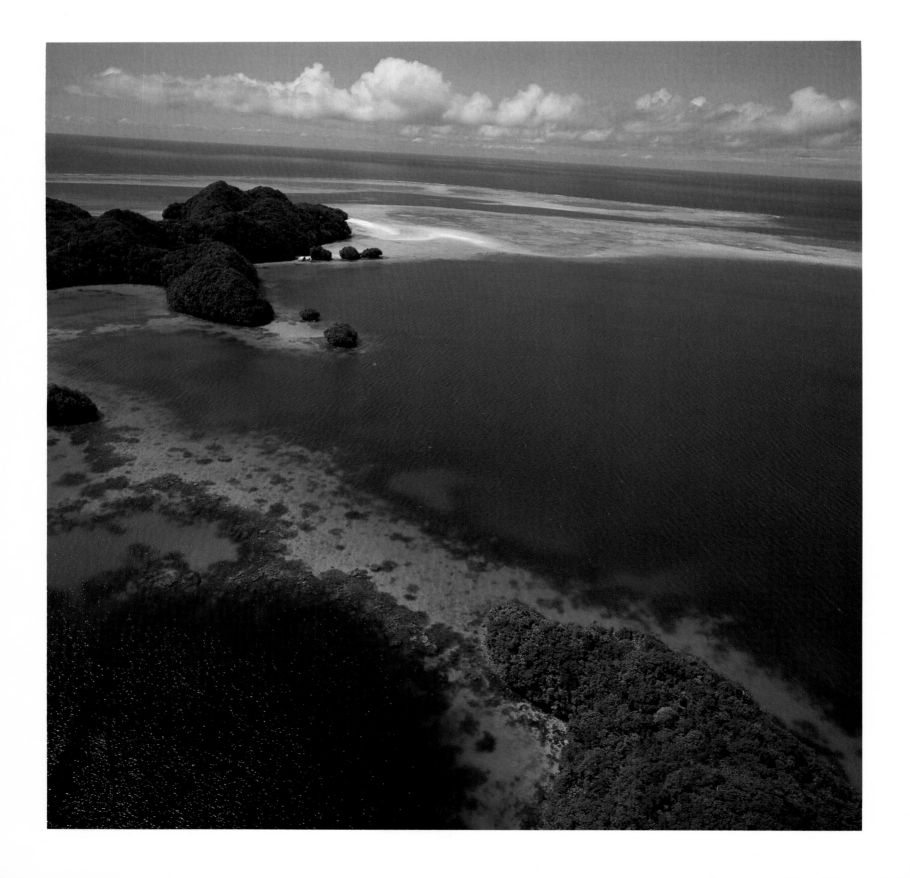

Preface

*Outer islands,
Palau*

Beneath the surface of the ocean there lie beautiful, fantastical seascapes that few have been privileged to experience. I first entered the oceanic realm in the early seventies. Here the waves are the sky, roofing awesome seascapes of coral reefs, submerged mountaintops, or vast kelp forests on a continental slope. Here I experience an amazing diversity, from cold green seas with jewellike invertebrates and mammoth baleen whales, to crystal, azure-blue seas, rich with corals. In the inner spaces of the ocean planet, man with his terrestrial breathing apparatus is an alien visitor, his sojourn necessarily brief.

My 4 x 5 cherrywood view camera was of no use here. Nor was the sturdy tripod that had always accompanied my patient landscape outings. In the underwater world, almost everything is moving. The living invertebrates that beautify the walls thrive where the currents are strong; the sea fans and gorgonians of the shallows flap back and forth in concert with the waves. The fish schools flow in ever-changing, kaleidoscopic patterns. The currents also sway the photographer, and the ocean surges waft him up and down. The moment in which compositional elements come together—like the "decisive moment" of street photography—is frequently measured in fractions of a second, in contrast to the time frame of the landscape photographer, who can patiently wait with his tripod-mounted camera for the perfect light.

Light in underwater seascape photography is a complex challenge. In seawater, tiny organic particles scatter the light, softening the contrast and the focus of a distant seascape as would an early morning fog. Passing through water, it is progressively absorbed, the long wavelengths first, then shorter ones. Thus, with increasing depth, the reds, then oranges, then yellows disappear until, at a hundred feet below the surface, the sea is an essentially monochromatic world of muted blues and greens. Curiously, the human brain compensates substantially for this selective diminishment of color. Photographic film does not.

Despite its complexities, photography under water has some exhilarating advantages over its terrestrial counterpart. In the three-dimensional ocean, I can move at will in any direction. I can "fly" without fear over a sheer wall, out above a chasm thousands of fathoms deep. I am weightless, with an infinite choice of camera angles.

Because of the limitations of available light and visibility in the ocean environment, I first concentrated on close-up photography, with lighting provided by electronic flash. Progressively I sought to capture the integrated environmental patterns that form the larger seascape. I longed particularly to convey the emotion and excitement of the seascape, its sense of wonder.

Years ago, when I first experienced the African veld, it occurred to me that it was not the wild animals alone, but their integration into the larger landscape that conveyed force, awe, and aesthetic pleasure. In subsequent years, involvement in environmental and conservation causes sharpened my thinking about the relationships between living organisms and their habitats. I was also profoundly influenced by Ansel Adams and Eliot Porter. Their balanced and sensitive sense of composition raised landscape photography to a new level.

Ansel Adams describes "visualization" as the process whereby a photographer sees in the mind's eye, before the shutter is snapped, the final result

he would like to achieve. This involves an analytic and emotional response to the subject, together with an understanding of the characteristics of lens, camera, and sensitized film leading to the final print.

It has been my objective to capture as closely as possible my actual perception of the underwater scenes. This has entailed a considerable amount of experimentation and frequent disappointments while searching for the most effective equipment and techniques in this often frustrating working environment. My Hasselblad, as a medium-format camera, is larger than its 35 mm cousins, and its underwater housings are heavy, thus making air travel complex. The reward for this inconvenience is a larger photographic image that provides significantly higher quality. To reveal the seascape, I need wide-angle lenses (with domes corrected for light refraction). These lenses provide depth of field—a wider range of focus between foreground and background—and enable me to get closer to my subjects, with less intervening water to disturb visibility and absorb the colors. A faster film (Ektachrome Professional 200) maximizes the depth of field, while making it possible to capture the available light of the scene. In many cases, I use a flash, not as a primary light source, but as subtle fill, to enhance the colors of the foreground that an observer sees but the film does not.

While underwater photography is best done alone, I am indebted to countless people for providing assistance with diving equipment, boat facilities, and travel arrangements. Carl Roessler of See & Sea Travel Service has efficiently arranged many of my trips to far-flung destinations.

I have enjoyed the companionship and advice of fellow photographers Paul Humann and Chris Newbert.

Our friend Gerard M. Wellington, currently with the Marine Science Program at the University of Houston, deserves special mention. The knowledge and insights with which he has provided Kirstin and me regarding the far-ranging aspects of marine ecology have proven invaluable to us. We also wish to thank Jeffrey W. Niemitz, Department of Geology, Dickinson College, for his assistance. And I would like to express my gratitude to Betty Childs of New York Graphic Society for her encouragement and guidance in bringing our book to fruition.

Finally, I owe much to my wife, Kirstin, and our family, who have enthusiastically supported this effort, and have been tolerant of my long absences while doing underwater photography in remote locations around the world.

Feodor Pitcairn
March 27, 1984

Hidden
Seascapes

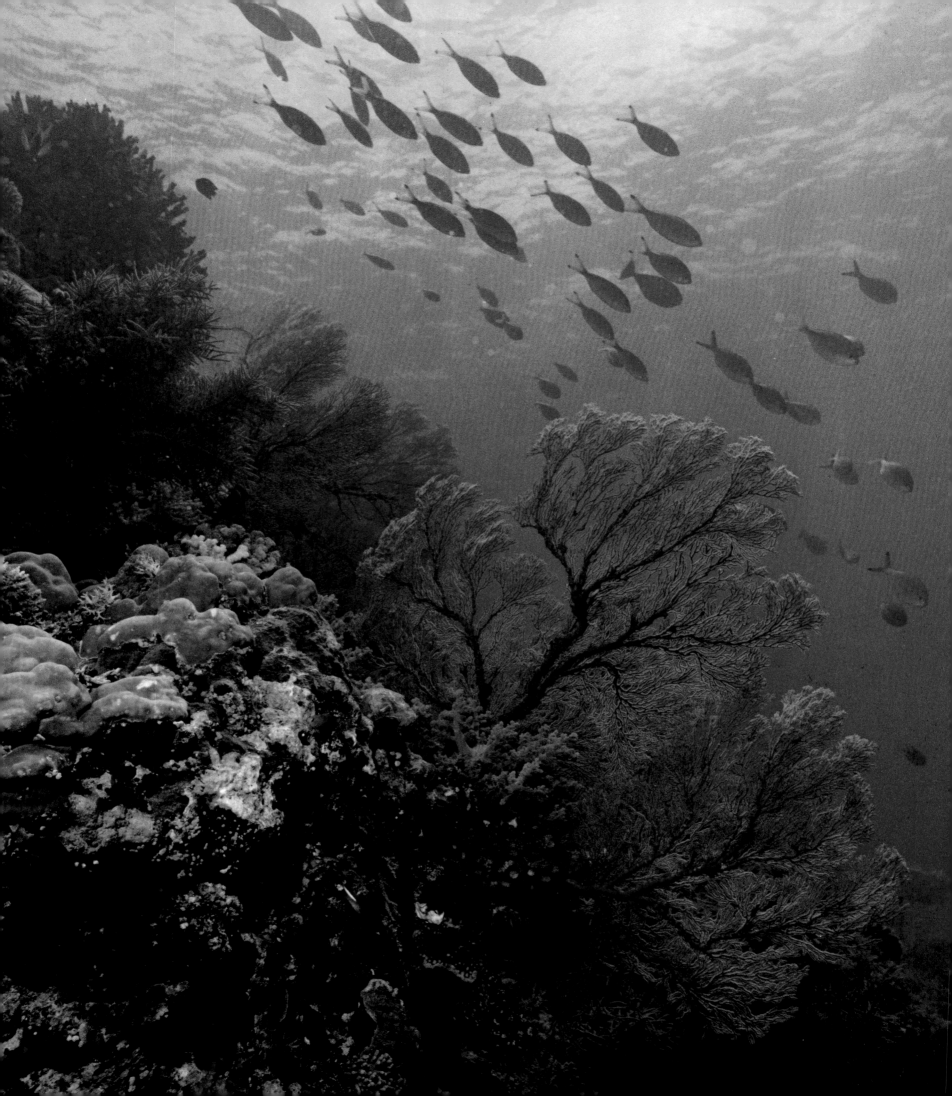

The Shaping of the Seascape

The surface of the ocean is maddeningly opaque. A coral reef may lie below, in clear, transparent sea, yet up on deck I stare and stare, and cannot see a single thing beneath the glinting surface. For whenever light is passing from the air into the sea, the thin moving line of the interface is turning some light back, becoming a bright, reflective veil that hides from the world of air the splendors of the sea.

If the contours of the earth were flattened out —no hills, no abyss, no shores—the globe would be wrapped in an envelope of ocean nine thousand feet thick. If I in my boat were adrift on that sea, the last land creature alive, I would see nothing but sea-surface, sky, the sky's reflection, and my own. No matter what animals lived in that sea, I would see no life at all, unless a fish jumped, or a whale breached, breaking the surface veil. And unless it jumped, the fish or whale could not catch sight of me, for the surface is a mirror on both its sides, and a fish looking up would see its own reflection in a gleaming surface-sky, and the keel of my boat poking through.

If the whale could reach the floor of that hypothetical sea, he would find it flat and featureless. This is exactly how the real ocean floor was, until recently, depicted: a cold, dark, flat, and featureless plain, buried in ooze—eerie, but dull.

Happily, Earth is not ironed smooth. It is grand with its continents of mountains and valleys and plains—and with the trenches, ridges, and volcanoes of its ocean floors. Water drains from the heights and collects in the basins, sixteen hundred million billion tons of it, and even when gathered into seas, it covers seventy-one percent of the earth. We cannot breathe its oxygen; it is too salt to drink; its depths are cold, perpetually dark, and under crushing pressures. Until the middle of this century, our ability to probe the deep seafloor was so limited that we knew less about its contours than of Mars.

Change came with the Second World War. Submarine warfare brought improvements in undersea technology and stimulated interest in the ocean floor. At war's end there was demand for seafloor exploration, and the technology existed with which to begin. Within the next three decades, the unknown portion of the earth's surface was at last surveyed and mapped.

Where men had envisioned a featureless plain, they discovered the greatest mountain range on earth—the midocean ridge—twisting and branching beneath the oceans for forty thousand miles. For most of that length its crest is split by deep, cracklike rift valleys, in whose depths molten rock rises from the hot mantle below.

The discoveries made on the ocean floor revolutionized our concepts of the entire planet. Earth's outer shell is now envisioned as a mosaic of thin, rigid plates (seven large and several small) that float like rafts on the hot, plastic layer of the mantle. In that layer, huge, slow convection currents circle: hot material rises, spreads beneath the plates, then cools and sinks, and its flow drives the overlying plates, impelling them across the surface of the globe.

Plates diverge at the midocean ridges. Formed of molten rock rising in the rift, they are pulled apart and to either side by the force of the mantle currents. Where they tear apart, lava rises in the

3

gap, creating new crust, which will be torn and pulled away in turn. Thus the ridge is flanked by two plates spreading like conveyor belts in opposite directions, either sliding past surrounding plates or colliding with them. In collision, one plate usually overrides, while the other is deflected downward, sliding into the mantle, where it melts.

Continents are chunks of continental crust, embedded in the plates of oceanic crust, and moving as they move. Continental crust is thick, its granitic rock buoyant; oceanic crust is thinner, but its basalt is dense and heavy. When the two collide, a continent's buoyant crust generally overrides the denser seafloor. Continents therefore have permanence. Though they are split, reassembled, or deformed, their rock is seldom destroyed; some has survived nearly four billion years. Ocean basins, however, are ephemeral, opening and shutting as continents move.

The shaping of the ocean basins as we know them began some two hundred million years ago, when all Earth's continents were united in a single supercontinent, Pangaea, encompassed by one huge, global ocean. When shifting forces in the mantle began to pull at Pangaea, her crust domed and cracked, and from the mantle below lava rose in the cracks. The lava grew dense and heavy as it cooled, and sank below the level of the continental crust, forming long, deep rift valleys. Eventually, great rift systems slashed through Pangaea, as the Great Rift System gashes East Africa today. As the sea broke in and filled them, the valleys were new oceans: first the Atlantic, and

then the Indian Ocean, divided the supercontinent.

The young seas were long and narrow, but as their floors spread, the growing plates carried the continents farther and farther apart. The plates of the Indian Ocean floor rafted India far north, and Australia northwest, overriding the floor of the ancestral sea and greatly reducing it. India collided with Asia, but Australia still moves, drifting steadily northward.

The Atlantic's widening floor carries the Americas westward. The advance of North America has so far consumed four thousand miles of the northeast Pacific floor—plate, ridge, and all. What was once a mid-Pacific ridge is now the East Pacific Rise, lying well off-center in the eastern basin, and extending north only to the mouth of the Gulf of California, where it disappears, transformed by the overriding continent.

From this point, a series of faults, running northwest, cut through the rise, tear Baja California from mainland Mexico and open the Gulf of California, Earth's youngest sea. The faulting continues north as the San Andreas Fault Zone, shearing coastal California from San Diego to north of San Francisco. Then the rise resumes, briefly, on the ocean floor off Washington State and British Columbia.

The basin of the great ancestral ocean is now the Pacific basin, much diminished, but still the largest and deepest of them all. Encroachment, however, continues. Continents are still moving in across its floor and will someday squeeze it shut. While Pangaea's ocean closes, a new ocean is spreading on the other side of the globe. Arabia and Africa are being pulled apart, and sea has

flooded the rift between, creating another infant ocean, the Red Sea.

Not all seafloor is oceanic crust. More than seven percent is continental crust: the flooded edges of the continents. The volume of water in the ocean basins varies. During an Ice Age, huge amounts of water become trapped in continental ice sheets, dropping the level of the seas—the sea has stood four hundred feet below its present level, leaving the entire continental crust exposed to air and weather. Each time the ice retreats, water returns to the ocean, flooding the coastal plains. We are now in a warming trend. Sea levels are high. The edges of the continents run out into the ocean as continental shelf, a seafloor that has been shaped by wind, rivers, ice, and rain.

A scuba diver can no more explore the rifts and trenches than the pilot of a piper cub can land on the moon. The limitations of the pilot's machine, and his own physiology, confine him to a thin layer of air just above the surface of the earth. Similarly, equipment and physiology confine the scuba diver to a very thin layer of water, immediately beneath the surface of the ocean. The diver's realm is the uppermost ocean, the upper slopes of the oceanic mountains, and the upper reaches of the continental shelves. His realm is the sunlit seascape, where light and living things bring beauty to the rocks that tectonic forces raised.

The interplay of light and water vests this seascape with a strange, otherworldly aura. Water, and the particles it carries, scatters and absorbs the light, reducing visibility as particles of mist obscure the distant hills. It is never possible to see anywhere near as far in ocean as on land; divers gloat when visibility exceeds two hundred feet. The more fertile the water, the more plankton it carries and the lower the visibility, until in some waters diving resembles driving a car through heavy fog. On a night when the moon is down, the surface looks like ink, but once a diver's eyes adjust the glow of bioluminescence faintly lights his way. Low visibility, however, tends to heighten imagination: what lurks out there, beyond the range of vision?

Wherever a diver swims, the "ocean curtain" is closing in on objects left behind, while new ones emerge, first as blue unfocused blobs, then clear and colorful. The effect can be uncanny: in a clear ocean an animal the size of a humpback whale will materialize from nowhere, and vanish as abruptly.

On a rare, exhilarating occasion, the sea is so startlingly clear that there seems no limit to vision. The seascape suddenly has no boundaries, as though the water immersing it had vanished, leaving behind a surrealistic scene that equates to the terrestrial, yet is not.

As sunlight filters through the sea, the short wavelengths—the blue light—are most easily scattered, and a diver in a clear, sunny sea is enveloped in sparkling blue. When a cloud in the sky passes across the sun, down in the ocean the seascape flattens and softens into silhouettes of blue; the highlights disappear, and the dancing, shimmering refraction of sunlight on water is gone. In the virtually bottomless waters about an oceanic mountain, no floor reflects the sun, and the sea is a uniquely rich, luminous blue never seen in shallows. In a cold sea, laden with plankton, the

plants obscure the blue, enclosing all in shades of misty green.

Plants and animals create the seascape's texture and palette, drawing hard and angular lines, or exquisitely delicate traceries. Some scenes are cheerless, in muted browns, others shout with color. A temperate sea is dark-seaweed greens and the pink-gray of calcareous algae against a mist-green backdrop. Its accents are warm, rich shades of yellow, orange, and orange-red. A tropic sea is bright blue water, bright-white coral limestone, and the creamy yellow-brown of living corals. There are many blues, with blue-reds, pinks, and lavenders. Though usually confined to tiny fish, oranges and yellows are vivid and stand out.

To the inanimate seascape of rock and water, animals bring action and noise. Sometimes silence envelops the ocean, sometimes the water may crackle with sound. When the shallows are filled with tiny, pervasive tickings, a thousand small crustaceans are clicking their legs or claws. A grating, rasping sound is perhaps the guts of a parrotfish grinding up bites of coral. Fish can squeak, grunt, growl, or groan. A sudden hush may herald the approach of danger. When dolphins ride the bow wave, their clicking and whistling penetrate the hull. One of the biggest sounds in all the ocean is the singing of a humpback whale. Water conducts sound better than air, and the humpback's song travels through the ocean for miles. From fifty feet away, it will shake a diver's body.

The exuberant play of sea lions brings the sea alive; the shuddering motion of a frightened fish school casts a moment's shadow. The indolent grace of a hammerhead shark speaks of arrogant power. In a sheltered spot, the ocean floor may be serene and still, the only movement the lazy sway of sea fans. When currents mount, when large waves are breaking, the sea is tenser. On a peaceful, uneventful day, divers take time to poke about and enjoy the small invertebrates. When the large predators are out in force, or the harbor seals are playing hide-and-seek among the kelp, they command attention.

In balmy tropic waters divers need only "shorty" wet suits, and require few weights. As they spend little energy on keeping warm, they can use their air slowly, and stay down longer. Cold-water diving provides stark contrast. In chill that would kill an unprotected swimmer, divers don thermal underwear, then bulky, waterproof dry suits, which they pump full of air as further insulation. By then, they need thirty-five pounds of lead to sink. Only the strip of skin around their mouths stays bare, reminding them how rapidly cold water reduces body heat.

A diver can be as weightless as an astronaut in space, and can soar like a bird across chasm or wall. He can take his photographs heel-over-head as easily as right-side up. Bracing against the force of a stiff current, however, he has no illusions of neutrality. Nor when the pressure of increasing depth compresses the air in his dry suit and he finds himself sinking faster and faster, with his suit starting to squeeze. To decelerate, he must use air from his tank to further inflate the suit.

Plants and animals are the essence of a landscape, imbuing a region with a unique character, distinct from any other place on earth. In like manner, the flora and fauna of the ocean shape the character of the seascape, endowing each sea with a unique, recognizable personality, unlike any other sea on the earth. The mountains of Vancouver Island are majestic cedar forests, where grizzly bears still roam. Between island and mainland, ice-cold tidal currents race through narrow straits where kelp forests sway above masses of big, fat sea stars, urchins, and spectacular anemones. Grand Cayman Island is a flat coral platform, clad in scrub, palms, and mangroves. There are parrots in the bush, and a few surviving iguanas. From its reefs drop huge, precipitous walls, where the gorgonians grow ten feet tall and the sponges big enough to bathe in.

Life in the sea, like life on land, is fueled by energy from the sun, and marine life, like terrestrial life, depends on plants fixing that energy in food. In the sea, however, solar energy is scattered and absorbed so quickly that at a depth of three or four hundred feet there is insufficient light to support plant life, even when conditions are ideal. Turbid water may be too dim at fifty. Below a thousand feet, all seas are totally dark. Thus the food to fuel the entire ocean must be produced in the top few hundred feet.

Those top few hundred feet contain, in abundance, everything a plant requires to photosynthesize—except nutrients. The essential nutrients, such as nitrates and phosphates, are constantly recycled in the biosphere. On the land, plants take them up from the soil, animals obtain them from plants,

and both return them to the soil in wastes and in decay. In the ocean, this cycle is interrupted. The plants and animals take up nutrients at the surface, but their wastes, debris, and decaying bodies sink, carrying the nutrients to the bottom of the ocean. There they collect.

A sea's fertility depends on whether the nutrients can be returned to the surface layer. In cold seas and above shallow shelves water circulates rapidly, quickly recycling the nutrients. Where deep currents shoal, they bring nutrients from the depths. In the wake of an island, at a junction of currents, or where the wind drives the surface water away from a coast, there cold, rich water is drawn up from the depths, supporting abundant life. Where deep water cannot rise, the sea is nutrient-poor, and its life more sparse.

Most of the ocean's plants are microscopic, single cells that can float at the sunlit surface and absorb nutrients by diffusion. These are the phytoplankton. Despite their minute size, they are the base of the ocean's food chains, producers of all its food. Their primary grazers are the zooplankton, an assortment of near-microscopic floating animals that hide in the cool, dark layers by day and rise at nightfall to feed in the ocean pastures. Where the nutrient levels are high, the phytoplankton multiply astronomically. Where they bloom, the zooplankton bloom also.

The clear blue waters of the tropical seas are biological deserts. (That is why they are so clear.) The direct rays of an overhead sun can heat the ocean's surface to 80° F or more, creating a warm low-density mass that floats on the cold, dense sea, establishing a thermocline through which cold

water cannot rise, trapping nutrients below.

Paradoxically, it is only in the clear tropical seas that corals build reefs, and though the sea be desert, the coral reef community is phenomenally productive. Success in a nutrient-poor environment involves an ability to obtain the essential nutrients efficiently, and hold on to them. A common device in tropical oceans is for two disparate organisms to enter into a symbiotic partnership, recycling the nutrients between them. None do so with more spectacular success than the reef-building corals and their algae partners.

An individual coral animal, or polyp, is a tiny cylindrical creature, encased in a limestone cup; its tentacles are usually in multiples of six. Its partners are zooxanthellae—minute, single-celled, yellow-brown algae that live inside the animal's cells in such great numbers that only half a polyp's tissue is animal tissue—the other half is plant. The coral-zooxanthellae team is extraordinarily self-sustaining. With an input of sunlight for the algae, and a small uptake of nutrients by the animal, they bypass the problems of a nutrient-poor habitat to flourish exceedingly, building by far the largest structures of any animal on earth, including man.

Zooxanthellae can live free in the ocean, but a coral's cell assures them a place in the sun and refuge from predators. Instead of living suspended in nutrient-poor ocean, the algae are bathed in body fluids rich with coral wastes that supply everything they need to photosynthesize, including nutrients. Thus equipped, the zooxanthellae convert carbon dioxide and waste products to food. Forty percent of the food, or more, is passed along to the coral host, thereby recycling some of the nutrients it had excreted, while satisfying its requirements for carbon. But the coral must supplement this source of nutrients, either by absorbing organic material from the water, by catching plankton, or by scavenging organic matter, such as the fecal pellets dropped by the fish schools above.

Corals can also survive on their own, but without the zooxanthellae the rapid rate of calcification needed for reef-building cannot be sustained. They cannot accrete large skeletons, and cannot build reefs.

Partnered by zooxanthellae, a coral colony accretes the external calcium carbonate skeleton characteristic of its species. Whether in the shape of dainty antlers or a massive mound of several hundred tons, the skeleton must be formed to withstand the mechanical forces of its environment while ensuring its zooxanthellae maximum exposure to the sun. The hundreds of species, each building to its own design, construct a fantasia of forms—plates, tables, antlers, brains, lettuces, and mounds—always the sum of structural needs and the search for sun.

The corals of a reef are constantly competing for space in the sun, the more successful overtopping and shading out the less competitive, or actively killing their competitors' polyps. As colonies die and their skeletons crumble, others grow on top, and die in turn, the whole compacting to a massive, wave-resistant mound, habitat for multitudes of other plants and animals, which add their skeletons and debris. On top, a living layer is stretching, jostling, competing for sun, growing as high as the surface and waves allow. Should the reef's foundation sink, or sea level rise, the corals will

grow upward until once more restrained by surface and waves. If the sinking continues over millions of years, the corals construct vast ramparts of limestone, looming thousands of feet through the sea.

If beds of free-living multicellular algae, such as sea lettuces or kelp, could flourish on the reefs, they would overshadow the corals and kill them, but free-living algae require high levels of nutrients, so their presence on the reef is sparse. Meanwhile, there are large numbers of plant-eating fish on reefs, surprisingly large numbers considering the paucity of plants to feed on. What algae do grow are cropped continually, keeping them in constant check. The corals easily predominate.

In cool seas no thermocline forms to trap the nutrients in the depths, and water circulates freely, constantly replenishing the nutrients of the surface layer, keeping the sea rich. Multicellular algae grow luxuriously; reef-building corals do not grow at all, for their zooxanthellae are sensitive to cold and cannot survive below 70° F. The only corals in the cool seas of the temperate zone are those like the tube corals, which have no zooxanthellae, and accrete small skeletons very slowly.

The whales that breed in warm seas of Baja or Hawaii return to cool northern waters to feed. In a cool, rich sea the rate of productivity is high. Plankton bloom prodigiously, and plankton-feeders of all descriptions blanket the current-swept walls, and countless schools of fish move through the sea, feeding on the plankton, or on other fish. High fertility does not select for the symbiotic relationships so common in the tropics—there is no need. Creatures that play a cryptic role in tropical waters come out of hiding in colder environments and dominate the fauna of the bottom and the walls. Some grow surprisingly large. Ubiquitous starfish and urchins graze on the plentiful algae, or prey on those that graze. In the midst of so much plenty predators abound, from voracious invertebrates to large marine mammals, such as seals, sea lions, and killer whales. Large, free-living algae form lush, thriving beds on the substrate; kelp grows forty to fifty feet tall. Many invertebrates graze on them, but plant-eating fish are rare, far fewer than in the plant-poor tropics. While the seaweeds benefit from their absence, it is unusual to see so much food underwater with so few fish adapted to eating it, which seems to indicate that the majority of fish require high-protein, carnivorous diets to withstand cold.

The seascape offers adventure, the fascination of marine life, and magical beauty; above all, it offers the delight of unspoiled wilderness. Most of the seascape is still pristine, much of it unexplored. On a large scale, deep-sea exploration and scuba diving have been feasible for less than forty years. That is a very short time. Our new-found abilities to explore beneath the ocean's surface have brought us new understanding of our world, but the technology that opens the sea for study and for enjoyment is also opening it to unprecedented exploitation. The threats are many, and overwhelmingly complex. Surely as men come to know the sea, they must come to hold it dear, and increasingly endeavor to protect it.

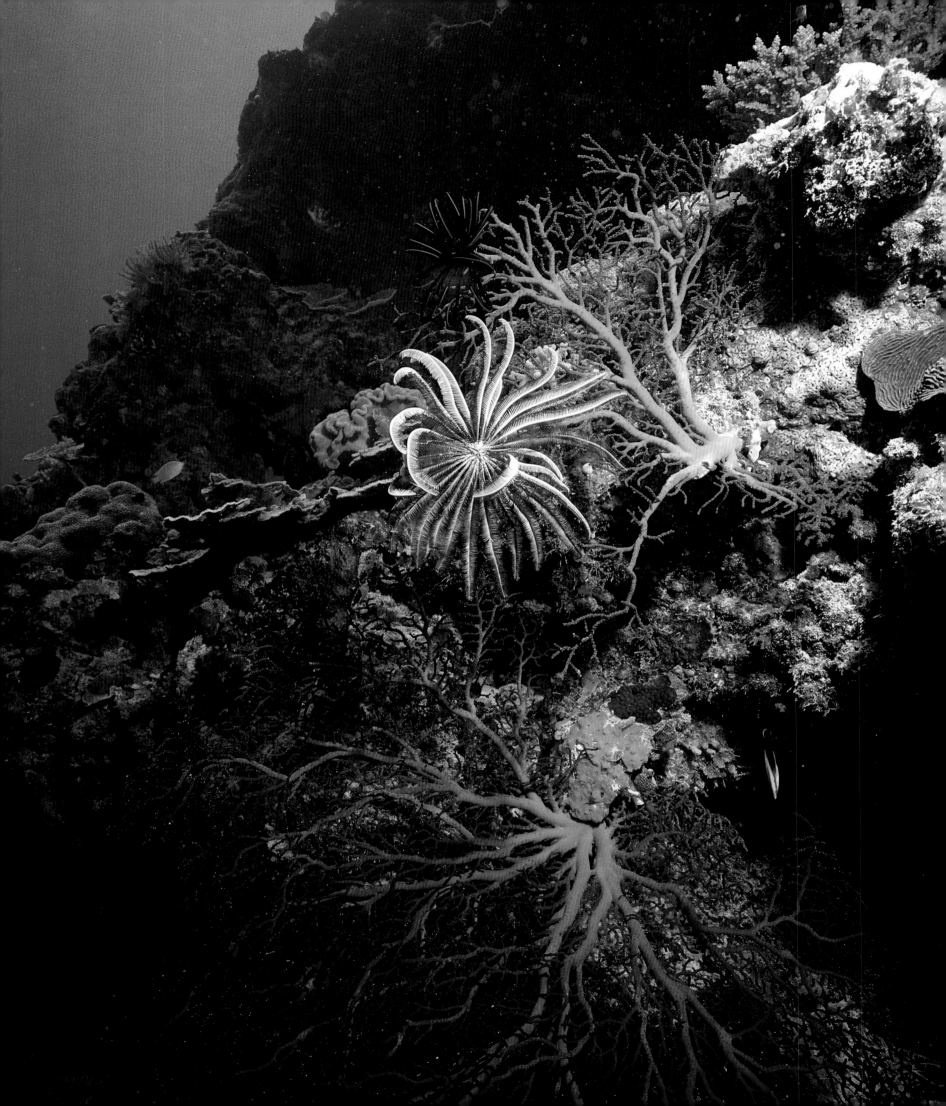

Volcanoes in the Sea

Island Arcs and Backarc Basins

The Great Reef of Ngemelis, Palau

A "ring of fire" encircles the Pacific Ocean, a zone of earthquakes and volcanoes where the plates of the Pacific floor are sliding beneath the surrounding plates and into the mantle. The great rigid slabs grinding past each other spawn earthquakes. Where the downgoing slab bends, it pulls the ocean floor into a long curving trench, enormously deep. Where the slab passes into the mantle, rock melts and rising through the upper slab, erupts on its surface as a line of volcanoes; if they erupt on the ocean floor, their peaks rise above the sea as long curving archipelagoes, or island arcs.

In warm seas, corals anchor on a volcano's undersea slopes, building a reef that encircles the island—a fringing reef. But the volcano's foundation is not stable. The oceanic plate is constantly cooling and contracting, dropping the volcano ever deeper in the sea; as it subsides, the island shrinks, spreading a lagoon between the reef and shore. As the reef subsides, the corals grow, reaching for sun, building a rampart hundreds or thousands of feet high—a barrier reef. When at last the entire volcano is submerged, its peak supports a monumental ring of coral, often with islets perched on its crest—a coral atoll.

Most of Earth's island arcs are strung along the Pacific's western margin. Palau is a small archipelago in Micronesia, its foundations a curving ridge of volcanic mountains rising just west of a trench where the Pacific Plate runs beneath the Philippine Plate. Strung along the ridge for a hundred miles are coral islets and atolls, worn volcanic peaks, and a magnificent barrier reef, enclosing a large lagoon. Though small, Palau is rich in habitats, a biological "center of diversity" with more genera and species of fish, corals, and invertebrates than anywhere else in the tropical Pacific.

Farther west, the Philippine Plate dives in turn under the plate of Eurasia, creating an enormous trench, and beyond it the volcanic arc of the Philippines. Of seven thousand islands some are large and mountainous, some have active volcanoes, but most are less than one square mile. Frequently the construction of an island arc is accompanied by the spreading of a shallow "backarc basin" between the arc and the continent. Between the Philippines and Asia is the South China Sea. There, Apo is a tiny, lonely island with a lighthouse and a fringing reef; just off shore, a massive, spectacular coral reef lies out of sight beneath the water.

North and east of New Zealand, the Pacific Plate is overridden by the Australian Plate, its descent creating a gash across the seascape seven miles deep—the Tonga Trench. In this region, however, the northward march of the Australian Plate has produced a complex rotation of the oceanic crust: the Fiji Islands lie between two trenches, at the intersection of a once-active arc and an active one, apparently the center of the slowly moving swirl. This geologic rarity has produced a volcanic plateau on which the Fijis are a few high volcanic peaks and craters, among a wondrous welter of coral reefs, atolls, and islets.

West of Fiji, the Coral Sea is a complex backarc basin. Though its geological evolution and history are still poorly understood, its basin was probably formed by the spreading of the sea floor between the Papua peninsula and Coral Sea Plateau. The plateau, which extends from Australia's Barrier Reef two hundred miles out into the Coral Sea, is a shallow undersea platform; it is subsiding. Here and there isolated reefs and atolls loom from its floor, magnificent submarine structures almost reaching the surface, rarely breaking through, and so remote that in two weeks of diving not even an airplane overhead disrupts the sense of wilderness.

PALAU

Barracuda pack,
Blue Hole Corner, Palau

When Palau's volcanoes were young, the reef lay close to shore where rivers, emptying in the sea, killed the coral and cut gaps in the reef. Though now the reef lies miles offshore, the gaps persist as passes, and through them the tides pour in and out of the lagoon, setting strong tidal currents racing along the outer walls. At Blue Hole Corner, the reef angles out into the sea, where waves sweep across its top. As the tides change and the currents build, the fish in their multitudes come streaming in to feed. Nowhere I have dived, in warm seas or cold, have I seen so much action all at once. Just beneath the surface hundreds of halfbeaks dart and skitter. Ribbons of gleaming sennets flow across the rubbly floor, and huge, spectacular schools of jacks swoop in from the ocean, swinging wide across the reef top, and back to sea. Three-foot barracuda hunt a hundred strong. Steel flanks flashing, they patrol along the reef edge, stalking the schools that feed on the current's plankton and on surface schools of needle-fish or flying fish. Barracuda are large, voracious predators, with wolflike, slashing teeth, but their bodies are so narrow that head-on they look small and unalarming. They can move in on their prey unnoticed, until the final, swift lunge. A school of predators is disastrously effective against a school of small prey fish. When many attackers slash simultaneously through a school of smaller fish, their accustomed response—to a single predator—is thwarted; thrown into confusion, they scatter and are easily caught.

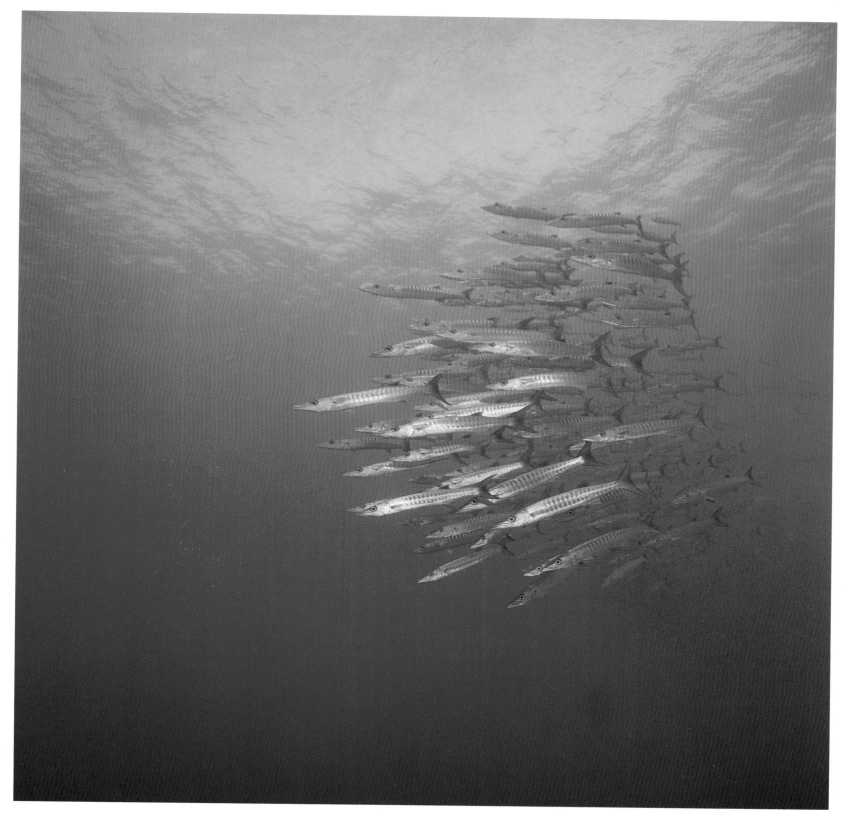

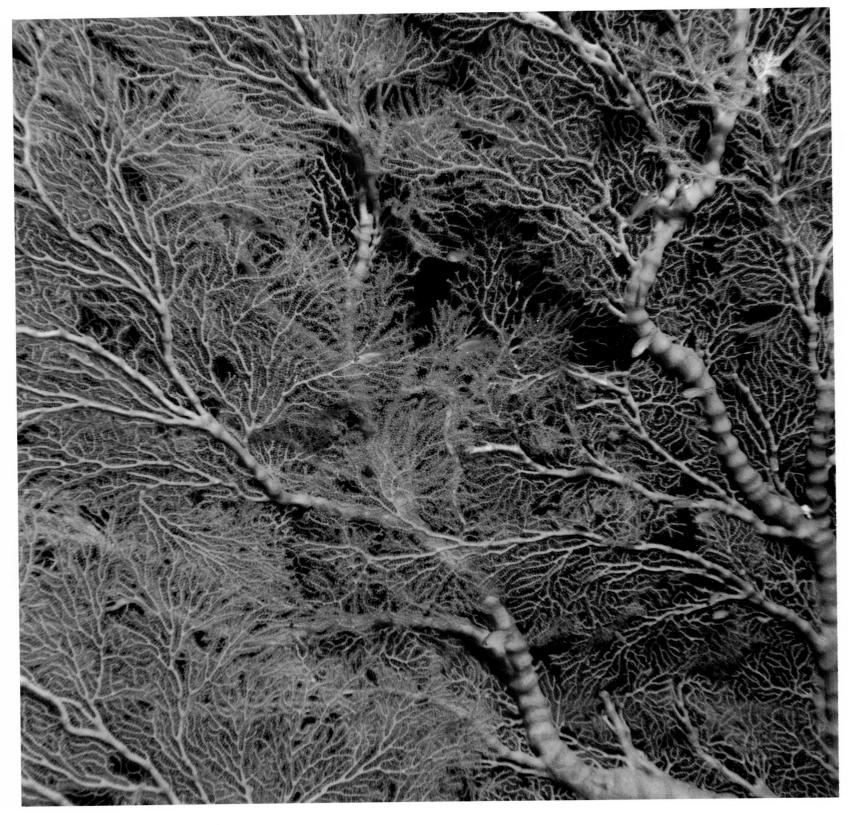

14

A sea fan feeds on plankton. The plants and animals of the plankton are for the most part microscopic, or near-microscopic, and even where they are abundant, the animals that feed on them must process large amounts of water to capture a single cell. To process the water efficiently, many plankton-feeders, from sponge to whale, filter out the plankton, often making use of currents, which transport and concentrate them. Wherever rich currents are sweeping a substrate, plankton-feeding invertebrates are anchored, harvesting the organisms that the current carries past. A sea fan aligns its wide, flat network at right angles to the current, so that the water is streaming directly through the mesh. Polyps line the edges of every branchlet, so spaced that any plankton carried through an interstice must pass within the reach of some polyp's tentacles, to be stunned by their stinging cells and ensnared. The sea fan's slender branches have a core of gorgonin, so light and flexible, and so very tough, that a colony can be delicate and lacy, yet almost impossible to tear or cut. A light, flexible sea fan can fasten securely on walls too steep for heavier corals. Often jointed for added flexibility, it will sway instead of break under pressure, and it thrives in strong currents or surge. At Peleliu Island, the wall is perpendicular and subject to heavy waves. Where few other organisms can grow, the sea fans reach eight feet across and are so prolific that the wall is known to divers as "Sea Fan Alley."

High beneath the surface of the lagoon a jellyfish is swimming, its pulsing bell shooting it forward in rhythmic bursts, revolving as it goes. On its ruffled arms several hundred mouths catch the light and sparkle. In the tissue of the mouth arms live symbiotic algae, which the jellyfish must expose to sun. Usually, it suns them as it swims, revolving steadily to ensure each arm an equal dose of sunlight. The lagoon of the jellyfish is a very different world from the crystal-blue turbulence of the outer reef. Isolated by the reef and jungle-clad islands, its waters are quiet, and rich with the nutrients of rotting vegetation. Tides flow in through gaps in the reef, flushing parts of the basin, but they do not reach the backwaters. More than three hundred little "rock islands" dot the lagoon. Where they cluster they create winding mazes of channels and coves, where the water is still and brown with tannin. Nutrients accumulate, plankton bloom, and jellyfish pulsate along just beneath the surface, twirling as they feed.

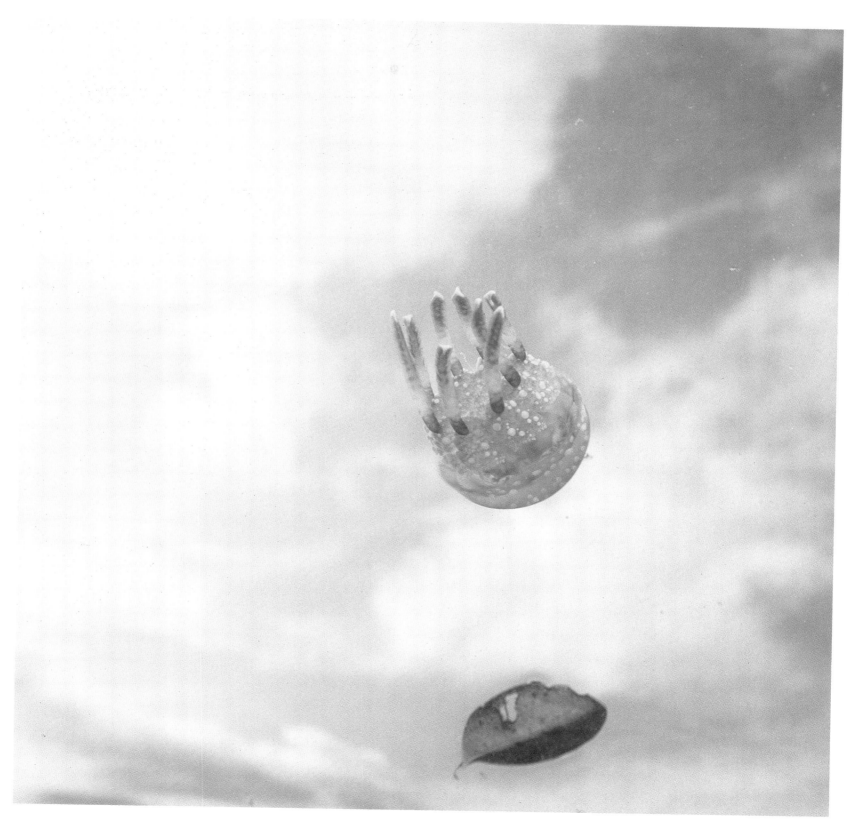

At Peleliu Island the wall is immense, and its face so severely vertical that, at a hundred feet, it is midmorning before we see the sun break above the wall top. The reef here juts out into the Philippine Sea and is exposed to heavy waves and surge. The sea fans are magnificent, growing larger and lovelier the deeper we go, and feather stars a foot across are clinging to their branch tips, but except for the sea fans, the great wall is stark, its mood tense. I have large waves crashing above me, and the feel of open ocean at my back—a feeling much enhanced by the attentions of the sharks. At ninety feet, we are clinging to whip corals, with parades of gray sharks passing. At sixty feet, they are still swinging in. Back at the top of the wall, we stop to decompress. A school of fusiliers arrives, traveling fast, with a gray shark hot behind. The shark swerves to miss me and races on, but an entire squadron follows, like fighter planes flying in a "V" formation. One peels off to check us out. We are up, over the lip, crouching in the coral.

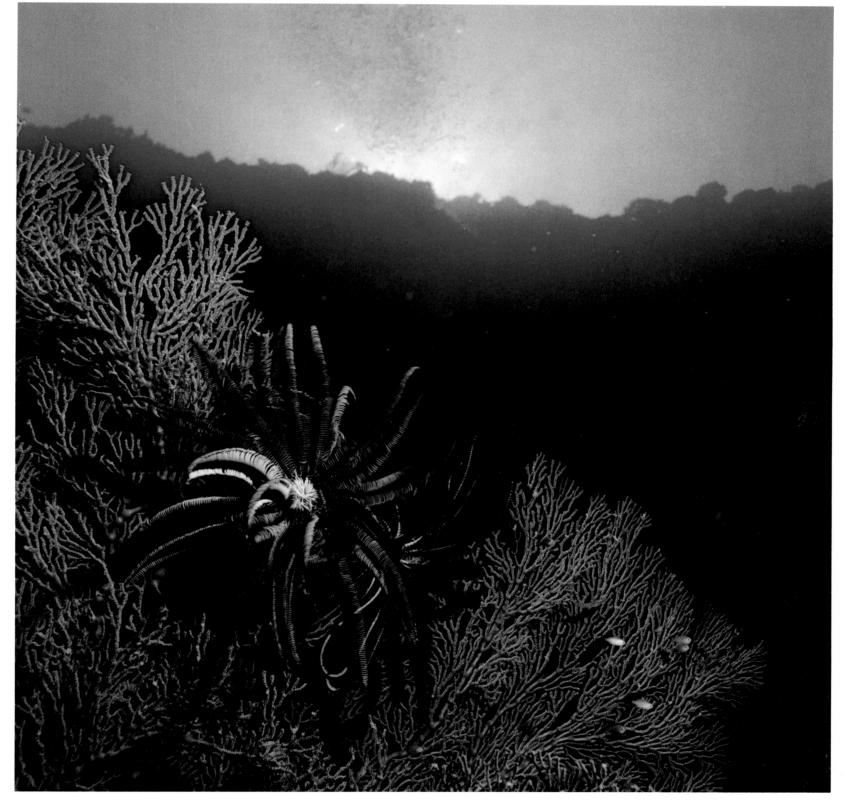

The slim, snaky needlefish is a surface-dweller, a ravenous carnivore that preys on the small fish, like herring, that school at the surface. Thousands of needlefish congregate above the reef top and hang, drifting, just beneath the surface of the waves. Their drifting is not aimless; they are stalking their prey, and once within range will dart in, with incredible speed, lashing long, thin jaws and needlelike teeth. Needlefish and barracuda are "water column stalkers," which prey on smaller fish in the open water and specialize in making themselves invisible to their targets. Both are therefore very slim of body, and their narrow profiles belie their size, so they can close in on their quarry unnoticed, then seize it with a sudden lunge. In both species dorsal and anal fins are set like the feathers of an arrow, opposite and well back toward the tail, and serve to keep the darting fish on target. Almost all fish are predator and prey at once; the needlefish fall prey to barracuda.

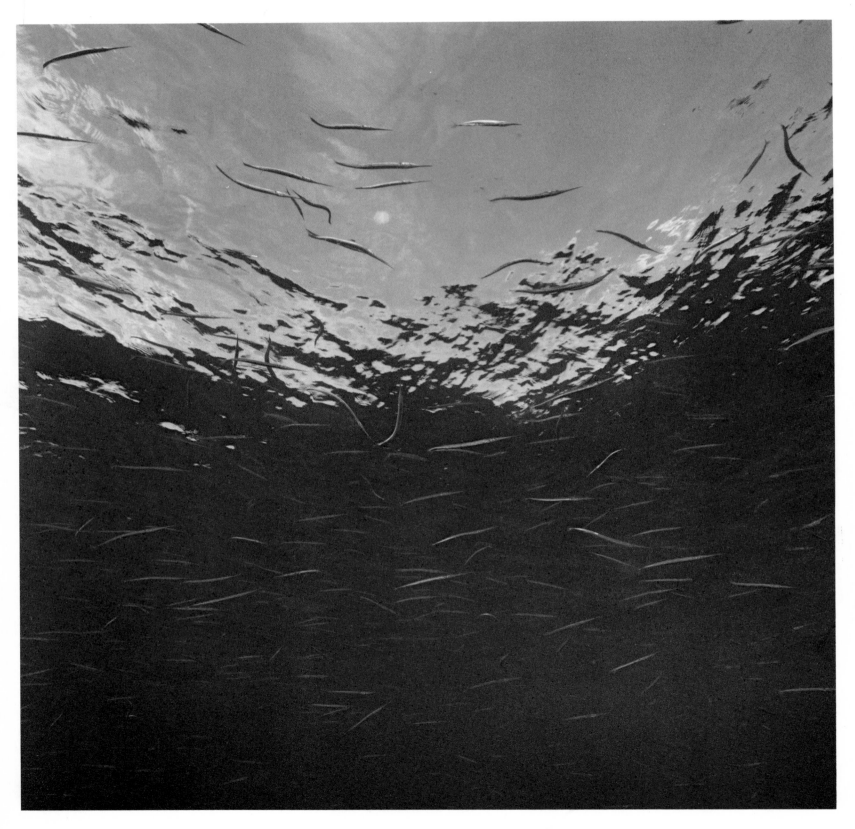

A sea snake is hunting on the reef. It appears from the surface, a slim flexuous shadow, winding swiftly downward. At sixty feet it levels off and slips into the coral. I fin down the slope to find it. Five feet of superbly coordinated muscle glide through the tangle, threading through the crannies where small crustaceans and fish take cover, where fish lay eggs on the walls. Now the whole snake disappears, ferreting through the tunnels. Now the head, or a banded loop, humps above the growth again, and I pick up the trail. While sea snakes are remarkably unaggressive, they are cousin to the cobras, and their venom is a potent neurotoxin. Provoked, they can kill. Yet I dodge about the hunting snake without a moment's fear. It pays no heed, but searches on, working doggedly up the slope until, at twenty feet, it breaks off and dashes for the surface and air.

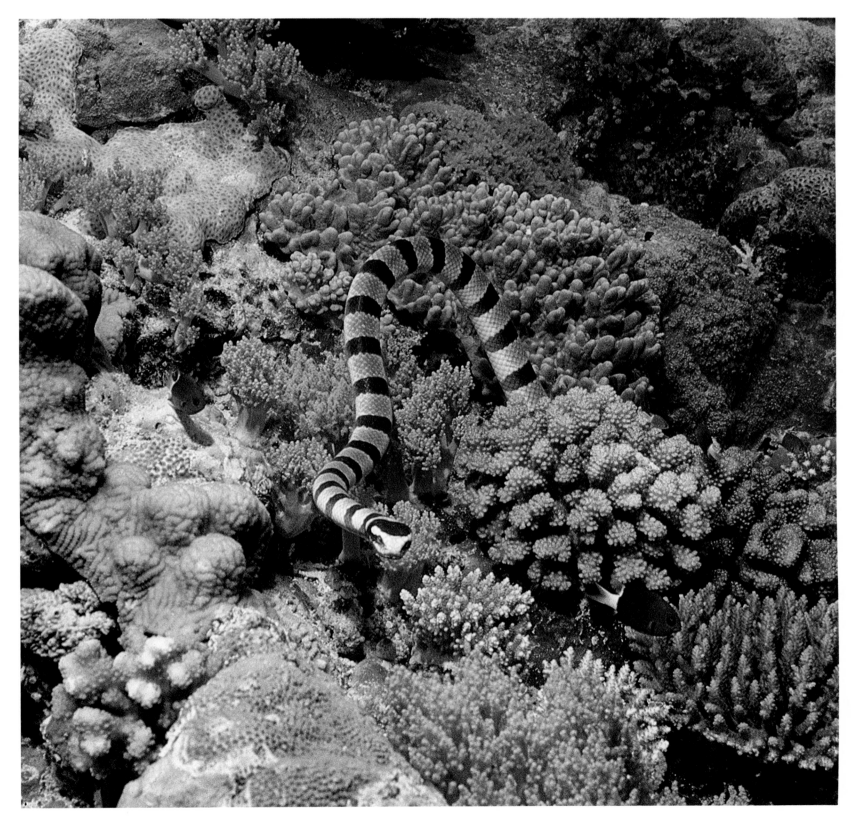

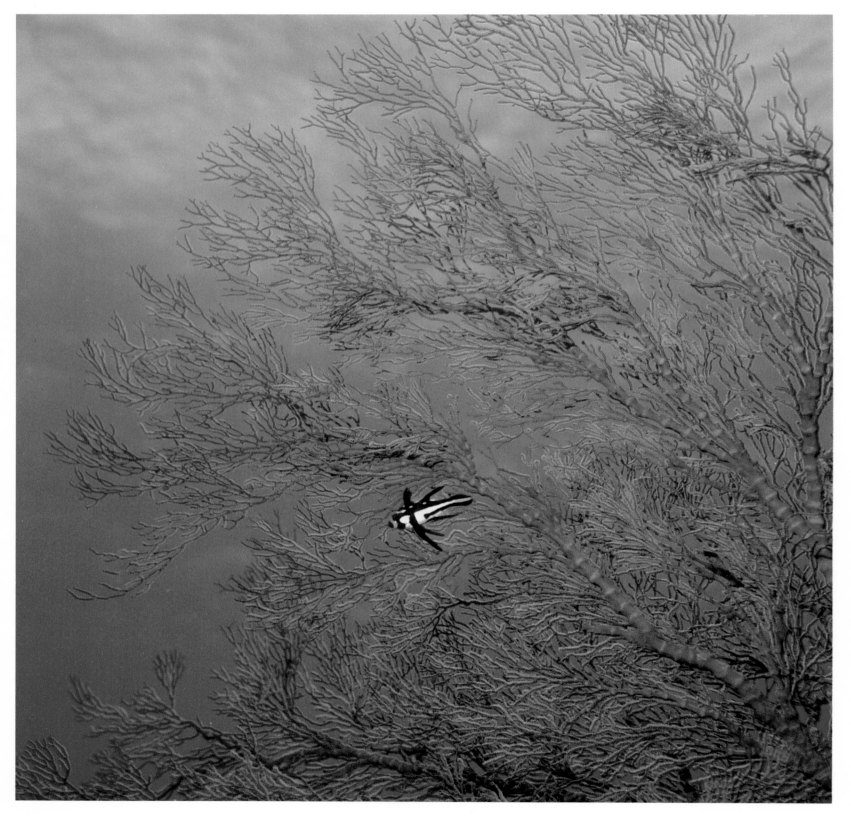

*Juvenile snapper
by sea fan,
Ngemelis, Palau*

Each time I dive the Great Wall, I stop to check a certain sea fan. The odd little juvenile *Macolor* is always there, prettier and more graceful than the adult of the species, and scarcely one quarter its size. When fish larvae settle, they metamorphose to tiny, sexually immature juvenile fish, which usually resemble the adults but often, like the young *Macolor*, vary the adult pattern. Most juveniles feed on plankton, and, as their size makes shelter imperative, it is common to see them feeding close against the face of a sea fan, poised to slip through its gaps. The juveniles on a reef represent an infinitesimal fraction of the eggs released there. Whether the eggs are tended, or released into the current, almost all reef-fish larvae live in the plankton. Few survive. It is impossible to observe what occurs in the plankton, but some clues about larval existence can be gleaned from the juveniles. From the moment a larva emerges from the egg, each day's alternation of light and dark puts down a ring on its ear bone, like the annual rings of a tree. Once it finds a reef and drops out of the plankton, the larva hides in the dark to metamorphose. No rings are put down in the dark. So when it emerges as a juvenile, a distinct hiatus in the rings of its ear bone records its age at settlement. The ear bones of the juveniles show that the larvae remain in the plankton anywhere from thirty to a hundred days, able to postpone settlement until they reach a suitable substrate.

The symbiotic corals are remarkably self-sufficient, but to survive they must obtain certain of their requirements from the environment, primarily energy from the sun to fuel their zooxanthellae, the minute algae living in their cells. They must also take up essential nutrients, such as phosphates and nitrates, to supplement those that the algae recycle. The bubble corals live either in fairly deep water or in the shallow but murky back bays of the lagoon, where multitudes of suspended particles are filtering out the sunlight. Like most corals, they have tentacles that expand after dark to capture zooplankton, securing the nutrients needed by the colony. During the day, however, when the feeding tentacles contract, small vesicles begin to swell. Filling with water, they blow up into a mass of fat little bubbles, crowding together and completely obscuring the skeleton beneath. The bubbles capture sunlight. Compensating for the low ambient light, their expanded surfaces, like wider windows, let extra sunlight into the polyp's tissues, fueling the zooxanthellae in their cells. When the sun goes down, the bubbles deflate, making room for the tentacles to feed.

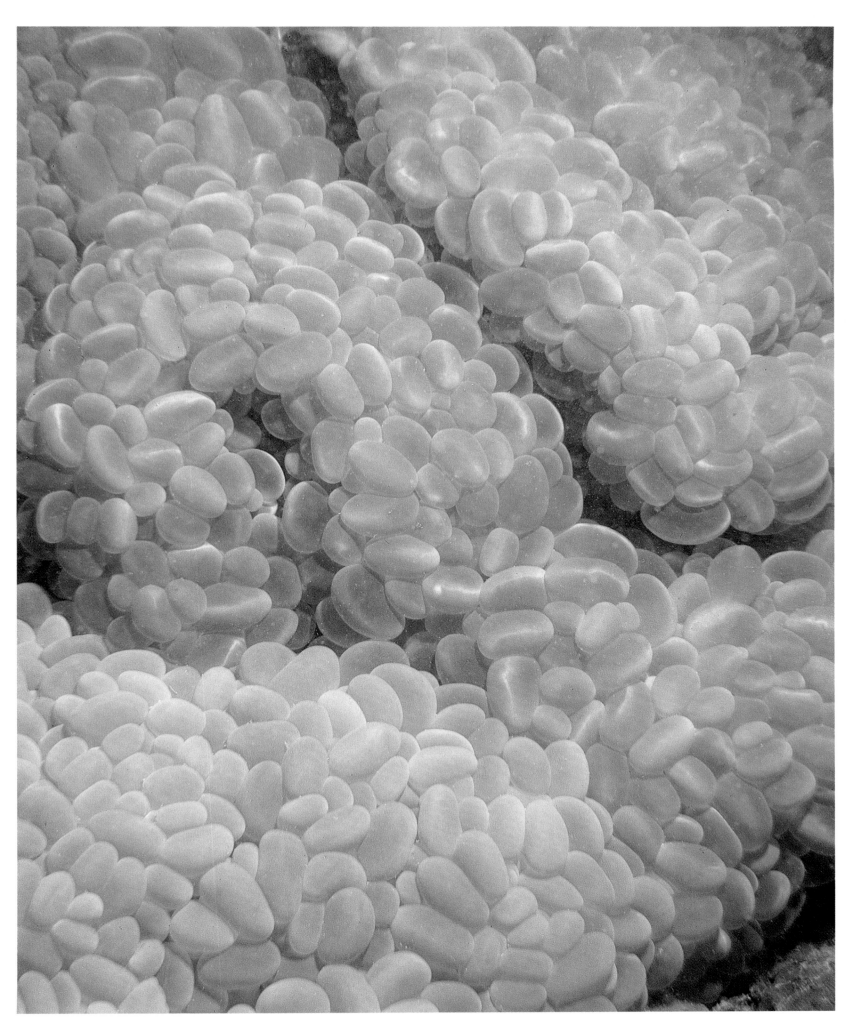

The reef top,
Turtle Cove, Palau

In the south, the reef grows to the surface. Small coral islets form on its crest, and from there, the reef top slopes to the drop-off, where the wall falls away to the abyss. This slope takes the brunt of the incoming waves, and on it the corals form buttress-like mounds with canyons winding between where spent waves wash back to sea. The mounds are blanketed with organisms, almost all of them symbiotic animals that are recycling nutrients with resident algae. The stony corals are all sturdy, robust forms, able to withstand a high-energy environment. Their yellow-brown color is imparted by the yellow-brown zooxanthellae living in their cells; related algae live in the leather corals. The white, berrylike ascidians, and the tiny pink ones, are harboring blue-green algae. These animal/algae partnerships depend on the algae's ability to photosynthesize. They flourish on the sunlit reef top, competing so successfully that few other animals can gain a foothold.

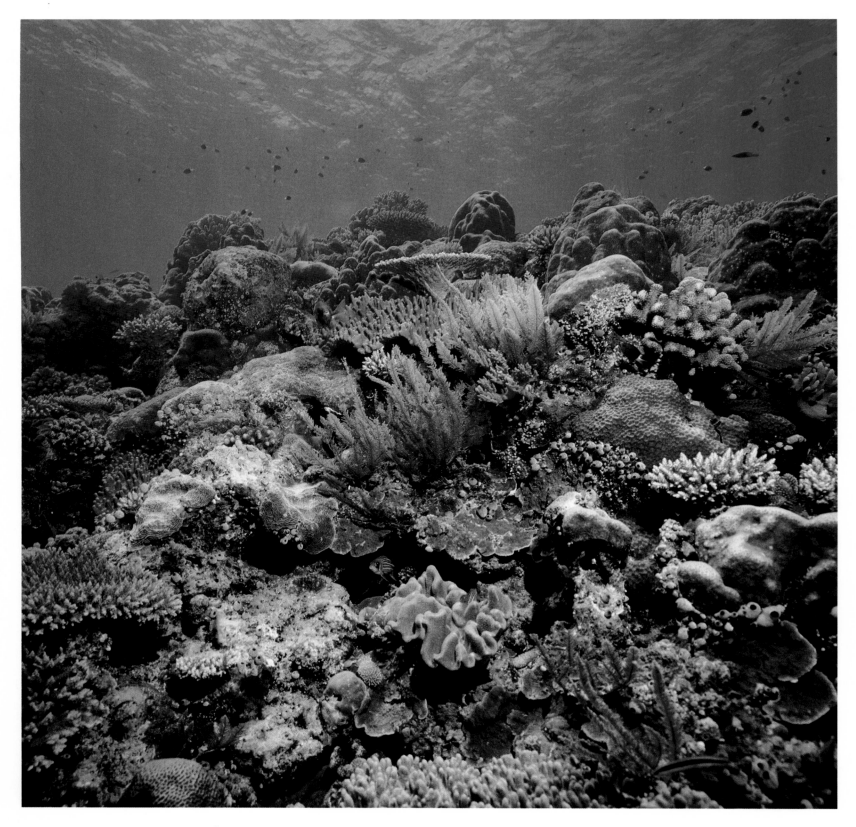

Skunk clownfish with
half-closed anemone,
Turtle Cove, Palau

Ⅰn the slack between currents, the giant sea anemone has partly closed. Its muscular column bulges, and its tentacles are gathered to a tuft on top, but its resident clownfish are still tucked into the tuft or are hovering close beside. All clownfish live in symbiosis with a sea anemone host, and their lives depend on its protection. The anemone's tentacles are covered with stinging cells that fire at touch, injecting a paralyzing toxin. Clownfish have a thick mucous coating that does not excite the stings, and they can lie ensconced in a mass of tentacles that their predators dare not approach. An anemone is normally the territory of one monogamous adult pair—a large, dominant female and smaller, subordinate male. With them live some subadults, smaller still, and all male. Should the female die or disappear, her mate transforms into a female and is soon laying eggs in her place. Then from the reservoir of subadults, the largest one grows to replace the breeding male.

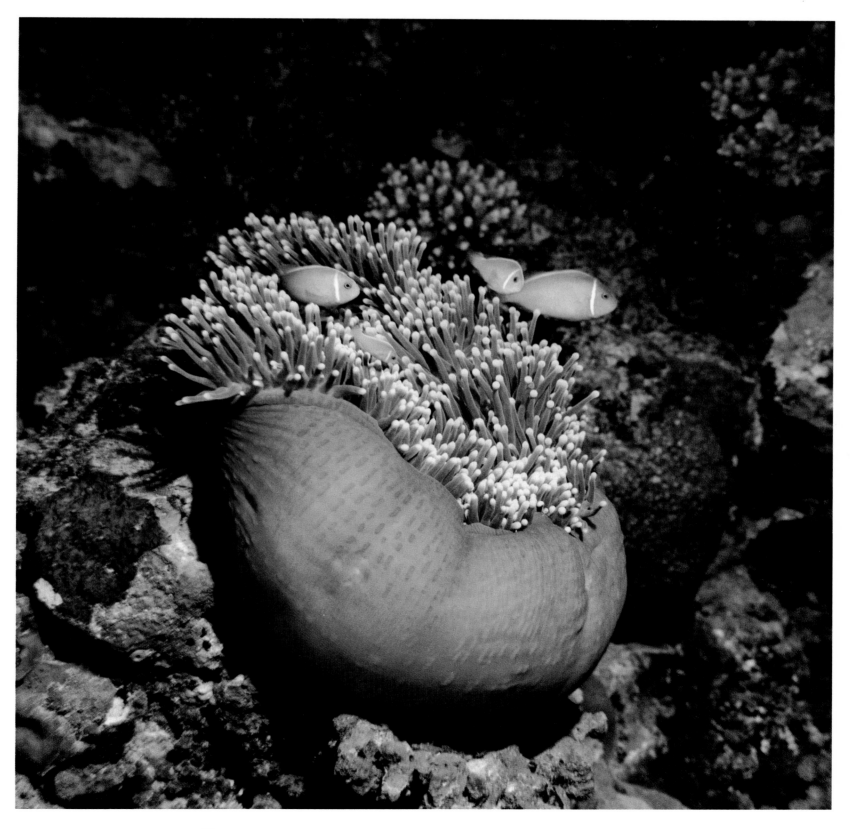

Squirrelfish in chalice corals,
Rainbow Reef,
off Vanua Levu, Fiji

Swimming down along the anchor chain, I round a large coral structure, then continue my descent until, at forty feet, I come upon a stretch of almost flat, sandy floor, and off in the distance a huge bank of coral rises from the sand. The closer I come, the more surprised I am. About eight feet high, and easily eighty feet wide by eighty feet long, the whole patch reef is a bed of gigantic coral cabbages. And oddly, it is all one species. There are no other corals at all, nothing but the one cabbagelike species of *Turbinaria*, and clouds of swarming fish. In each coral, a swirl of thin, overlapping plates unfurls from the center. They are covered with flesh: polyps stipple the inner surface, and new growth highlights the curling edges. Squirrelfish have made the "cabbages" their daytime shelter. They are tucked between the "leaves," or hang just above, vivid against the monochrome of corals. Untrammeled by the constraints of the terrestrial photographer, I rise slowly above the bed, seeking the ideal viewing angle from which to make my photograph. Kicking very slowly now, and using breath control to maintain my position, I determine my final composition.

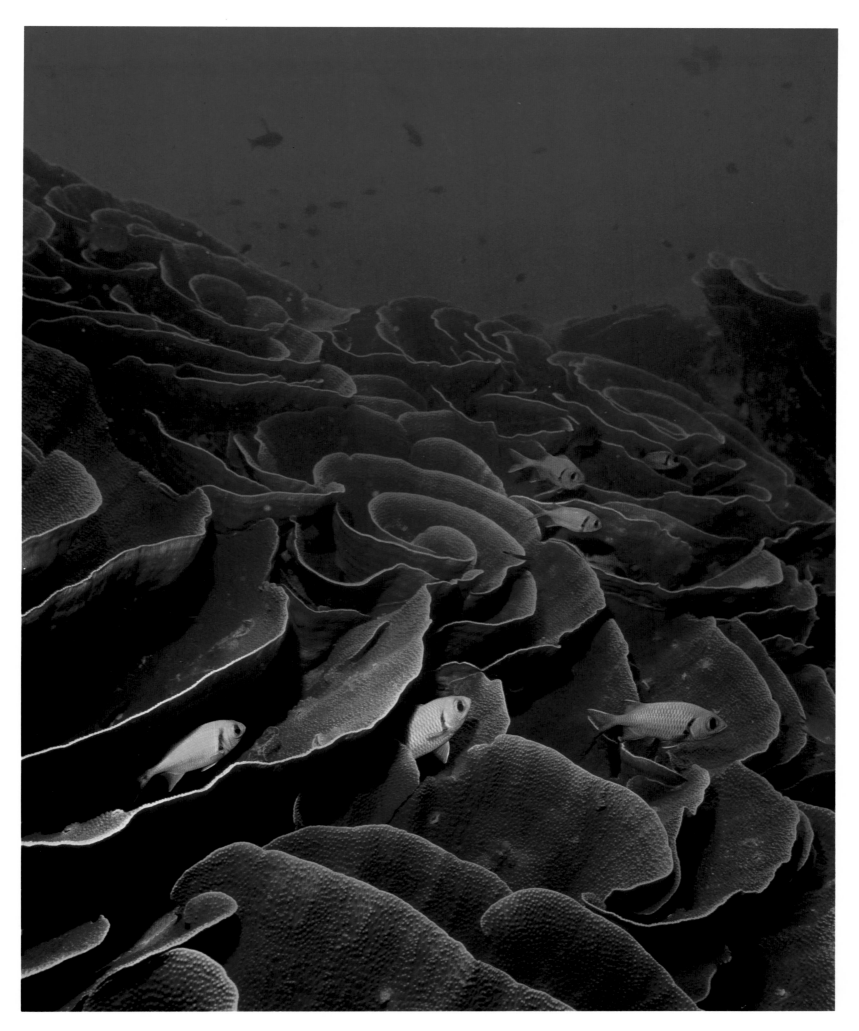

29

Working my way against a strong current, I swim along the base of a sixty-foot wall. Out on the floor, on top of a coral mound, a strong splash of color catches my attention. In the open, the current is stiffer still. I have to kick hard to make progress, and as soon as I am close enough, I drop to the floor, crouching in the lee of the mound. Its bulk affords some protection, and I "walk" the rest of the way in on my knees. My colorful object turns out to be a hunk of coral limestone, oddly shaped and heavily encrusted; what caught my eye were its gaudy patches of sponge and the particularly luscious red soft coral jutting from its side. Sitting with my legs splayed on either side, as only the double-jointed can, I achieve stability and raise my camera to evaluate the composition. Unhappily, the visual elements simply do not make a picture. Then, gliding across the coral mound, come three yellow-fin butterflyfish. I hold my breath lest my bubbles frighten them away. They sail gracefully into the frame of my viewfinder, and I freeze the fleeting composition with my shutter.

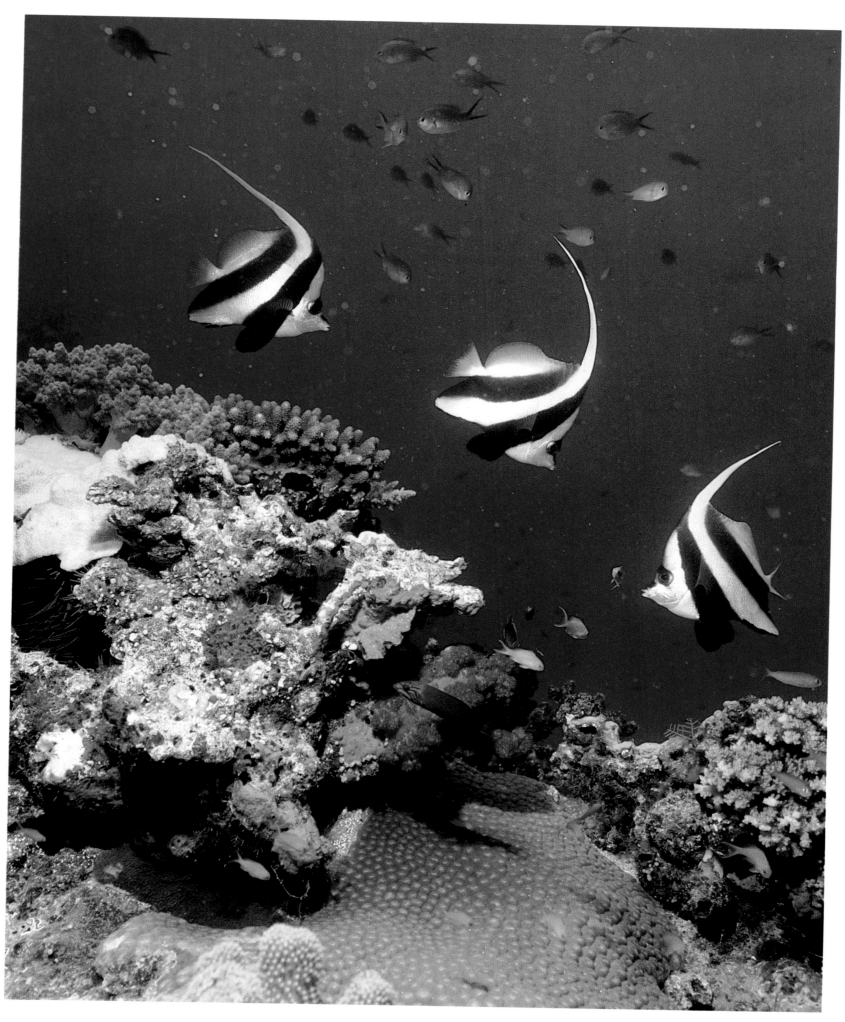

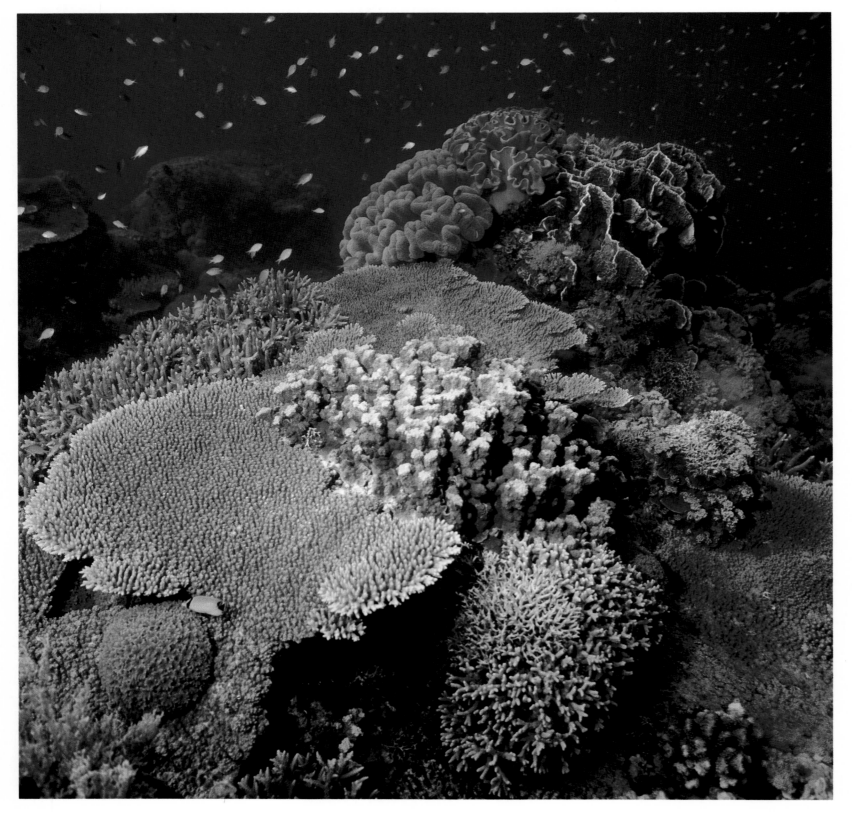

Coral garden,
Apo Reef, Philippines

The water at Apo is so clear that there seems no limit to vision, and the underwater gardens could not be more perfect. Miles of winding reef lie pristine, unsullied by predator or man, and the corals are old and well established. Some parts, however, bear the unmistakable stamp of a crown-of-thorns invasion. That these parts too are beautiful is testimony to the reef's resilience. In the normal course of competition, fast-growing corals weed out the slower species by overtopping them and depriving them of light. The crown-of-thorns starfish reverse this effect. As they crawl across the reef, devouring coral polyps, they feed preferentially on the fast-growing species, such as fire coral and table coral, cutting them back. The less competitive forms, like finger corals, can now make headway, and the soft corals, which are poor competitors, are quick to establish on the open surfaces. Algae spread across the starfish-damaged corals, slowing their recovery, but as the reef's many herbivores nibble it off, the corals soon reappear, and the recovering reef is once more perfect, with a greater diversity of species and forms than if the starfish had not come.

All living things have some ability to repair damaged tissue, but many invertebrates can actually replace a lost appendage or reconstitute an entire body from a fragment. Starfish have a high capacity for regeneration. They can replace lost arms, or cast off an injured one and regenerate it. In many species an arm and a piece of the disc are all that is needed to regenerate an entire star. Starfish of the genus *Linckia* go one step farther— unlike any other starfish, they can reproduce by casting off arms. While the body grips the substrate, one of its arms simply walks away and starts pulling. By the time it has pulled for three or four hours, its tissues have stretched as much as two inches; and finally it separates, to become another starfish. At its severed end, the wound closes, leaving a hole that will become the new animal's mouth. The healed surface then produces four minute lobes that will become the rest of its arms. Even a year later the new star is a curious-looking animal, consisting of one large, tapering arm with tiny arms crowning its broad end. In the meantime, the parent starfish has been regenerating the arm it cast off. Not surprisingly, it is difficult to find a perfectly symmetrical *Linckia*, with five equal arms.

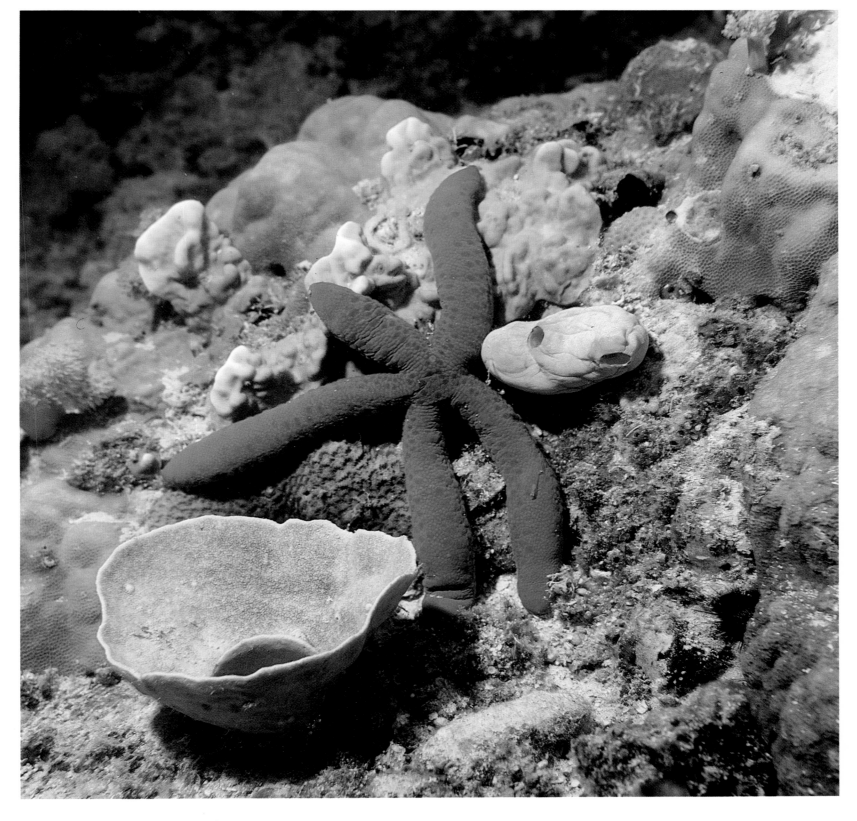

At Apo, most of the reef has grown undisturbed for a very long time, and on the forereef huge old table corals loom above the understory, their thin, flat profiles offering minimal resistance to the surge. Their majestic platforms can grow to eight feet across, holding countless polyps to the sun, while casting pools of deep shadow on the brightly lit floor. In their shade, fish move and sponges encrust, but no reef-building coral can survive. If the algae in a coral's cells can photosynthesize, they supply its food, recycle its nutrients, and enhance the rate at which it builds its skeleton. But they must have light. In the jostling competition of a coral reef, the successful coral is the coral that can preempt space in the sun. Table corals grow very rapidly, spreading laterally about two inches a year; if unchecked by predators, they quickly overtop their neighbors and, growing sideways, shade them out of existence.

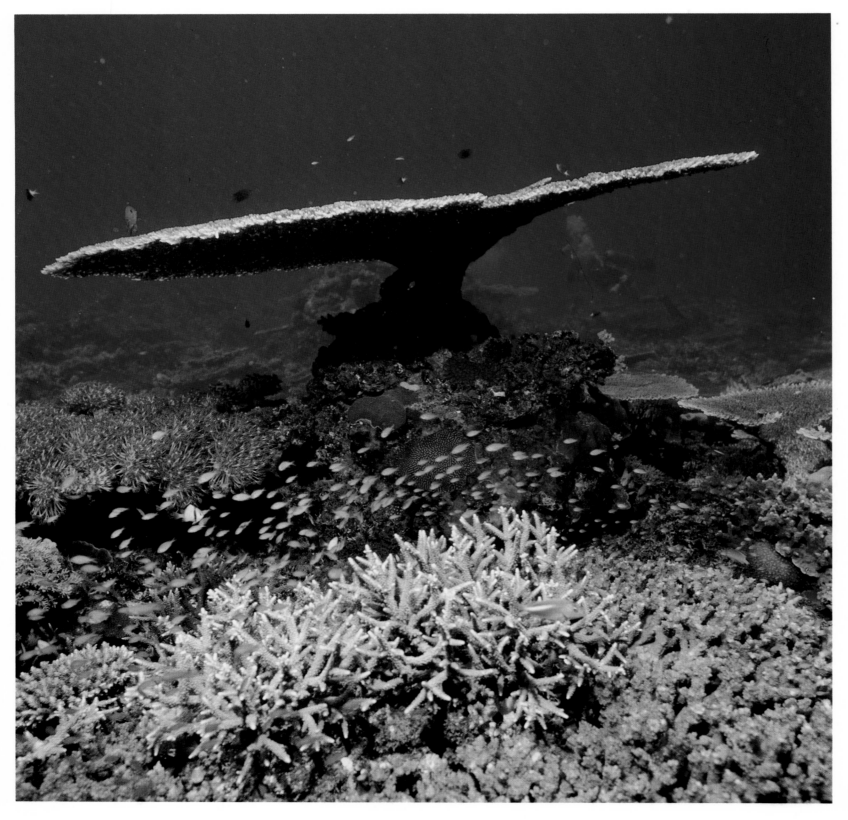

Chromis *above staghorn coral,*
Apo Reef, Philippines

Where the reef crest falls away, the inter-weaving branches of the antler corals form impenetrable thickets that are topped with spikes of bright new growth and swarms of little blue *Chromis.* School after school hovers just above the branch tops, feeding on passing plankton. Each, as we approach, disappears abruptly, the whole school diving together, as though pulled by a single string. If we wait, the fish return, still in unison, and resume their feeding. A very small reef fish can only survive by finding a safe retreat and reaching it in time. Staying close to familiar escape routes greatly increases their chances of reaching safety. These *Chromis* center their schools on one particular coral head and stay there, feeding inches above it, using its crevices as shelter and settling into them at night. Their synchronized behavior is added protection. When any individual detects danger, his flight elicits an immediate, synchronous response, and the entire school vanishes.

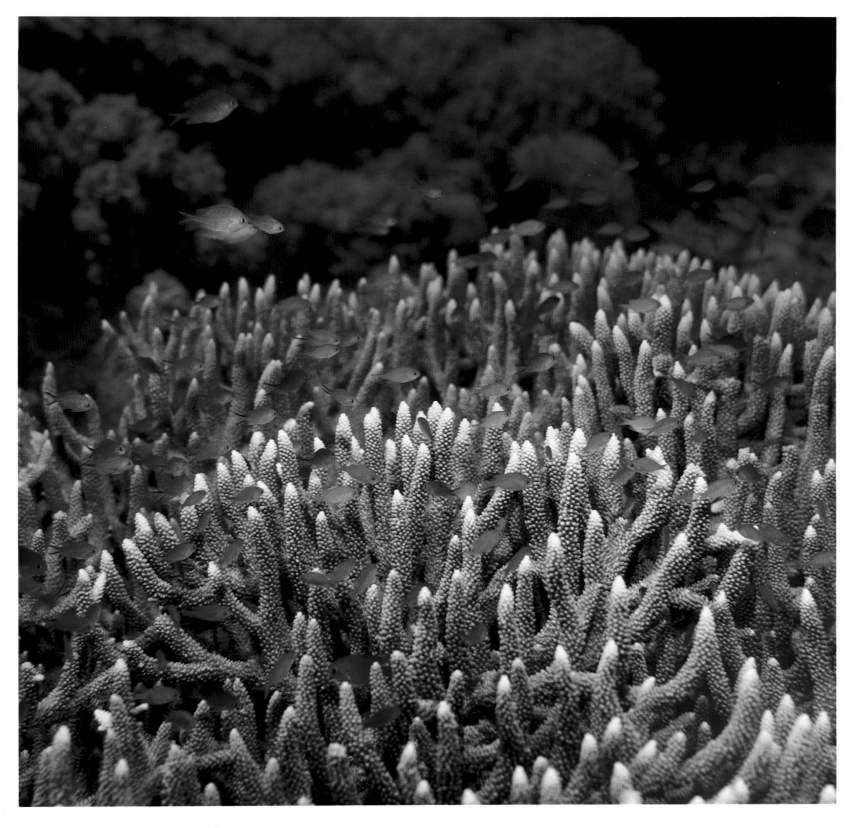

Cuttlefish,
Apo Reef, Philippines

The cuttlebone we hang in bird cages is not bone, but shell, the modified, internal shell of *Sepia*, the cuttlefish. *Sepia* is a mollusk, like a snail or clam, but a mollusk that has dispensed with external shells in favor of mobility. It now wears its shell embedded in its mantle, a thin, rigid plate of the same composition as clamshell, but of very different structure. The "cuttlebone" is a stack of thin-walled chambers, partly filled with gas, and it serves as a buoyancy organ, bringing *Sepia*'s density very close to that of seawater. So buoyed, the cuttlefish can swim by undulating the thin, muscular fins along its sides and can move slowly just above the floor, searching for shrimp and other prey, squirting water through its funnel to stir up the sand. In emergencies, however, it moves by jet propulsion: contracting strongly, it expels a jet of water through its funnel so forcefully that its body is shot backward. It leaves behind, to distract its foe, a dark cloud of ink, or sepia.

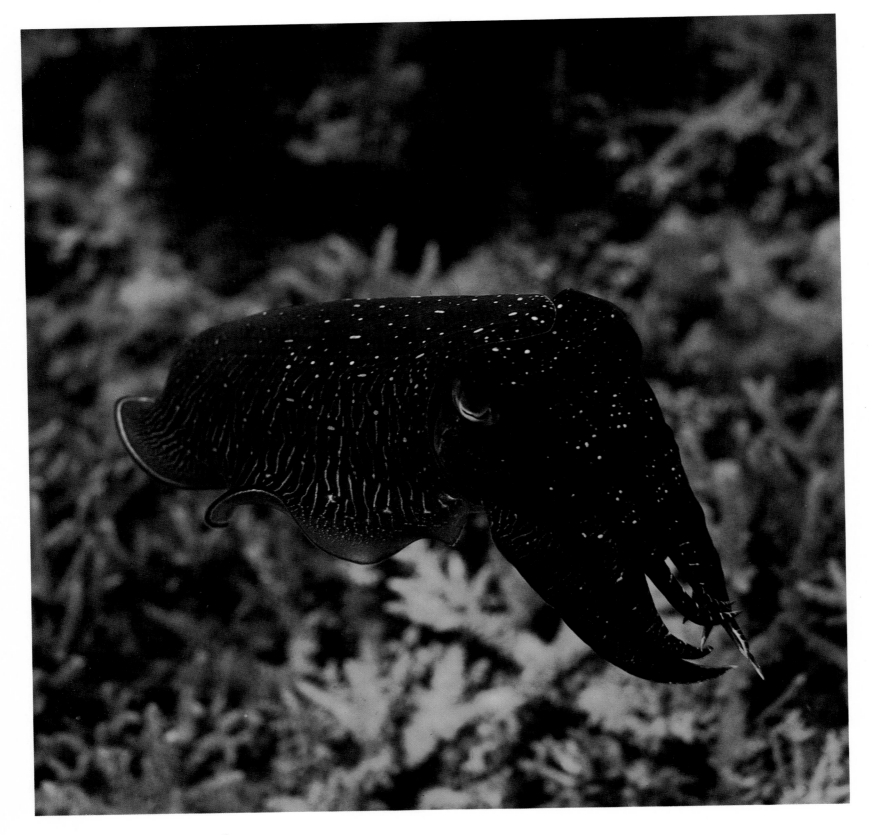

Black-backed clownfish
in anemone tentacles,
Apo Reef, Philippines

The relationship between the clownfish and the giant sea anemones is of benefit to both. The fishes' benefit is clear. They gain security. They are small, defenseless fish, and somewhat inept, never safe from predators except when surrounded by a sea anemone's stinging tentacles. The amount of time a clownfish spends inside its host varies with the species, but all clownfish spend the night buried deep beneath the tentacles, and during the day they leave only to feed. The more dependent the species, the less distance they venture, and the more frequent their retreats into the tentacles. The anemone's benefit is less obvious. It gains nutrients: all the while the clownfish are sheltering in its tentacles they are depositing their wastes, providing their host with a steady supply of nutrients in an environment where they are often quite limited.

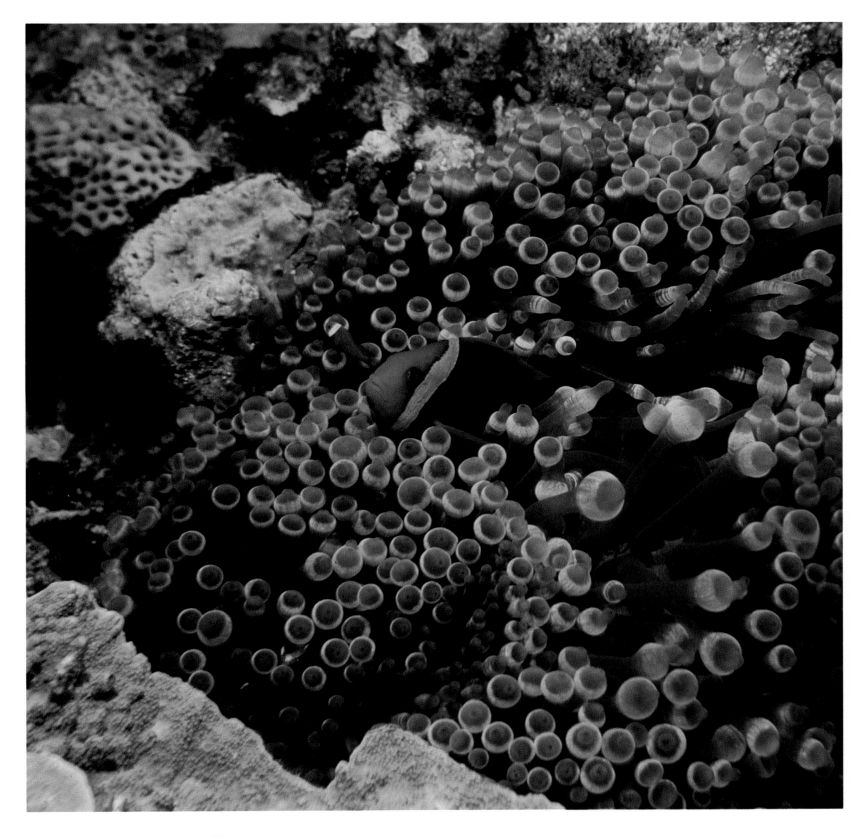

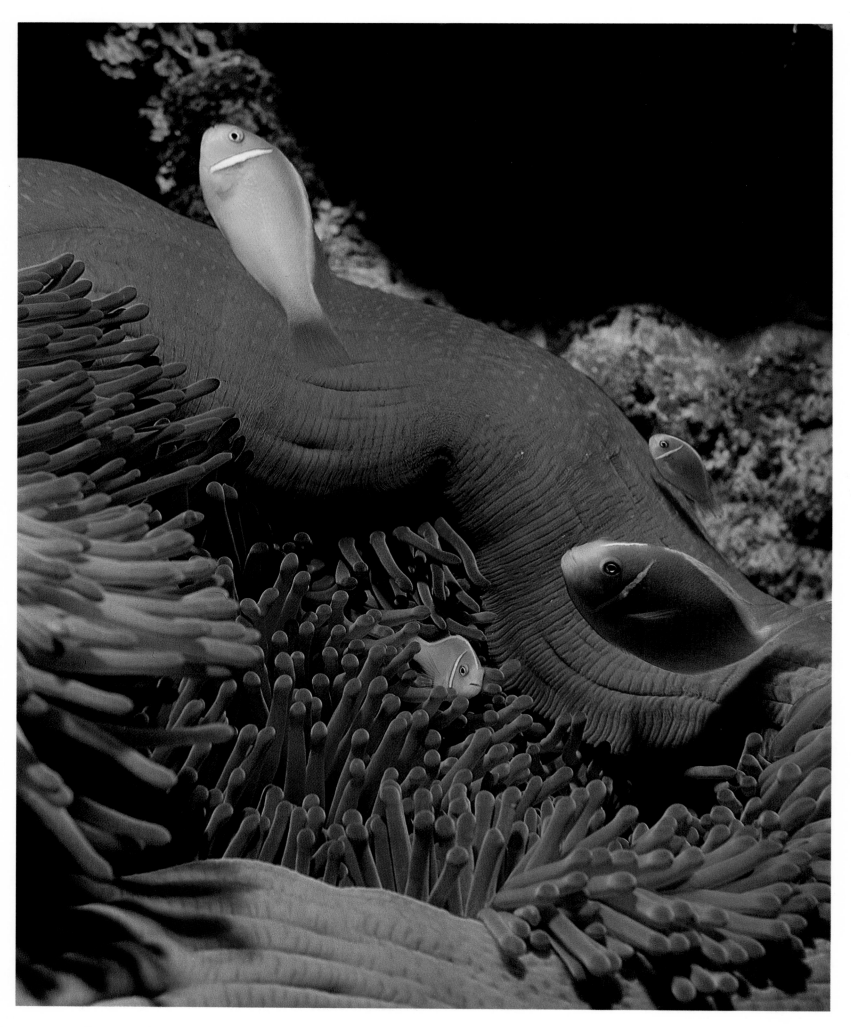

*Skunk clownfish
in gaudy anemone,
Marion Reef, Coral Sea*

The column of *Radianthus ritteri* may be orange-brown, blue, or an amazingly lurid violet. The anemone's oral disc reaches thirty inches across, and it is one of several species of giant sea anemone that harbor symbiotic clownfish. The clownfish live among their tentacles, but must venture outside to forage. These rather slow, clumsy little fish have many swift, agile competitors, so they carry food back to the anemone, to store it where the other fish cannot come. They can place their food on the anemone's oral disc, but it often rolls off. A sea anemone has no brain, no central nervous system; it would seem incapable of learning anything at all. Yet the giant sea anemone learns to recognize the movements of a food-bearing clownfish and to open its mouth in anticipation, enabling the fish to store their food, without delay, right inside the anemone's pharynx —an impregnable food-safe. The fish appear to be feeding their host, but later on they dive into its mouth and retrieve their morsels, slightly digested, but safe. This conditioned response by the anemone is of real benefit to the relatively inept clownfish—rapid, safe food storage may well make a difference to their survival. The anemone gains only the food that it manages to digest before the fish reclaims its meal. In the long run, however, its main benefit is the nutrients the fish deposit, and what benefits the clownfish benefits their host.

A coral reef is a labyrinth of tunnels, holes, and crevices, and always, at any time of day, a multitude of animals are hidden inside. Animals active by day rest in the crannies at night, and during the day those crannies are occupied by the night-active animals. Sick or injured animals are supremely vulnerable and seek the relative safety of the crevices. But by day or by night some species of moray is prowling there. Moray eels are specialists, crevice predators adapted to ferreting out animals in hiding. Crevices are dark places. A moray's visual acuity is poor, but it is equipped with a highly developed sense of smell, and tracks down its prey by smelling it out. The prey are mostly small, able to slip into narrow chinks and fissures.

The moray's head is small, its body long and snaky, much modified for a life of squeezing through tight places. It has dispensed with paired fins, spines, gill plates, even scales, anything that might catch or snag on a rough bit of coral. The speckled moray, widespread in the Pacific, hunts mostly by day, capturing small fish and crustaceans. One of the more visible species, it often lies at the mouth of its hole and, with care, can be hand fed. The ferocity of morays is without doubt exaggerated, but they do deserve respect—divers are cautious when they plunge their hands into holes. That small, pointy head is domed for the attachment of extra-strong jaw muscles. Those wicked teeth point backward, to prevent a captive pulling free.

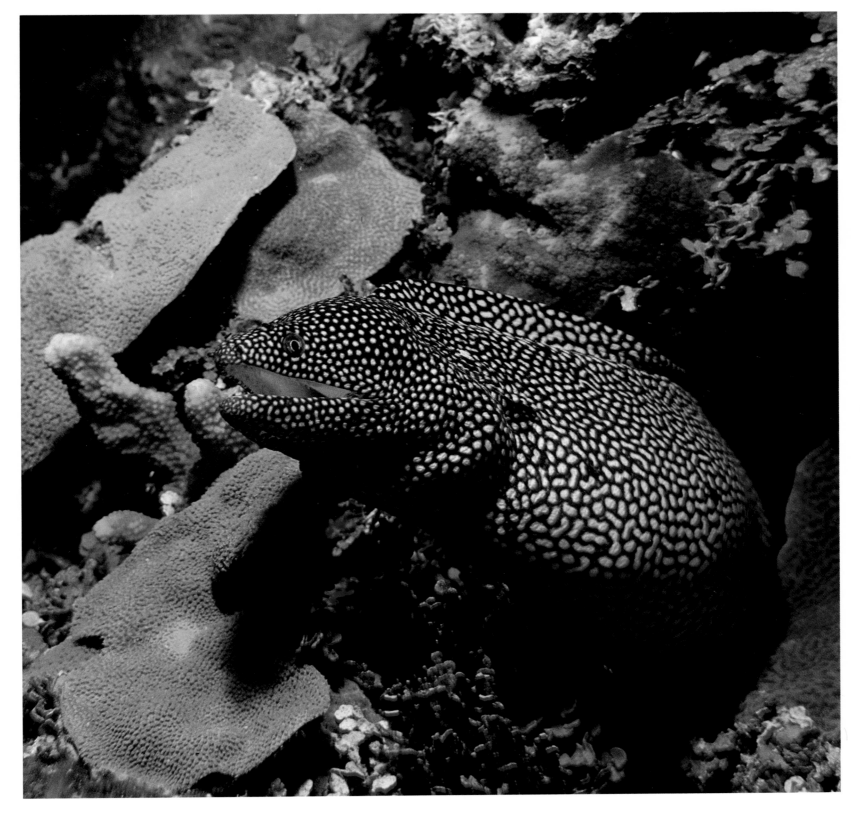

Osprey Reef rises on the deeper, northern section of the Coral Sea Plateau and looms several hundred feet above the floor, almost reaching the surface, but nowhere breaking through. Osprey is a large formation, an atoll with a perimeter of perhaps sixty miles. Only a few spots have ever been dived—few even have names. We set out full of plans, but when we arrive, a cyclone is passing to the north, kicking up heavy seas. We anchor on the reef's lee side. Wall dives are impossible, but below, among the dark shapes of coral mounds, gleams the pale aquamarine of sand. We can dive in the protection of sand channels. I swim along a winding, sandy-floored canyon that slopes steadily down toward the sea, ending in the open water, with the wall dropping away below. At the mouth, a large school of trevally jacks drifts upward, in a graceful spiral.

Bumphead parrotfish pass, then a gray shark. The shark circles, and I hide until it is gone, then notice the mouth of a much narrower channel opening into the large one. I swim inside. Steep coral walls stretch fifty feet above me. Moorish idols glide through the corals, as do exquisite butterflyfish. Soft corals inevitably invite vegetable comparisons. The leather corals here have pale, convoluted tops —they are cauliflowers. My little canyon stretches before me, its white floor beckoning like a winding country road. I wonder if I am the first to follow it, whether anyone has been here before. A school of dark sweetlips crisscross it, in a bumbling, undisciplined mob. A couple of spangled emperors raise a cloud as they root in the sand for mollusks. I do not regret passing up the wall dives; I am happy to be here.

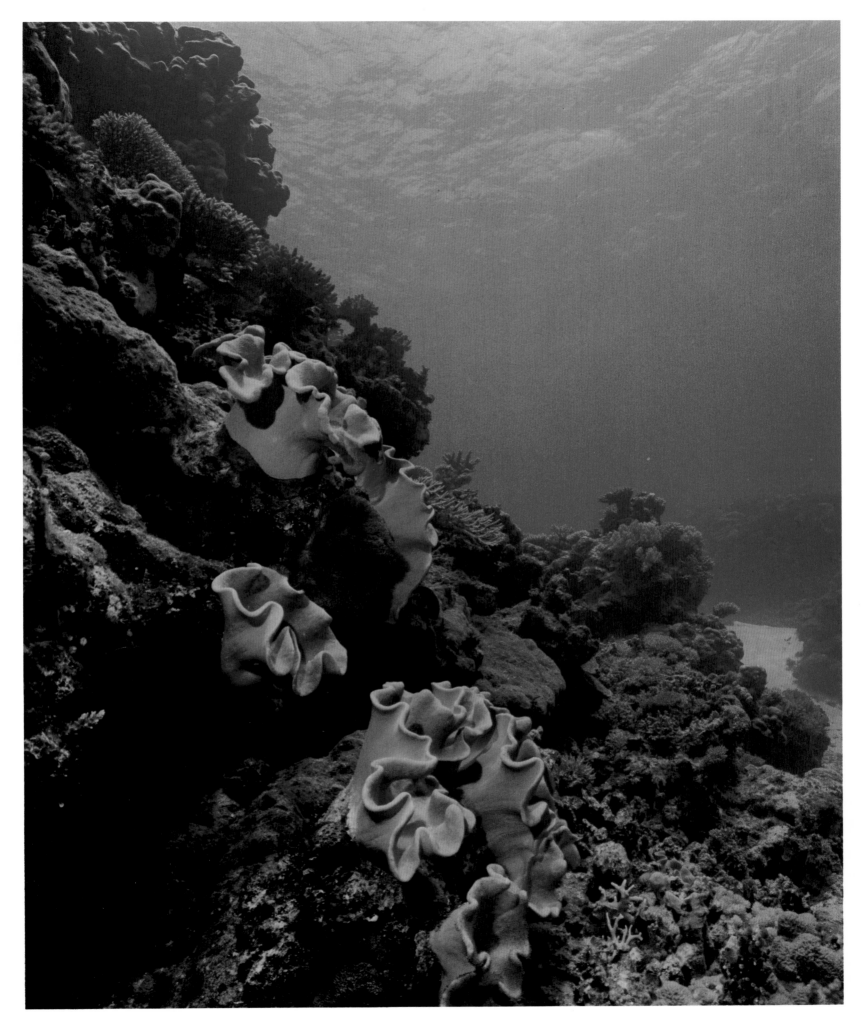

A *Turbinaria*, or chalice coral, lies on the floor of a sand channel, toppled from somewhere on the big coral mound behind. The coral rests on its side, its flared rim curling, a beautiful, flowing sculpture. The flowing curves were sculpted by the coral's growth after it tumbled to the sand. *Turbinaria*'s polyps and zooxanthellae are arrayed on the inner surface of its plates, and when the colony ended up on its side, most of its algae ended up in shade. When the plates grew, they grew unevenly. On the top and either side, the plates arched backward, so that they no longer shaded the polyps below, while their algae-bearing surfaces were curled toward the sun. It is not uncommon for a stony coral to fall—they are heavy, and waves dislodge them, or their base erodes, or boring organisms weaken their skeletons. When they break off and roll out on the floor, they enable the reef to grow laterally. A coral can only anchor on a hard substrate; it cannot establish on sand. Fallen corals become a foundation on which other corals can colonize, and the reef face moves forward, to buttress the reef.

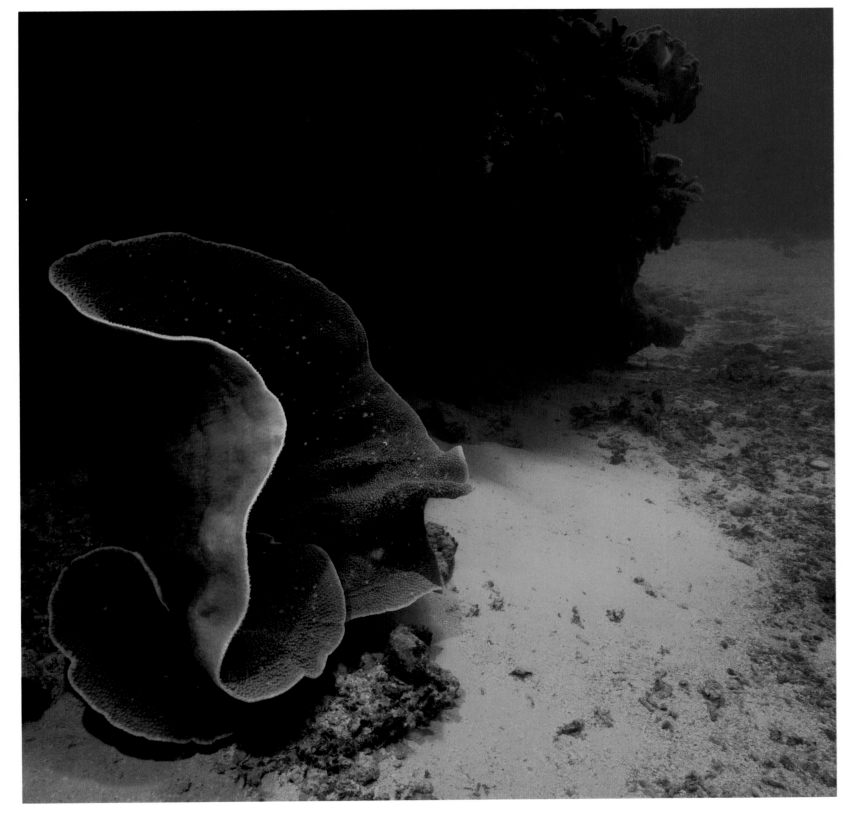

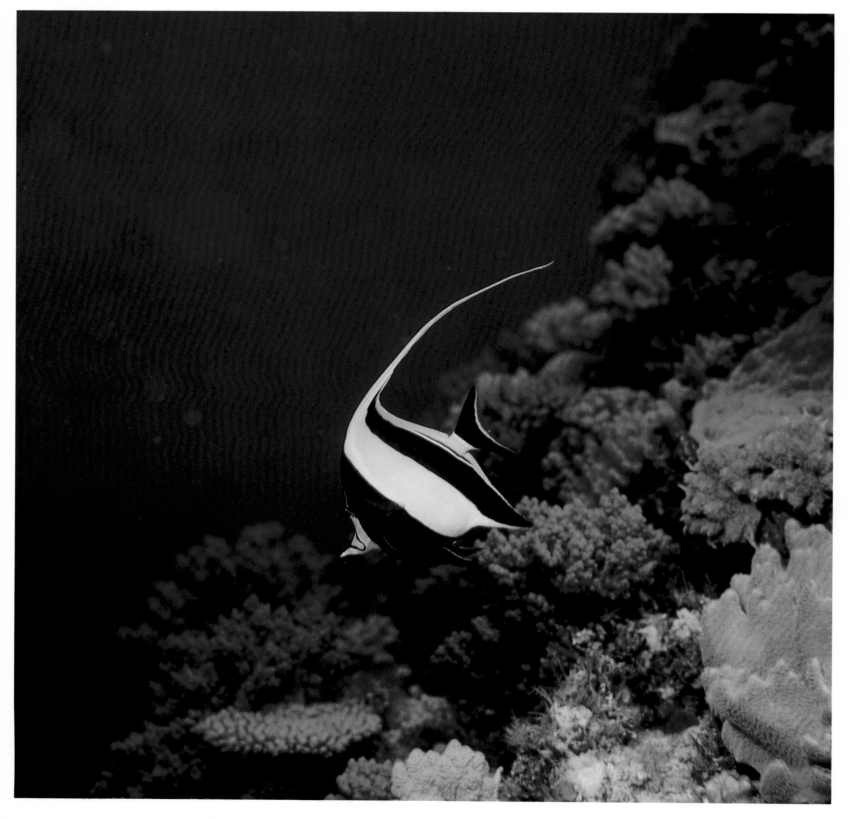

Supple, wafer-thin Moorish idols glide about the reefs in twos or threes, probing the cracks for invertebrates. They look like very large butterflyfish, but have the distinctive, long-lived, acronurus larvae of the surgeonfish family. No adult fish adapted to reef life can cross the huge expanses of ocean that divide the coral reef habitat—but their eggs and larvae can, and the dispersal of the young is a reproductive strategy employed by almost every reef fish. Those that can, produce as many eggs as possible to allow for severe attrition, then migrate to the edge of the reef and release them into the currents. Small, bottom-dwelling fish that produce fewer eggs lay their eggs in shelter, tending them until the larvae hatch and swim up into the plankton. Such larvae get a late start, and these species tend to be restricted in distribution; larvae hatched in the plankton, with a head start and food from the egg to sustain them, travel farther. The Moorish idol's acronurus larvae are especially adapted to planktonic life and can stay there a hundred days (the record for a reef fish), spreading the Moorish idol across the entire tropical Indo-Pacific, from Galapagos to the Red Sea.

As almost every predatory reef fish is itself preyed upon, it must possess not only the means to capture prey, but the means to deter predation. Many fish bear prickly spines, but without a doubt the most formidable defensive weapons evolved by fish are the hypodermiclike, venomous spines of some members of the scorpion-fish family. A spotfin lionfish is a slow-moving predator of the floor and hunts by night; I disturb one resting during the day on a crevice wall. Instead of fleeing, it assumes an aggressive posture, fanning its splendidly spiny pectoral fins; they are impressive, but the spines to watch are the spines rising like hackles on its back. There, red-and-white peppermint-striped sheaths house needle-sharp spines, each with grooves from top to bottom containing venom glands. The spines of the anal and pelvic fins, on its underside, are also venomous. If a predator is sufficiently ill-advised as to grab at a lionfish, every spine it touches will break through its sheath, puncture the offender, and inject venom into the wound. When humans are spiked by lionfish, the wound is exceptionally painful; the effects of the venom can be serious and, on rare occasions, fatal. Thus protected, lionfish move about the reef with that air of unconcern peculiar to the animal that nothing dares touch.

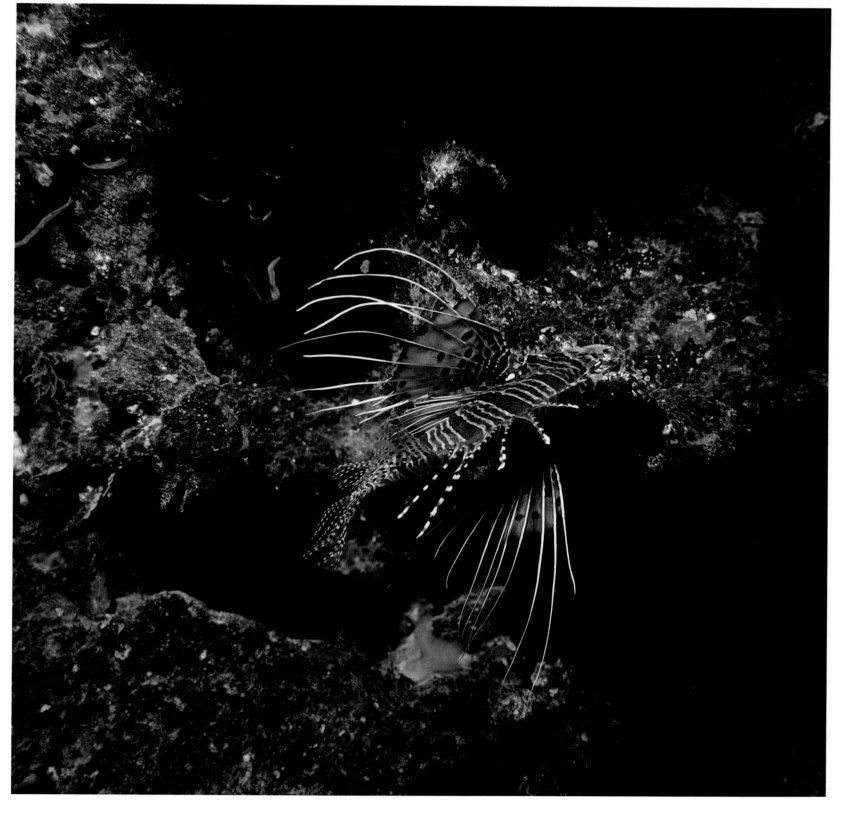

With increasing depth, the amount of light reaching the floor decreases rapidly. By thirty feet—or even less—light intensity has diminished to the point that many of the symbiotic corals are increasing their surface:volume ratio, in order to capitalize on the light still available. Instead of mounds or sturdy branches, colonies deposit thin, flat, platelike skeletons that will command space on the reef and will expose as many symbiotic zooxanthellae to the light as possible. *Pachyseris speciosa* can grow in a bowl-shape, or it can spread out in thin, flat lobes, overlapping like shingles. Plates this thin are only feasible in deeper waters, where water motion is confined to currents; they would be demolished in the shallows, where waves exert ten times the drag force of a current. Thin, concentric ridges corrugate the plates' upper surfaces, with the polyps in the valleys between. As in most corals, the polyps' flesh is colorless—it is the zooxanthellae in their cells that are brown. Along the margins, where the plates grow rapidly, the newly budded polyps have not yet acquired algae, and the new growth is light in color, a pale rim highlighting every curve and swirl. The plates' overlap becomes shelter for small animals such as the feather stars, which sometimes feed with their bodies tucked in a crack for protection, and their arms (which are replaceable) out in the open, trapping plankton.

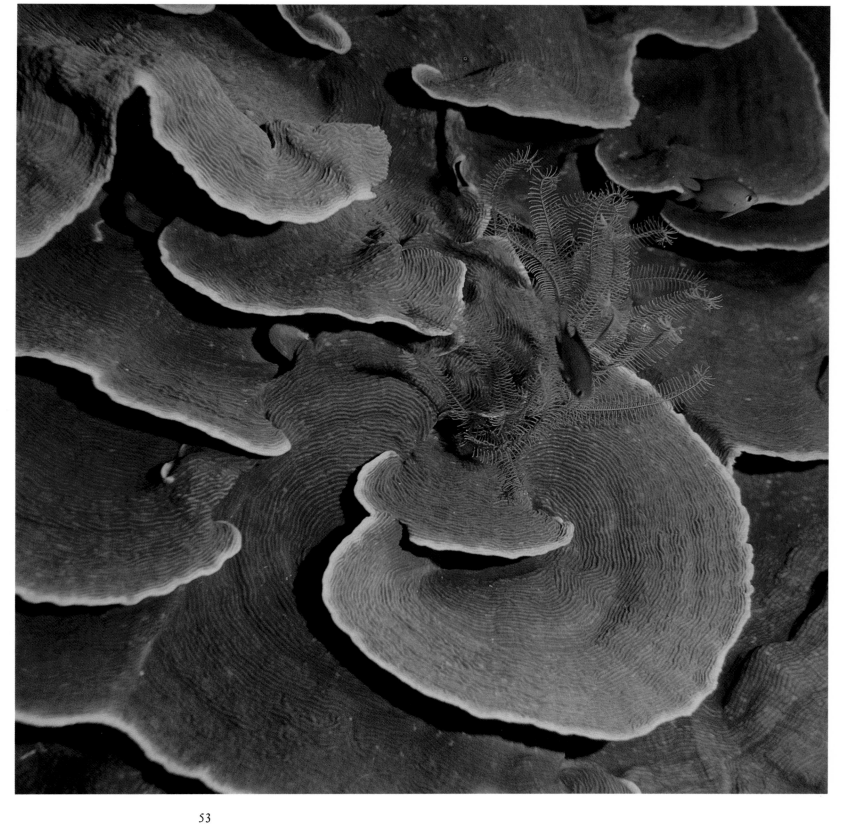

Yellow-faced butterflyfish
in plate coral,
Marion Reef, Coral Sea

A reef is scarcely a reef without butterflyfish; out of a hundred and sixty species, all but a few are inhabitants of the coral reefs. All but a few are bright and colorful—the yellow-faced butterflyfish, with its lovely, dusky colors, is one of the odd ones. The deep, superthin body of the butterflyfish is designed to weave through crowding coral thickets and shelter in narrow coral cracks. At the tip of its pointy snout its very small mouth has tiny, sharp teeth, specialized for "picking." Though very many species feed on coral reefs, and all are pickers, butterflyfish have minimized competition by expanding into an amazing variety of feeding niches. Some are planktivores, picking tiny crustaceans from the plankton; some are herbivores, picking off the algae that overgrow dead corals; the cleaners clean larger fish by picking off parasites and injured tissue. The reef is full of pickable food for carnivores: tiny shrimp, fish eggs, encrusting sponges, worms—one species nips off the tube feet of sea urchins. Butterflyfish with elongated snouts probe the crevices for cryptic invertebrates; one has a snout like a needle-nose pliers and tears strips of flesh off larger animals. Corals are an omnipresent food source. Some butterflyfish live on the mucus the corals secrete. Many nip off the exposed parts of polyps. Some butterflyfish are generalists, eating coral and several other foods; others are specialists whose diet is restricted to one species of coral.

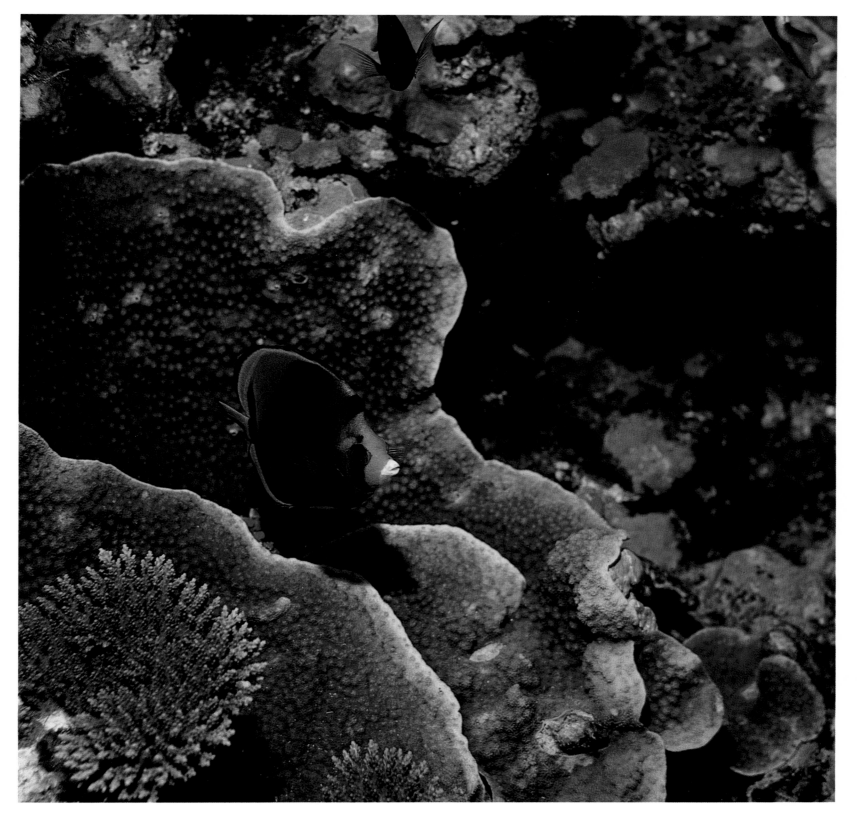

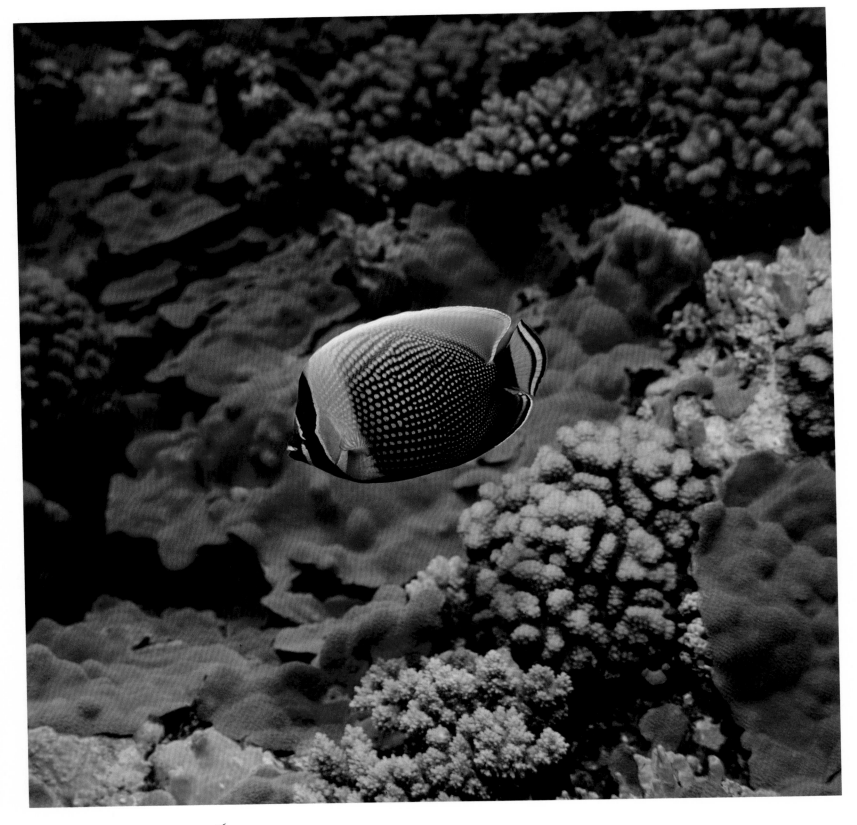

Reticulated butterflyfish,
Marion Reef, Coral Sea

Marion is a reef of yellow organisms, yellow crinoids, yellow gorgonians, yellow fish. *Turbinaria* corals grow across the reef in sheets; unlike most corals, they have colored flesh, and at Marion their colors range from yellow-green to gold. The butterflyfish come in all colors. Their deep, highly compressed bodies make ideal "billboards" for the display of colors and patterns, on which each species exhibits its own distinctive variation. All the ramifications of reef-fish coloration are a subject of debate, but some of its functions are well defined. One is species recognition. The color patterns of butterflyfish are the classic example of the brilliant "poster colors" with which a fish advertises its ownership of territory. They are also the signal that reunites a pair or group that have become separated. Coloration is protective. As eyes are often the focus of attack, nearly all butterflyfish have a dark vertical line through the eye to conceal the pupil; many species also have an eyelike spot near the tail to misdirect a predator's strike. Aside from the eye markings, the butterflyfish's brilliant patterns do not appear protective—they appear disastrously conspicuous. Yet they do, in fact, conceal. Butterflyfish use color like op artists, employing dazzling contrasts, little dancing dots, and abrupt changes in intensity to create optical illusions that disrupt the fish's outline, and distract the predator's perception of the fish as a whole. In the dim light of dusk, when predation is most intense, the illusions are particularly effective.

Symbiosis simply means "living together," but in biology it specifically refers to three types of interaction between species. A fish that lives in the cavity of a sponge is a commensal, a "sharer of the table" that neither helps nor harms its host. A lamprey sucks other fishes' blood, to the detriment of its hosts—it is a parasite. Most often, symbiosis is used to denote a mutualistic relationship, an association of benefit to both organisms: clownfish and sea anemones, exchanging nutrients for shelter, are mutualists. Mutualism is rife in warm seas, a stratagem whereby organisms can enhance their nutrient supply. Often, bacterial or algal symbionts live in marine invertebrates, recycling the nutrients excreted by the animal. Zooxanthellae are single-celled algae that live within the cells of coral, recycling wastes and, at the same time, accelerating the corals' rate of calcification, enabling them to build reefs. Related zooxanthellae live in *Tridacna*, the giant clam, and enable it to secrete enormous shells, up to five feet across. *Tridacna*'s size has inspired wild tales of killer clams that clamp on a swimmer's leg and drown him. In fact, *Tridacna* does not even capture many plankton. It mostly just "gardens" its zooxanthellae, exposing them to the sun. The algae multiply in its tissues, and the clams have special cells that gather up aging, worn-out algae and digest them.

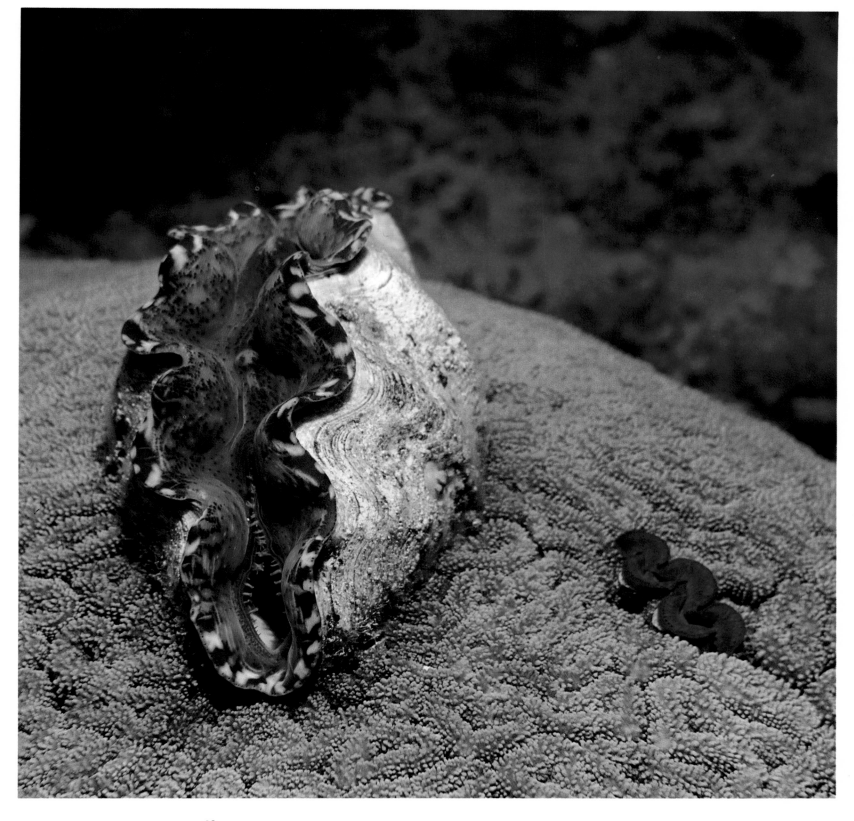

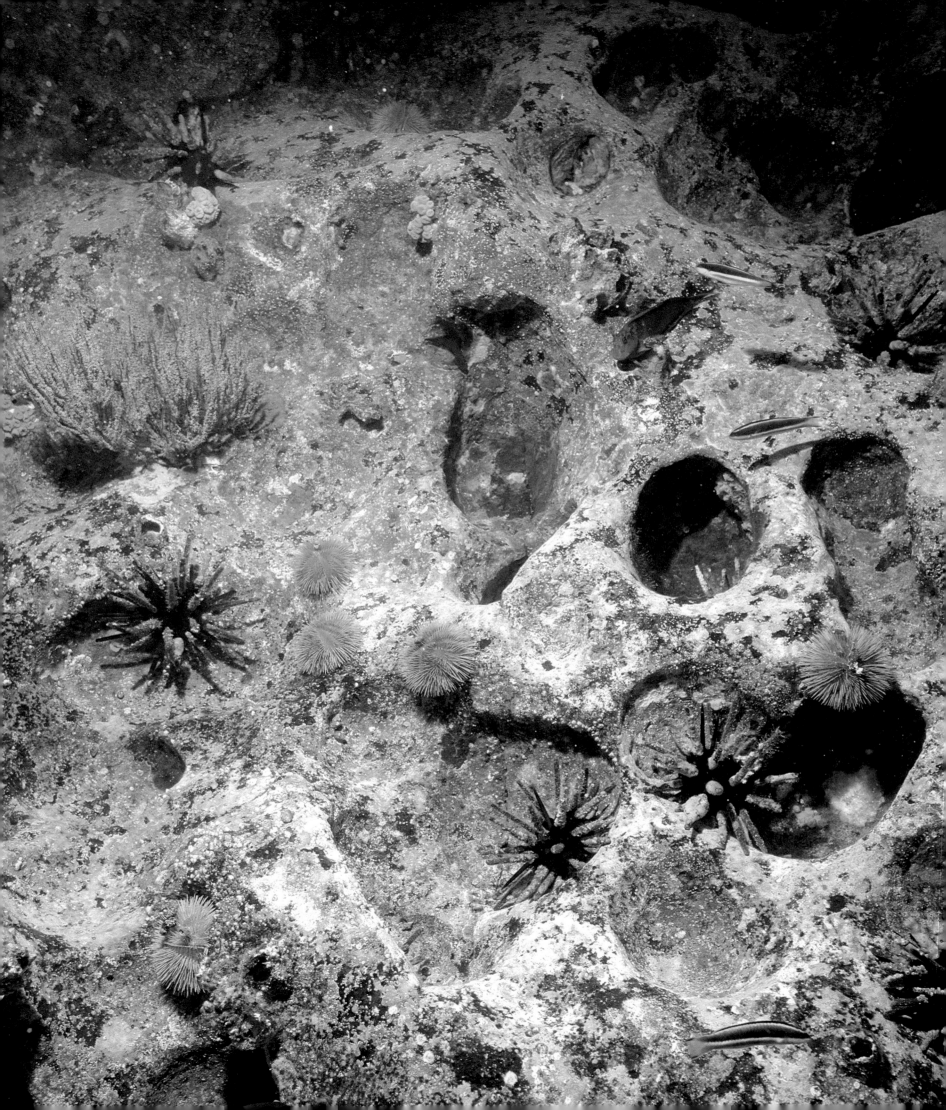

Volcanoes in the Sea

Hot Spots and Leaky Faults

The wall face at Gordon Rocks, Galapagos

The architecture of volcanic seascapes has special excitement. Awe-inspiring walls of rock cleave the ocean from surface-sky to fathomless depths. Craters lie drowned, with barnacles and corals encrusting their floors; sharks lurk in winding lava tunnel caves. We swim down slopes of layered lava, through archways and caves, past mountainsides stepped like ancient ruins or scored with deep ravines.

Almost all volcanic activity occurs along the plate margins, where the rigid slabs are created or destroyed. Yet in several dozen places around the world, volcanoes erupt far from any margin. These volcanoes are fueled by a "hot spot" beneath the plate: a plume of magma that melts the cold slab and rises through it to erupt on its surface. If the magma erupts on the ocean floor, it builds an undersea volcano whose summit becomes an island. But its base rests on a plate of oceanic crust—and the plate is moving.

As the plate drifts, it carries the volcano with it, away from the hot spot, and eventually the volcano's source of magma is cut off. Behind it, the magma forms a new conduit to the surface and erupts on a new portion of the floor. The hot spot's position is fixed in the mantle for millions of years, while the plate moves past like a conveyor belt, on which a succession of volcanoes grow, become islands, and drift away in turn, creating an island chain, or archipelago.

Far out in the middle of the Pacific Ocean, the Hawaiian Islands are the product of a hot spot beneath the vast Pacific Plate. The plate drifts northwest, carrying a long chain of volcanoes. Southernmost, and youngest, is the "big island" of Hawaii, composed of several overlapping volcanoes,

two very active; from peak to ocean floor, Hawaii's Mauna Loa is the tallest mountain on earth. From Hawaii, successively older and subsided volcanic islands give way to coral atolls, until the chain peters out as drowned atolls, or guyots, then is swallowed in the Aleutian trench. The big island is also drifting, and south of it the next volcano is already growing beneath the sea.

On the skirts of Mauna Loa, the Kona Coast faces south across a vast, unbroken ocean. The volcano falls away fairly rapidly, and only a short distance out the sea is the intense vibrant blue of very deep ocean, a vast three-dimensional environment that divers call "the blue water." Diving here is very different from diving on the reefs. Taking only masks and snorkels, we make long, breathholding dives, swimming with the animals of the open ocean—ocean triggerfish, whale shark, blue marlin, whales, and porpoises.

In the East Pacific, the Galapagos archipelago straddles the equator six hundred miles off Ecuador. The fourteen major islands are all volcanoes, from a small, low older island in the southeast to two young, mountainous islands in the west, with six active volcanoes between them. Lava breaking through on the submarine slopes has built countless parasitic cones, which rise above the sea as offshore rocks and islets.

Equatorial seas are usually warm and nutrient-impoverished; the waters of Galapagos are fertile, for Galapagos spans the equator just where the currents of the East Pacific meet. Upwellings of deep water along continental shores keep the Peru Currents rich and cool all the way to the equator, where they turn west, sweeping through Galapagos. The Cromwell Current is a countercurrent that

crosses the Pacific from west to east more than three hundred feet below the surface; deflected upward by the western volcanoes, its cool, salty waters, laden with nutrients, upwell along their coasts, then filter through the archipelago. These currents support a wealth of marine life, and many animals of the islands as well. Sea lions, fur seals, and penguins, unlikely denizens of the equator, thrive in Galapagos because the sea is rich.

Hot-spot islands can be hundreds or thousands of miles from any other land. The plants and animals that colonize them are chance arrivals, carried enormous distances on the wind or the currents. Their small populations, cut off from the genes of their parent stock, are prone to rapid evolutionary change, giving rise to new endemic species. In an archipelago, members of a single species may become isolated on a number of different islands and give rise to several related species, each unique to a specific island. It was these species that so impressed Darwin when the *Beagle* called at Galapagos.

Considering the small size of these islands, we feel the more astonished at the number of their aboriginal beings, and at their confined range. Seeing every height crowned with its crater, and the boundaries of most of the lava streams still distinct, we seem to be brought somewhat nearer to that great fact—that mystery of mysteries—the first appearance of new beings on this earth.

Charles Darwin,
The Voyage of the Beagle (1845)

Where two plates meet, they may diverge, as at the midocean ridges; one may override the other, as at the trenches; at their other boundaries they simply slide past each other on parallel courses. Then they move along vertical faults, known as transforms, and usually no crust is created or destroyed. Sometimes, however, a transform fault is not quite in alignment with the geometry of the plates' motion; then crust is destroyed, or molten rock upwells along its length. A transform fault that extrudes volcanic material is described as a "leaky fault."

On either side of India, two gigantic north-south ridges run parallel across the Indian Ocean floor. Like gargantuan train tracks, they mark the two great transform faults between which India traveled north to Asia. The smaller, the Chagos-Laccadive Ridge, runs down the west coast of India, and on south, for more than a thousand miles. Its origin has been attributed to a hot spot beneath the Indian Plate, but now it is considered more likely that the ridge is the result of a leaky transform fault.

Today, the Chagos-Laccadive Ridge is submerged, but all along its enormous length, small coral islands crown the submarine peaks. The Maldives is a group of coral atolls just north of the equator. The atolls are large; nineteen in all, they stretch along the ridge for hundreds of miles. In their lagoons, and on their encircling reefs, are countless thousands of smaller atolls, or faros, many of which do not reach the surface. The result is some two thousand tiny coral islets scattered across an endless expanse of reefs and sunlit sea.

Young sea lion,
Cousin's Rock, Galapagos

Above water, Cousin's Rock is an insignificant offshore rock, the remnants of a volcanic cone, not really big enough to call an islet. Below water, it is one of the most exciting dive spots in all Galapagos. The wall is stepped, and I level off at thirty feet on one of the rocky ledges. The rock is pinky-gray with algae, and studded with urchins with thick, blunt spines. Beside me, the water is very clear, with schools of fish everywhere, in whirling profusion. All at once, the fish schools scatter. A sea lion torpedos past. A tight turn, and it is back, staring into my mask. But I am soon forgotten. The sea lion's attention has turned upward, toward the surface, and it waits eagerly, mouth open wide. A second young sea lion appears, its fur still silvered with air, and greets its companion with a nip on the muzzle. They are off, twisting and turning, in an exuberant game of underwater tag. Then they zoom to the surface for air.

Swimming down the slope into darker, gloomier water, I pass through an unseen thermocline into a very cold layer. The cold seeps into my wet suit, making me shudder; then I snap to attention abruptly, for I sense large creatures nearby. Even as I turn, long, silvery amberjack are gliding past, large, and very close. Amberjack present no danger, but instead of swimming on, they turn, form a ring, and circle me. Thirty ghostly, gleaming fish, each five feet long or more, are whirling around me, and I am spinning at the center, trying to track them, mask pressed against the view-port of my underwater camera housing. It is not long before I am dizzy and disoriented. The amberjack stare with impassive curiosity and keep on circling. Then, losing interest, they peel off, one by one, shooting up through the fish-thronged water.

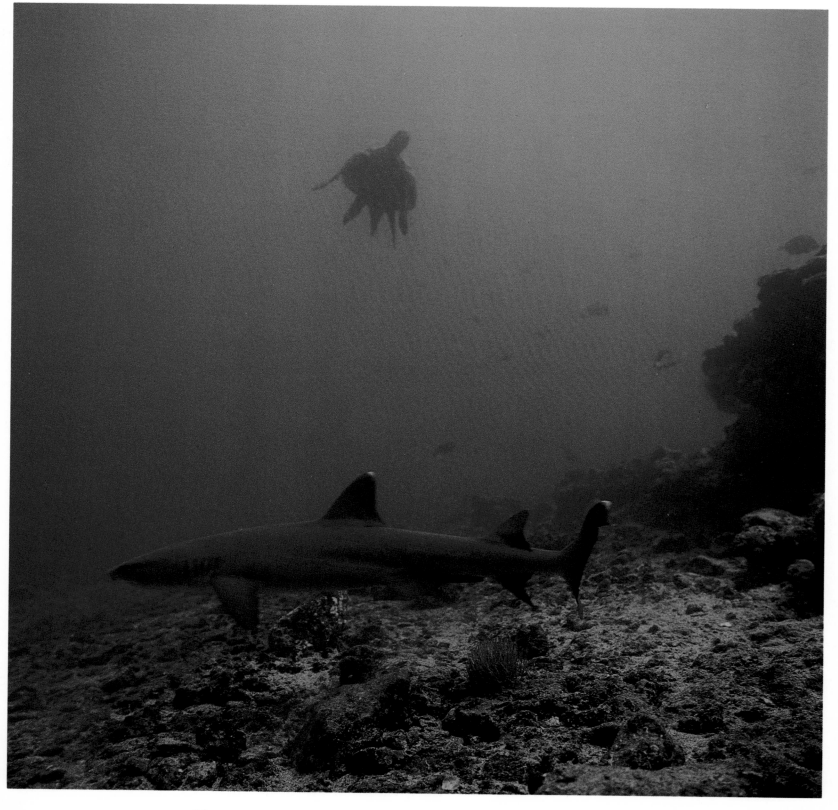

Green turtle and
white-tipped reef shark,
Cousin's Rock, Galapagos

A large green turtle appears, finning its way along the wall, and I swim toward it, waving my arms to mimic its flapping front fins. A male, perhaps in rut, he lacks normal caution, and comes right up to me—we are face to face. Then I reach out to touch his carapace and, in a burst of speed, he flees. I follow him down the slope to fifty feet, where the wall levels out to a sandy flat before the final drop-off. Beyond, it becomes a precipice, dropping hundreds of feet through the dark. Leaving the turtle, I start across the flats and, suddenly, a six-foot shark is swimming beside me. White patches gleam on its tail and dorsal fins. I know it is a white-tipped reef shark. And I know that they are docile. Nonetheless, it startles me.

I hear a shout. My partner is yelling through the water, and as I turn, I see why. A large school of eagle rays is cruising along the drop-off. They swim steadily, not hurrying, not stopping to feed; winglike fins, five feet across, flap lazily, long tails stream out behind. Eagle rays live in small groups, usually in twos and threes; this strange, spectacular assemblage must have come together to breed. I have never seen anything like it before, and a surge of adrenaline sends me racing along the flats to catch up. Beside me, twenty-five beautiful creatures wing through the sea, like a flock of large birds in slow motion. I am not swimming with a school of big fish; I have happened upon a visitation from another galaxy. For these few minutes I am part of their convoy. I follow until they turn, moving as a unit, and disappear into the blue curtain of ocean.

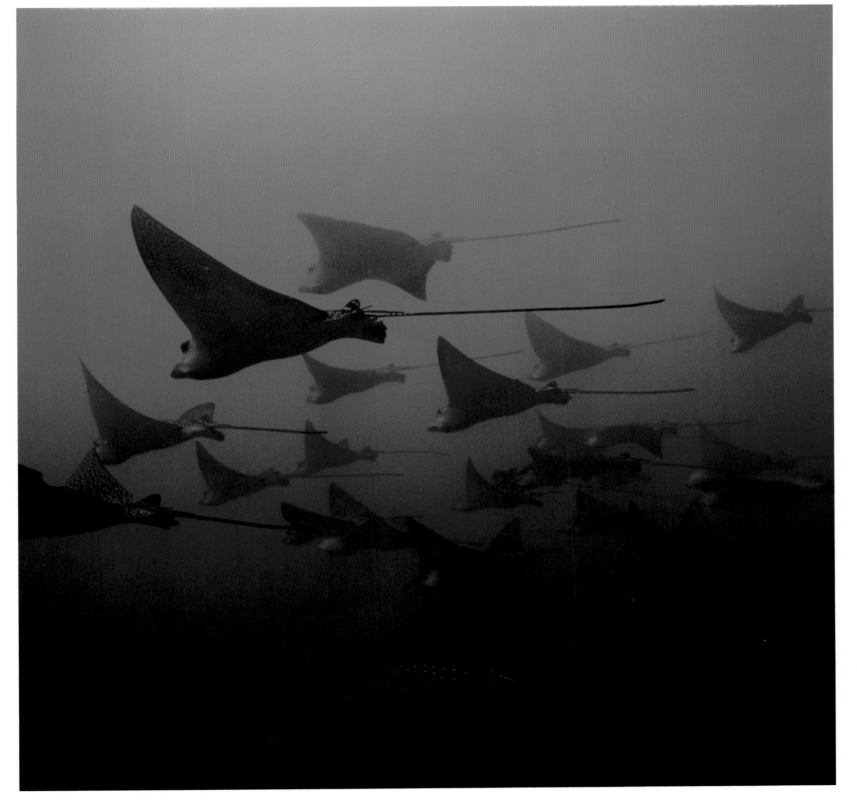

The life beneath the surface of the water about the Galapagos presents as great a contrast to the creatures of the land, as the fauna of a tropical jungle presents to that of the Arctic regions. The terrestrial organisms are relatively few in number and of sombre shades; the submarine creatures form an unnumbered host, many equalling the brightest butterflies and birds.

William Beebe,
Galapagos: World's End (1924)

On the undersea slopes of Isla Floreana stands a small volcanic cone. Above water all that is left of the crater walls is a ring of jagged, cactus-studded rocks, known as the Devil's Crown. Beneath the surface, however, strong currents swirl around the cone and course through the center of its submerged crater. Rich with plankton, they support a fertile food chain. Acorn barnacles mass in the current. Corals encrust the crater floor. Huge blocks of lava, tumbled from the crumbling walls, are a warren of cracks and crannies where the vulnerable take refuge—and where the predatory skulk. Ascidian colonies spread red, blue, or tarry black across the omnipresent pink of the algae layer. A bright array of starfish crawls across the top: yellow stars like Christmas cookies with chocolate-drop spines, plump cushion stars embossed in crimson, purple-blotched starfish with arms like sausages, and brick-red *Mithrodia*, with slender arms.

A diver can tell by the marine life around him in what part of Galapagos he is, for the flora and fauna depend on which current prevails. The coolest, most fertile seas are in the west, where the waters of the Cromwell Current well up from the deep, rich with nutrients. Plankton bloom so profusely they may reduce visibility to three feet or less, and on the walls, thick mats of organisms overgrow the rock, and overgrow each other, to feed in the plankton-rich stream. Sea fans arch above the tangle. Solitary tunicates fasten on the ledges, their bodies so enveloped in encrusting organisms that only their red-rimmed siphons emerge, taking in water and plankton. Colonies of black coral—their yellow tentacles like undersea mimosa—rise from the crowded wall face, carrying their polyps up into the open to feed. Invariably, a little longnose hawkfish lies in wait among the branches. Strange little yellow shrimp also live within the colony, mimicking the polyps in form and color in order to evade predation—perhaps in order to evade small hawkfish.

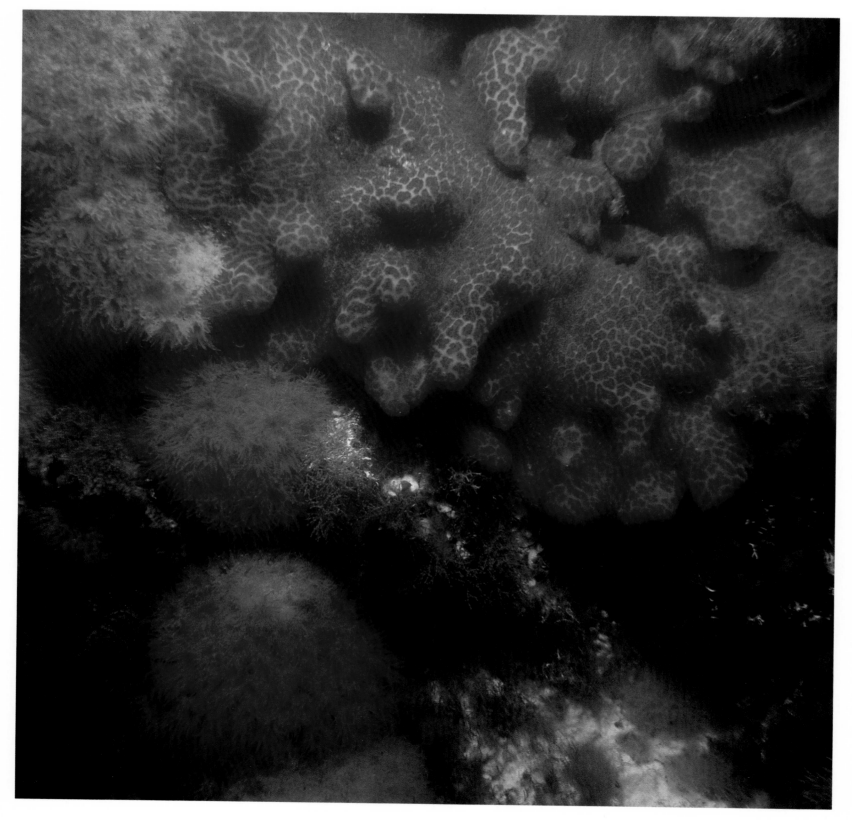

After dark, many zooplankton rise into the surface waters, and the night-feeding corals "blossom," opening out their tentacles. We dive at night at the mouth of Tagus Cove. Cool, rich waters are upwelling along the coast, and plankton swarm, their brilliant phosphorescence streaming behind the dinghy and sparkling from our fins as we swim. Transformed by night-feeding animals, the wall is bizarrely beautiful. The tube corals have exploded into magnificent powderpuffs of color, and all over the wall the lights pick out the lovely multicolored puffs of *Tubastraea tagusensis*, which lives only in Galapagos's western waters and is named for this cove. An enormous, bulging ascidian colony spreads across the wall, each individual animal a measlelike splotch of red in the pale mass. Lobes of the colony have bulged into the space of some vivid, foot-wide *tagusensis* colonies, and every polyp in contact with its mass is sending out long, specialized tentacles to digest its cells.

The submerged crater is alive with fish, all sizes, colors, and ways of staying alive. Tiny blennies take possession of old barnacle tests and live on the plankton drifting past their "doors." Butterfly and angelfish flit about the rocks, nibbling the encrusting invertebrates, while clouds of pale blue tangs drift through the shallows, grazing on beds of algae. Big groupers lie in ambush in the shadows. Beyond the crater walls, a tight-packed school of grunts hangs motionless; at night they will disperse and feed on the invertebrates of the crater floor. The water swarms with the schools of the plankton-feeding fishes. The creolefish are everywhere—the locals call them *gringos* "because there are so many." Their huge, loose-knit schools scatter through the sea, plucking individual plankton from the current. At the top of the food chain, large, swift predators come in from the open ocean. Hammerheads and Galapagos shark visit the crater to hunt. A pack of hungry amberjacks rises from the deep, knifing through the swarming water. Instantly, the scattered creoles tighten their formation and flee in a wide arc from the source of danger.

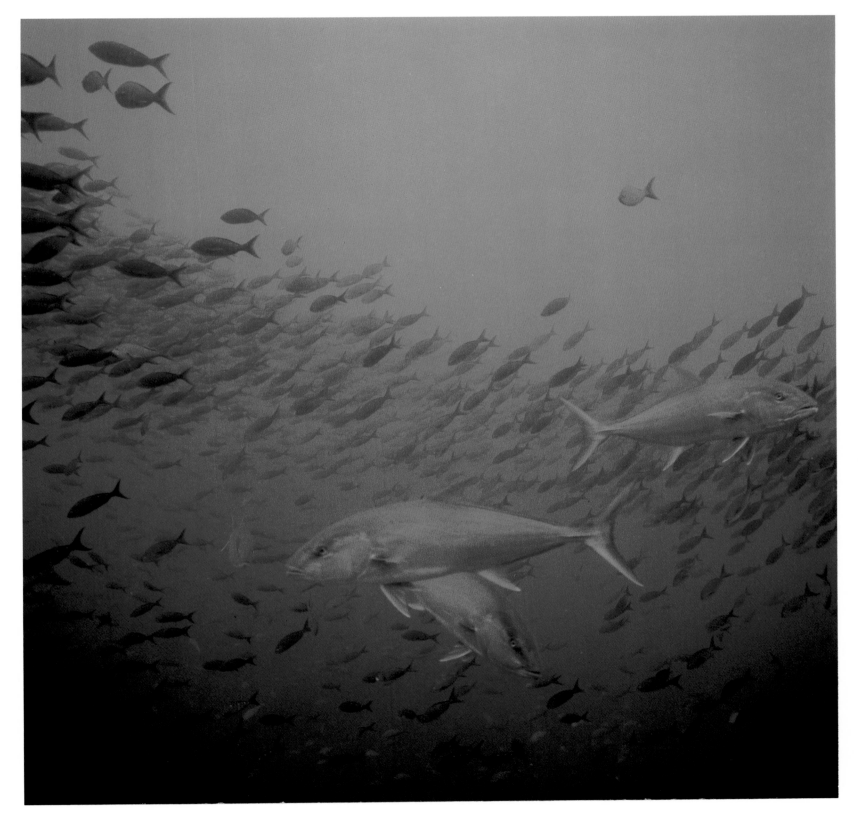

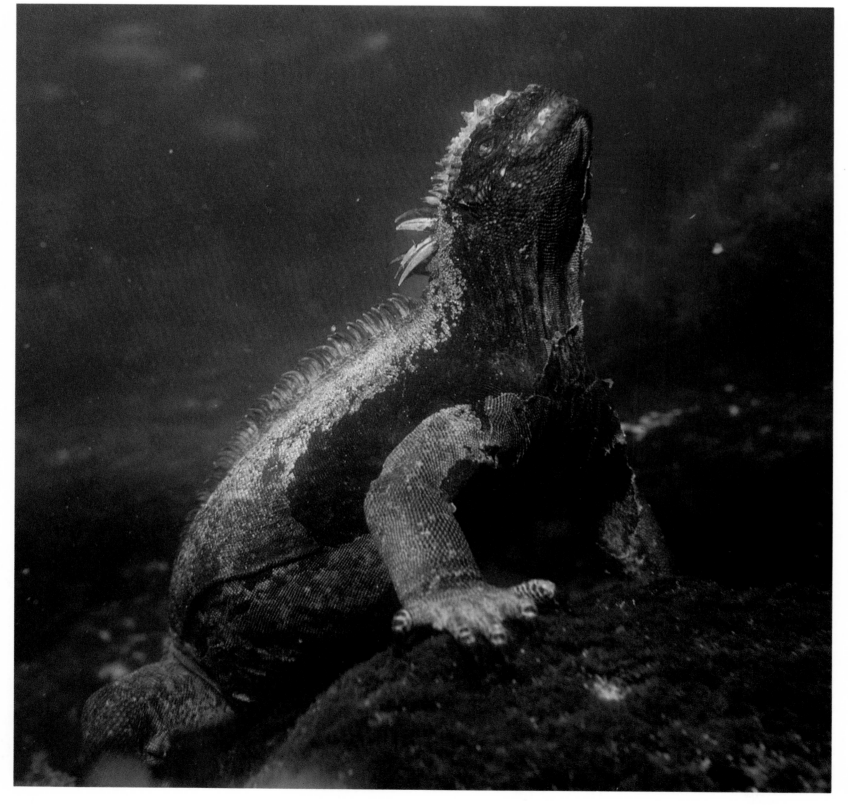

The Galapagos Islands are famed for their exotic animals, yet most of the islands are waterless, and the land harsh, unable to support an abundant fauna. A large proportion of the animals that live on the islands depend on the sea for food. The only lizard on earth to feed at sea is the Galapagos marine iguana. Its ancestors were land iguanas, cast up on a Galapagos shore. The arid coastlands are subject to severe, protracted drought, and it was probably in a time of food shortage that the iguanas resorted to eating the seaweed exposed at low tide. Over time, they adapted to an aquatic existence, evolving a flattened swimming tail, and large, curved claws for holding on to the floor. Today, the females and young still graze in the intertidal zone, but at low tide the large males swim out to sea and dive, cropping algae on the seafloor well beneath the surface. At Punta Espinosa, rich upwellings nurture luxurious stands of algae and thereby support a big colony of marine iguanas. After searching in deeper water, I swim toward shore, and at fifteen feet I find a large iguana feeding in a surge that sends me rocketing up and down. The iguana clings stoically. Gripping on the algal mat with his long, sharp claws, he fastens his teeth on hunks of algae and wrenches them free.

We travel by night to Marchena, a lonely outpost island in the Galapagos Archipelago. Huge phosphorescent masses move through the inky water, revealing fish schools below, and fleeting streaks, like meteor tails, are large, swift fish. At first light we anchor off black lava shores. The sun is just rising as I enter the water. Off in the distance are mounds of lava, like a castle wall, nearly reaching the surface; the surf is spreading swathes of white bubbles above me as I swim over the rim. Within, lava pillars loom from white sand. Striped sergeant majors bob up and down in the surge; big, solitary groupers patrol, slow and imperturbable, among the lava mounds. A moray eel is out in the open, in the morning light, swimming like a snake, sinuously. Here and there Moorish idols and deep-blue angelfish are flitting, color and movement against the dark rock. When my air is low, I pass back over the wall, and mirrored pompanos sweep from the surface, a school of a hundred or more, swimming swiftly and effortlessly with strong, deeply forked tails. As they flow past, the collective effect of their bright oscillating bodies is one of rippling light, like a great tinsel mobile.

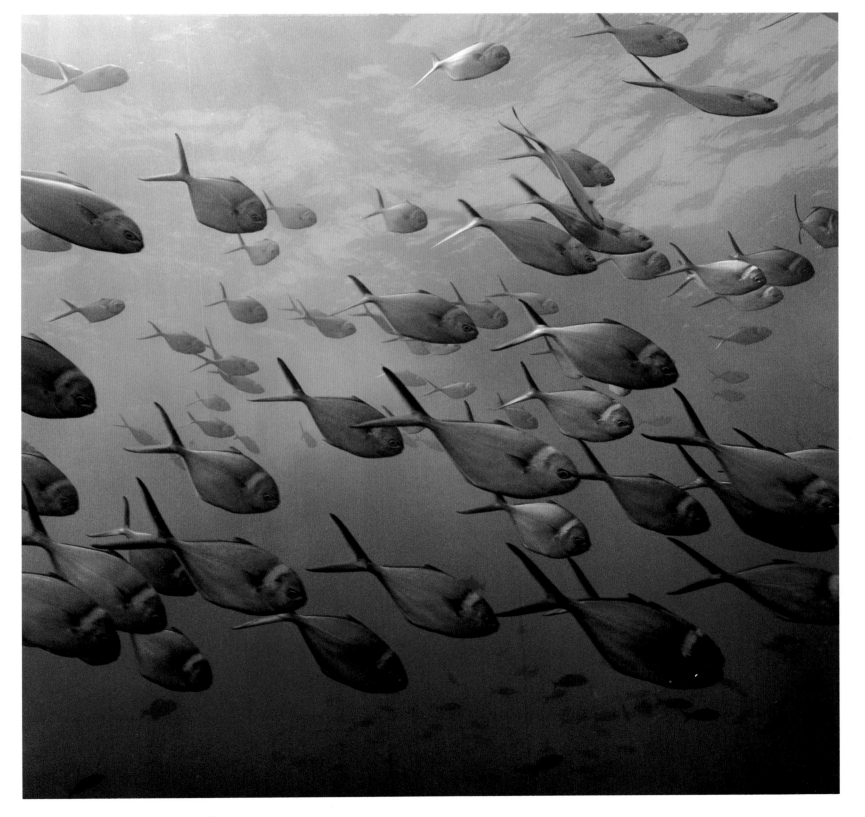

Whale shark,
Kona coast, Hawaii Island

A mile out from Kona, we spot a school of dolphins leaping and turn the Boston Whaler to take a look. In their midst, just lying at the surface, is a whale shark, twenty feet long. There is a mad scramble for gear. I grab my wide-angle lens, but once in the water, I have trouble getting far enough away for a photograph. No matter how hard I back off, the whale shark follows, its big, flat mouth nibbling at my fins. I try to guess what lies behind those tiny, side-mounted eyes. I remember a shark expert telling me that Jonah's "great fish" was a whale shark: it has a mouth large enough to hold a man, a gullet too small to swallow him, and a habit of ejecting oversized food by everting its stomach. Finally the big fish passes beneath me and, transferring its attentions to the outboard motor, starts mouthing the skeg instead, leaving me to take some photographs before it plunges, suddenly, straight down, and disappears into the blue depths.

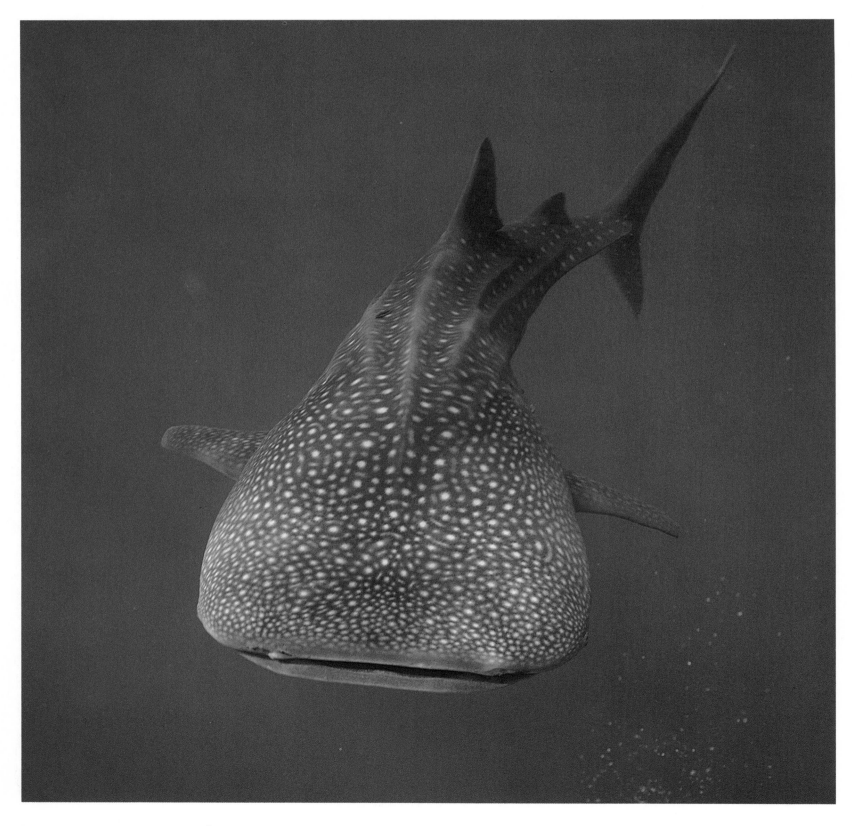

Whale shark,
Kona coast, Hawaii Island

Whale sharks are the largest living fish in the sea. A really large one can be sixty feet long and weigh several tons. Slow and sluggish swimmers, they often bask at the surface and boats sometimes ram them. Once in a rare while, they ram a boat deliberately, perhaps mistaking the hull for a rival. Ramming aside, they pose no danger. No whale shark on record has attacked a man (except perhaps Jonah). Its mouth is cavernous, over a yard wide. Yet it feeds on plankton, small fish, and squid, taking in prey in huge mouthfuls of water, which it forces out through its gill slits, where spongy tissue strains out the food. Little is known of the habits of whale sharks. They are tropical, most common off east Africa, uncommon off Hawaii, and they frequently stray into temperate waters. Wherever whale sharks occur, they are seasonal. For the balance of the year their whereabouts is such a complete mystery that it is suspected that they spend that time living in very deep waters.

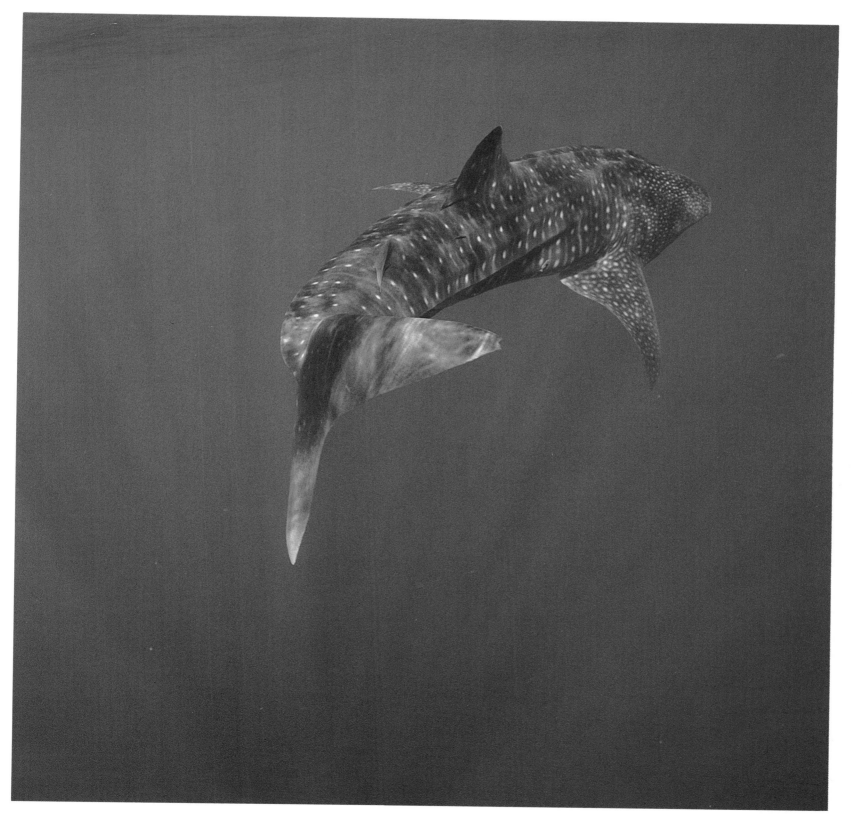

Within easy distance of Bandos, the sea is strewn with smaller islands, and we explore new ones every day, sometimes diving the drop-offs, but more often we explore shallow, sunlit reefs and lagoons, crammed with corals and colorful fish. In the shallows, the leather coral, *Lobophytum*, commandeers space on the crowded floor by spreading in sheets across the substrate and across the tops of the other corals. It then produces fleshy, fingerlike protuberances that greatly increase the surface area on which polyps can capture plankton and zooxanthellae can photosynthesize in the sun. Where two colonies of leather coral meet, growing across a crevice, they partially roof it, creating a sort of cave that a small school of *Anthias* uses as a refuge. The little fish are quite extraordinarily bright; the *Anthias* boast some of the liveliest —and loveliest—color combinations in the ocean, mixing vivid shades of yellow, red, and orange with lavender, pink, and turquoise. Even within a single school, the individual fish display a variety of colors and patterns, for every *Anthias* starts life as a female, progresses from subadult to adult, and eventually to male, changing colors with its role.

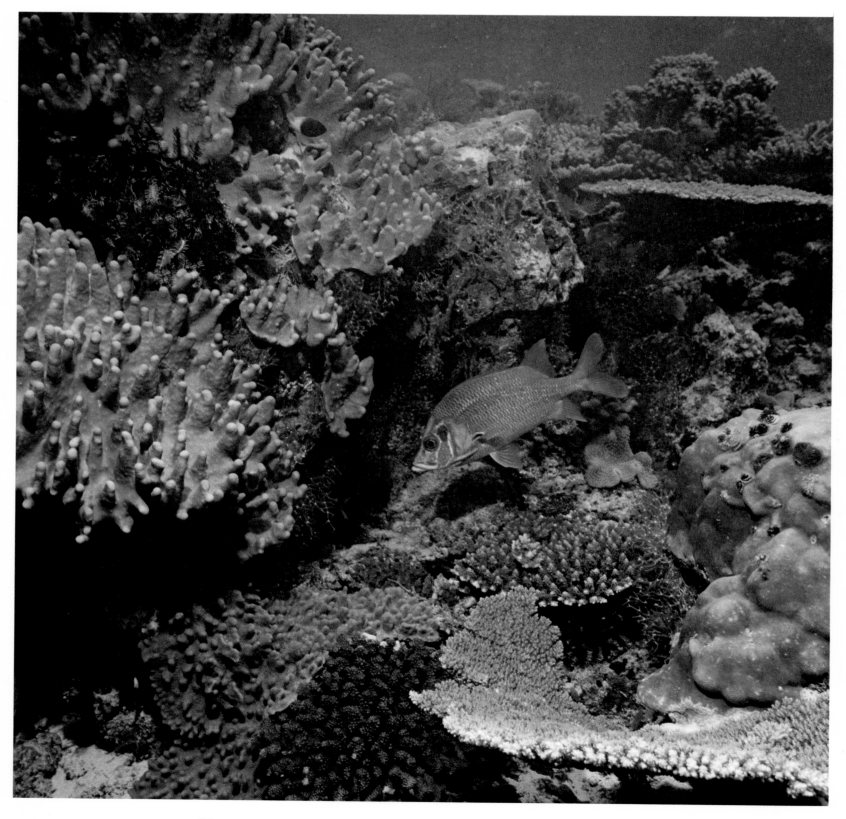

Around the island of Bandos, on mile upon mile of reef, the corals continue their age-old cycle of building and breakdown, of growing and dying, their skeletons crumbling and merging with the reef to become the foundation on which new corals grow. Sheets of leather coral spread across slower growth; table corals overtop them and cast deep shadows. The corals beneath them die. Within the corals' skeletons, armies of boring organisms tunnel. Adapted to dissolve or rasp away the limestone, the organisms erode and slowly weaken the coral colony. Through dead spots on a coral, serpulid worms excavate their tunnels, extending lovely whorled tentacles, like Christmas trees, to gather plankton, but retracting them with lightning speed whenever approached. Whatever reefs we dive, we are sure to find squirrelfish, two or more species. They are hiding beneath the coral heads and ledges, clustered in the caves, or hanging quietly close to shelter, staring with great dark eyes. Once night falls, the squirrelfish will emerge in astonishing numbers to hunt zooplankton in the water column. Their large eyes gather light in the dark water. Their red-orange coloring was conspicuous by day, but as there is no red light in a nighttime sea, their red is now black and conceals them.

The open reef is dominated by the light-dependent organisms, competing for position in the sun. Out of sight beneath runs a labyrinth of hollows and crevices that the sun never reaches, and there a quite different set of organisms prevails, soft-bodied, defenseless animals that would be devoured in the open. As they are not symbiotic and do not need sun, they survive in sheltered, cryptic environments: on the undersides of the corals, under ledges, on the walls of the crannies and caves. Competition for space is at least as intense as on the sunlit surfaces, one organism destroying the other by chemical interactions, or by overgrowing it. Off the larger atolls, we dive spectacular drop-offs. Under huge overhangs, the walls are massed with cryptic encrusting organisms, their jumbled forms and colors creating astonishing collages. The only corals that grow in this shade are tube corals, which have no zooxanthellae; from the humps and the knobs, their cylindrical pink polyps jut into the stream. An oyster, anchored in the current, has become a site for other organisms. Two species of sponge war for possession of its upper shell, each overgrowing the other, while colonies of ascidians and hydroids grow on top of them, and small worms inhabit their crevices. A small hawkfish perches on top of them all, waiting for an unwary smaller fish to stray within reach of its pounce. All that shows of the oyster beneath is the zigzag line of its gape.

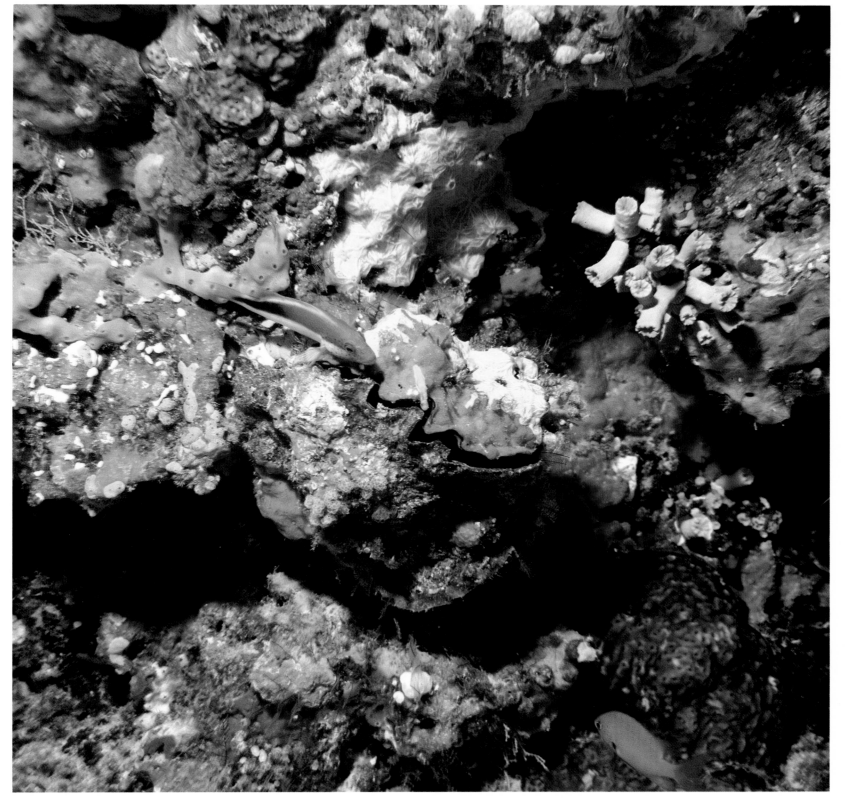

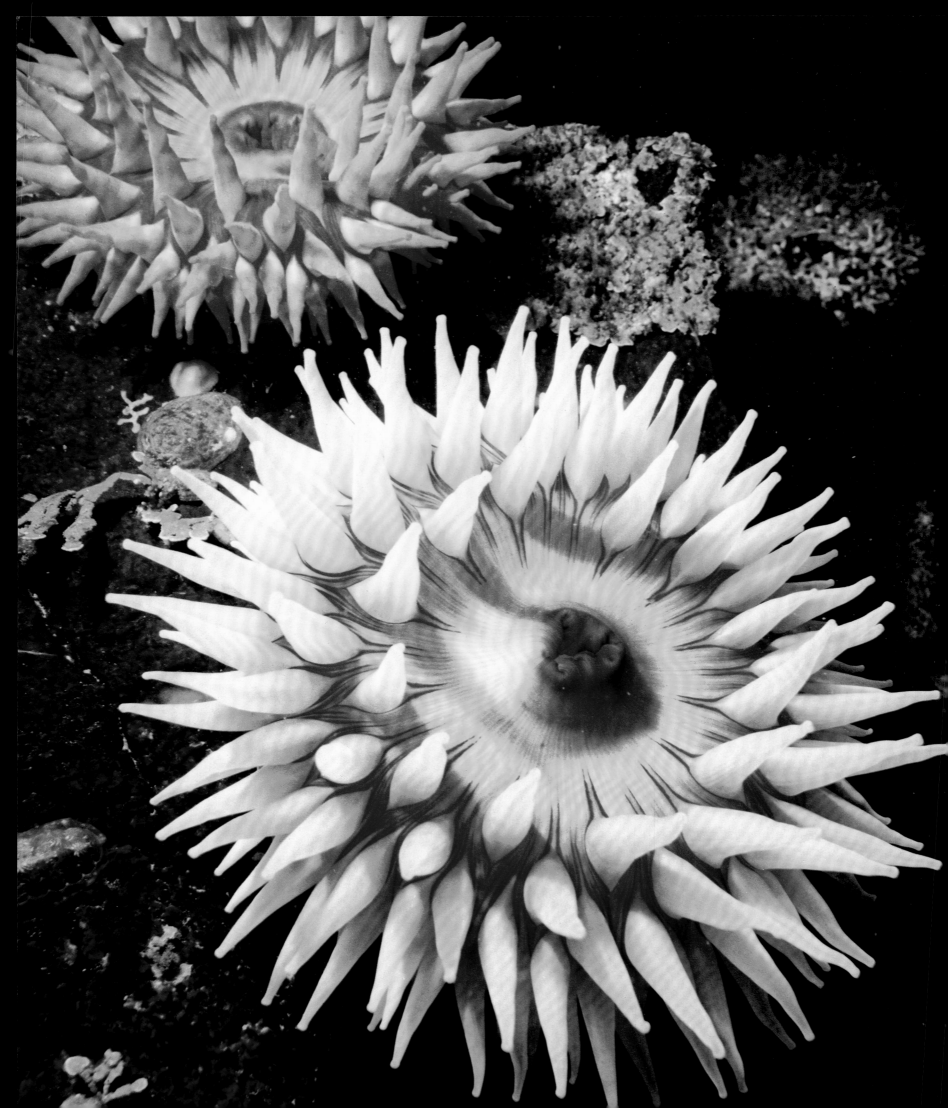

Continental Shelf and Microcontinent

A continent does not end at the tide line. The continental crust slopes out into the sea to a depth of about four hundred feet before breaking sharply toward the ocean floor. Over time, the level of the sea is not constant; it rises and falls as Earth's fluctuating climate traps water or releases it from the ice caps. At the peak of the last glaciation, most of the present shelf was exposed.

The continental shelf is molded by the geological activity occurring along the margin of the continent. As sea levels fluctuate, however, the shelf's features are subjected to erosion and deposition of sediments by marine forces and by the subaerial forces of glaciers, rivers, and wind.

On the ocean floor off Washington State and British Columbia, a northern remnant of the East Pacific Rise is spreading a small, slow-moving plate that collides with the North American Plate. Past collisions with this plate have thrown the coast into a chaotic jumble.

Four times during the last million years, the ice sheets have advanced and retreated across British Columbia. Cutting deeply into Vancouver Island's west coast, drowned glacial valleys form winding bays and inlets; the wide inlet of Barkley Sound is dotted with islands and islets. Along the trough between island and mainland, ice has gouged deep, U-shaped valleys, through which pour strong tidal currents. In the Johnstone Straits and Discovery Passage, the currents race between steep rock walls, accelerating where a channel narrows, or islands restrict their passage. At one point the currents can reach twenty-five feet per second.

Off Southern California, the continental platform is rugged. A system of faults associated with the San Andreas Fault has cut the continental crust into a checkerboard of downfaulted basins, hundreds of feet deep, between uplifted banks or high islands, such as Santa Cruz and Catalina. The continental slope drops seaward, and banks, islands, and intervening basins are known as a continental borderland.

Very occasionally, during changes in the motion of plates, a small fragment of crust is rifted away from its original site, then left stranded elsewhere. If continental crust, the fragment is a microcontinent. South of Cuba, in the Caribbean Sea, are the Cayman Islands, three small, coral-capped islands perched on a ridge of rock whose origin is uncertain. But from Grand Cayman's southern shore the ocean floor falls twenty-three thousand feet into the Cayman Trough, the transform fault where the North American and Caribbean plates creep past each other; the presence of the islands is attributed to this fault.

During much of its complex history, the Caribbean Sea was part of the ancestral Pacific Ocean, separated from the Atlantic by an island arc, soon to become the Greater and Lesser Antilles. Before the uplift of Panama joined North and South America, a trench was rotated through forty-five degrees and became the Cayman Trough. In the process, it either rifted small pieces of crust from the Greater Antilles, or uplifted crust along its northern edge. The high points of these tectonic remnants are now thickly overlaid with coral and break the surface as three coral islands, ringed with fringing reefs and seemingly bottomless walls.

In 1930, the *HMCS Thiepval* ran aground amid a cluster of rocks and islets on Vancouver Island's west coast. She now lies on her side in forty feet of water, her heavily encrusted hull covered with clusters of plumose anemones. Each cluster is a clone. *Metridium* reproduces by "pedal laceration": pieces of its disclike foot tear off and wander away a little, then their torn edges unite and form complete little anemones, all with the identical genetic makeup. Where two clones meet, the anemones at the border do battle, waving long "catch tentacles" that are armed with stinging cells, or contracting to bring armed filaments out through pores in their column wall. *Metridium* cannot flee danger— it travels half an inch an hour. It can protect its delicate tentacles by pulling them inside the column and closing the sphincter on top. When menaced, it can only contract. An anemone's body is distended by water, with no hard skeleton whatsoever. By contracting all its muscles at once, *Metridium* can expel the water and buckle its body wall, reducing itself, within seconds, to a wrinkled blob.

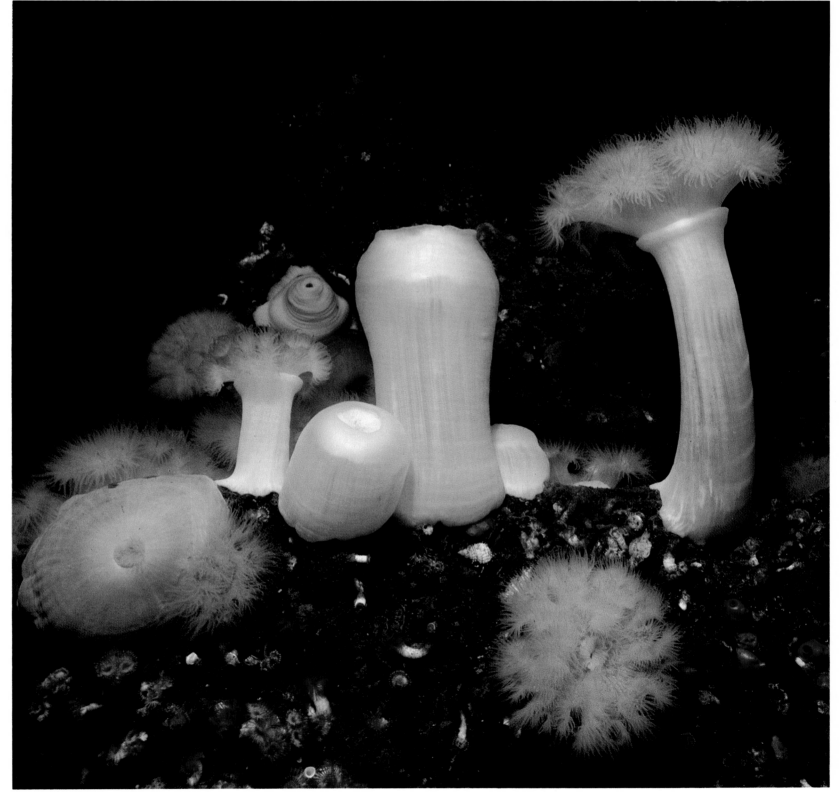

A starfish crawls on hundreds of little "feet" operated by hydraulic pressure. Every arm has a groove running from mouth to arm tip, with small elastic "tube feet" packed in rows inside. When water is forced inside them, the tube feet extend and grip the substrate with suckerlike tips. Then the feet force the water out and shorten, drawing the starfish forward. A lone tube foot exerts little force, but hundreds, working in concert, can pull a star up a sheer wall or force an oyster open. No matter how many arms, each arm tip has an "eye" and sensory cells, and as it travels, the starfish holds the tips outstretched or curls them upward to sample the environment from every angle. A starfish has no head, not even a front and back. When it moves, any arm can lead and all the little tube feet will step out in the appropriate direction. Once embarked on a given course a starfish tends to keep right on going, but if blocked and forced to change direction, it need not turn around; a different arm can lead off, and the tube feet will march in a new direction.

Basket star on encrusted wall,
Johnstone Straits,
British Columbia

Where the tidal currents race past rocky walls, basket stars position themselves to feed. Fastening to the wall with a few arms, they spread the rest at all angles, from parallel to the wall to perpendicular. This is a large species, with more than a hundred terminal branchlets. Outspread, a basket star creates a three-dimensional trap, a foot and a half across, that juts several inches into the stream. Into this trap the currents sweep tiny fish and zooplankton. A tiny animal, carried swirling through the thicket, is almost bound to collide with one of the branchlets and snag on its tiny hooks. Instantly, the tip of the branchlet seizes it, coils in a tight little knot around it, and holds tight.

Eventually, the basket star curls the whole arm to its mouth and transfers the food, but before making the transfer, it will wait for most of the branchlets to make their catch. This star has apparently just begun to feed and only a few small branchlets hold food, but eventually the entire arm is studded with little round knots, like so many miniature fists, each clutching its prey. Basket stars are related to starfish. They have five-part symmetry, with five basic arms, but the arms branch and rebranch and are thin, wiry, and extremely flexible; the star can scamper about on its arm tips like a gigantic, agile spider.

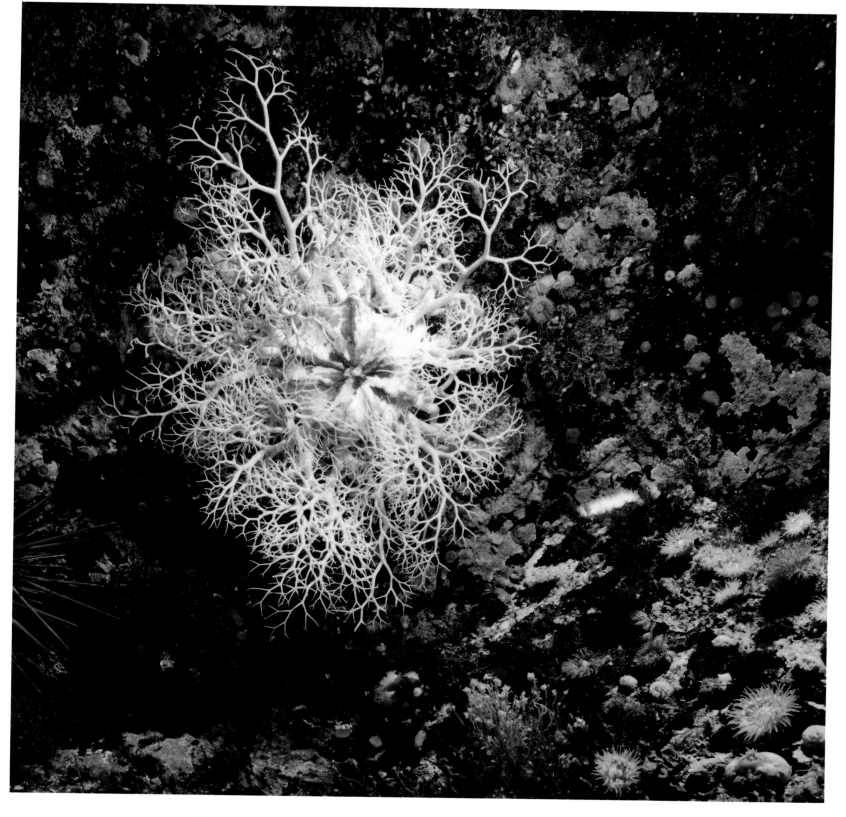

The classic starfish is an animal with five rays, or arms, but some species have considerably more. The sunflower star starts life with the traditional complement of five arms, but very soon grows a sixth. Then, on either side of the sixth arm, it produces two more, and on either side of these, two more again. It keeps on producing arms, two at a time, at the same site until it has as many as twenty-four; as its upper aboral surface has practically no skeleton, they are all soft and flexible.

Meanwhile, the sunflower star is growing, and may reach two feet in diameter. Size and flexibility enable it to move very quickly—it can cover nine feet in a minute, which is superfast for a starfish, and disastrous for its slow-moving prey. Sunflower stars are voracious predators and swallow their prey whole. They happily engulf entire sea urchins, spines and all, spewing out the hard, indigestible parts a day or so later.

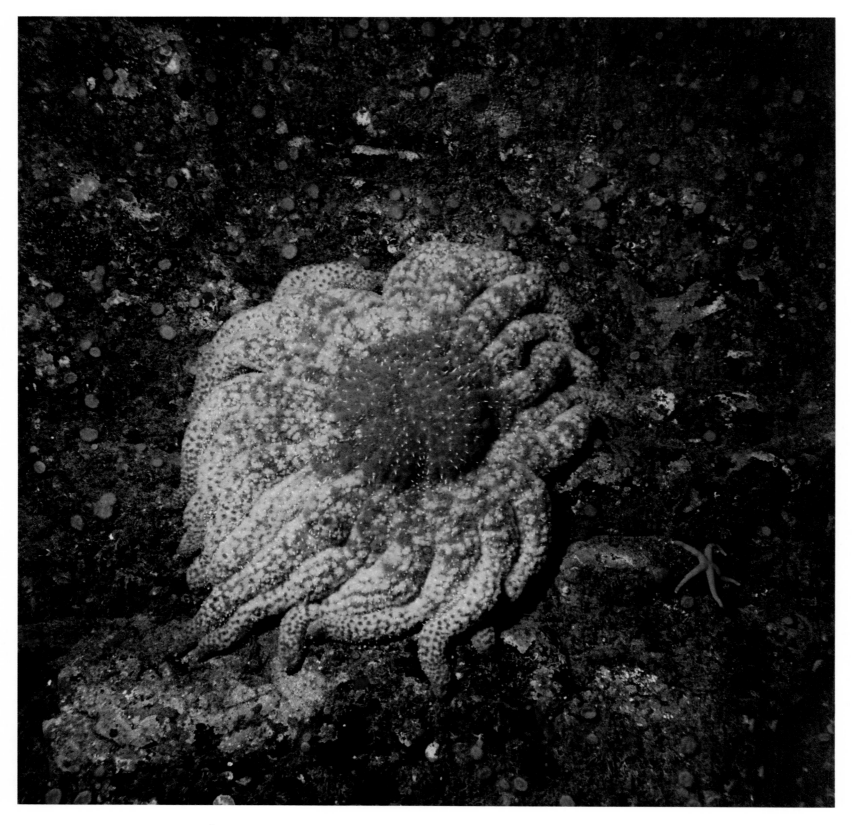

The wonders of the temperate seas are the richly colored invertebrates, which spread in exuberant tapestries across the walls. In the tropics, intense predation relegates the defenseless organisms to hidden nooks and caves. Those in the open are those with defensive strategies—noxious chemicals, limestone skeletons, or a strong shell. In the cool, rich seas, algae form forests, and big, beautiful starfish move about the floor, while the walls are glorious with billions of anemones, sponges, and small, unarmored corals. The orange cup coral, *Balanophyllia*, lives amid a "family" of assorted sizes, for it broods its larvae in its gastric cavity, and when they mature, they crawl out its mouth and settle nearby. The dahlia anemone, *Tealia*, grows to a foot across, in a dazzling array of colors and patterns. It feeds opportunistically, catching anything of suitable size that happens within reach, even dislodged barnacles.

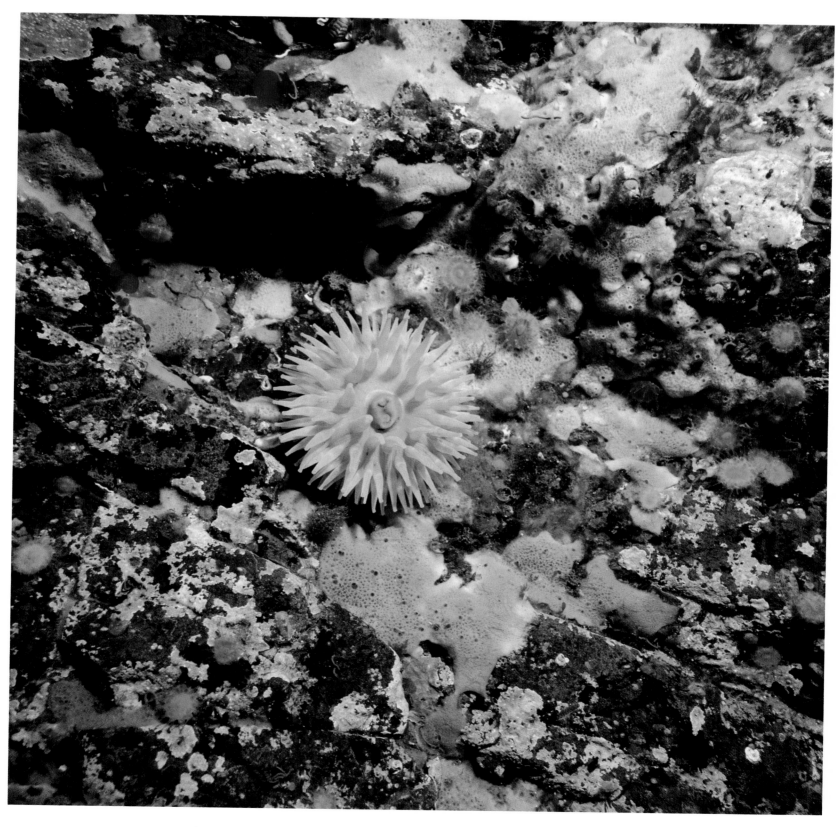

A cnidarian is an animal with tentacles, stinging cells, and a basically radiate symmetry, a description that encompasses a good portion of shallow-water marine life, including sea anemones, the many kinds of corals, and jellyfish. While the basic body plan of an anemone or a coral is the polyp, the jellyfish are medusae, bell-shaped forms rather like upside-down polyps, swimming free. However, in the life-cycle of some cnidarians, including jellyfish, the medusa form and the polyp form alternate. The medusa of the moon jelly, *Aurelia*, is a wide, saucer-shaped gelatinous bell, usually about twelve inches across, with pink horseshoe-shaped organs of reproduction shining through. Its larvae settle on stones or algae and become inconspicuous little polyps, not half an inch high. They live many months, budding off polyps like themselves. Then, at the appropriate season, each polyp constricts horizontally, until it looks like a pile of saucers that pinch off one by one as little medusae.

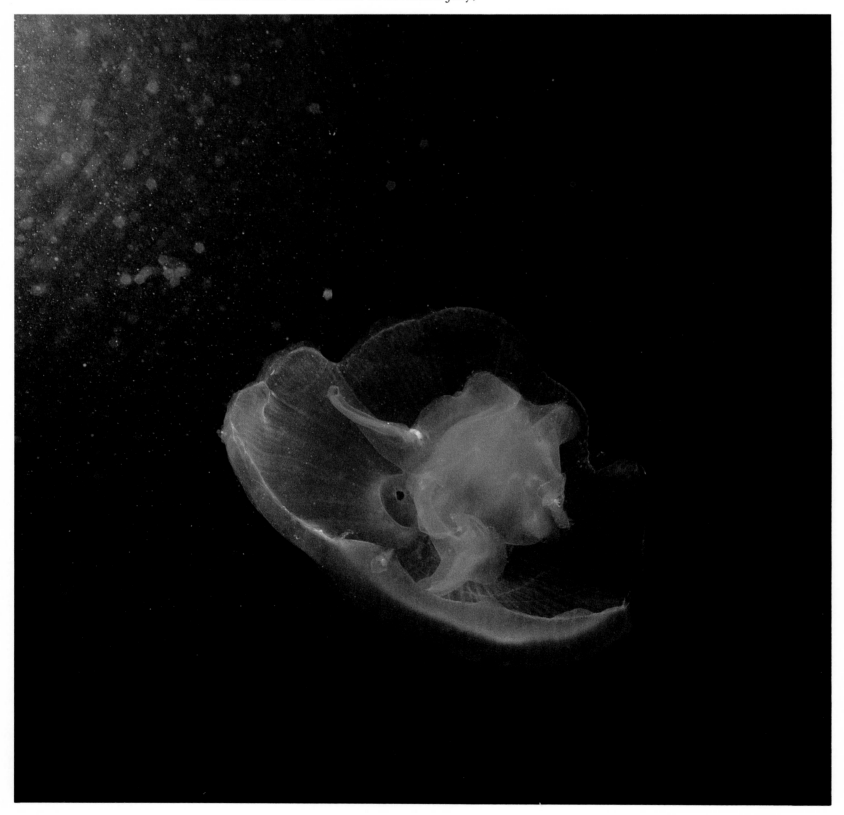

We have been diving Stubbs Island at slack water, between the flooding and the ebbing currents. Today, the current is still flooding strongly, and we dive in the lee, on the south side of Stubbs. The slope is less steep, the life on its face far sparser and less diverse than on the more exposed walls. Toward the end of the dive, however, I look up the wall and see a forest of plumose anemones rising above me. In the dim light of seventy-five feet they seem luminescent, a thousand ghostly, glowing forms marching up the wall toward the surface, until they are only a glimmer in the misty green water. Their slim columns, often a foot tall, hold high in the current a cloud of tentacles as fine as cobwebs, a web to snare the tiniest of plankton. As the current sweeps minute organisms against the deadly web, stinging cells stun them and mucus ensnares them; then cilia waft them to the tentacle tips, which push them toward the mouth. More cilia draw them inside.

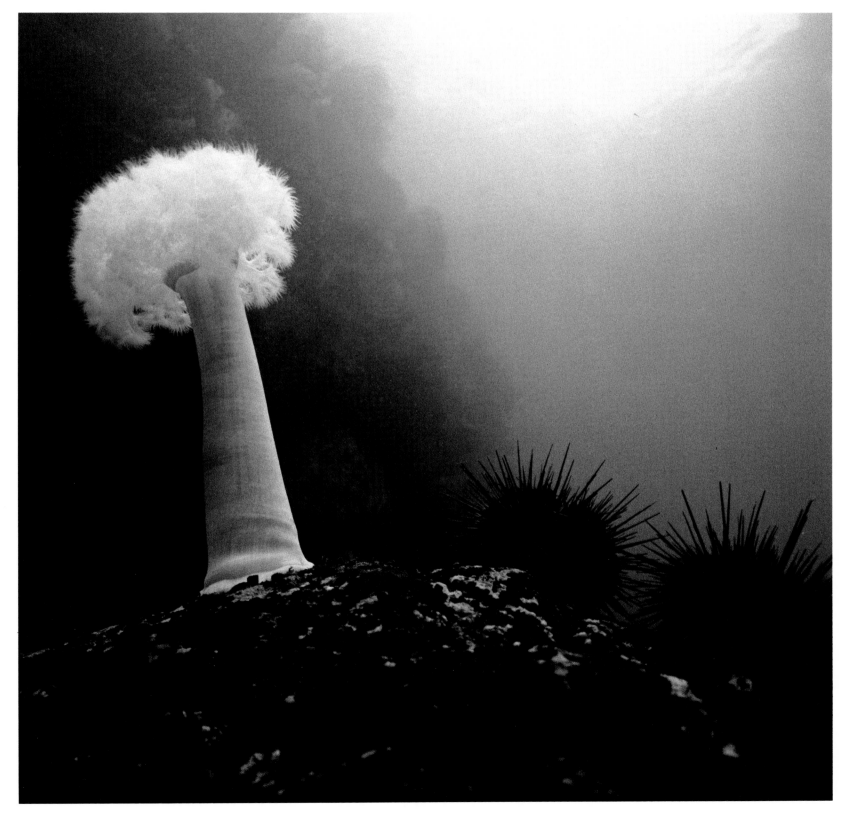

*Kelp bass in forest,
Catalina Island,
California*

Underwater, Catalina Island is surrounded by handsome forests of kelp where tall, slim stipes sway back and forth, forming shifting patterns. The kelp is anchored at about fifty feet by a "holdfast," from which fronds grow like Jack's beanstalk to the surface, producing leaflike blades as they grow. At the surface, they keep on growing, sprawling on top of the water in a dense, swaying canopy. The huge plants create a wide variety of habitats in cool, nutrient-rich waters where productivity is high: the fish fauna of a kelp bed is diverse and abundant. Paradoxically, few of the fish graze on algae—perhaps few can withstand the cold on a vegetarian diet. A large contingent prowl about the holdfasts on the floor—short, squat bottom-dwellers that prey on the wealth of invertebrates. Midwater, fish feed on plankton among the towering columns, or forage for invertebrates grazing on the blades, while hosts of small planktivores that feed in open beyond the bed seek refuge inside. Midwater, and in the surface canopy, masses of vegetation conceal lie-in-wait predators, and kelp bass lie waiting for some unwary little fish to stray from hiding.

I can only compare these great aquatic forests . . . with the terrestrial ones in the intertropical regions. Yet if in any country a forest was destroyed, I do not believe nearly so many species would perish, as would here, from the destruction of the kelp.

Charles Darwin,
The Voyage of the Beagle (1845)

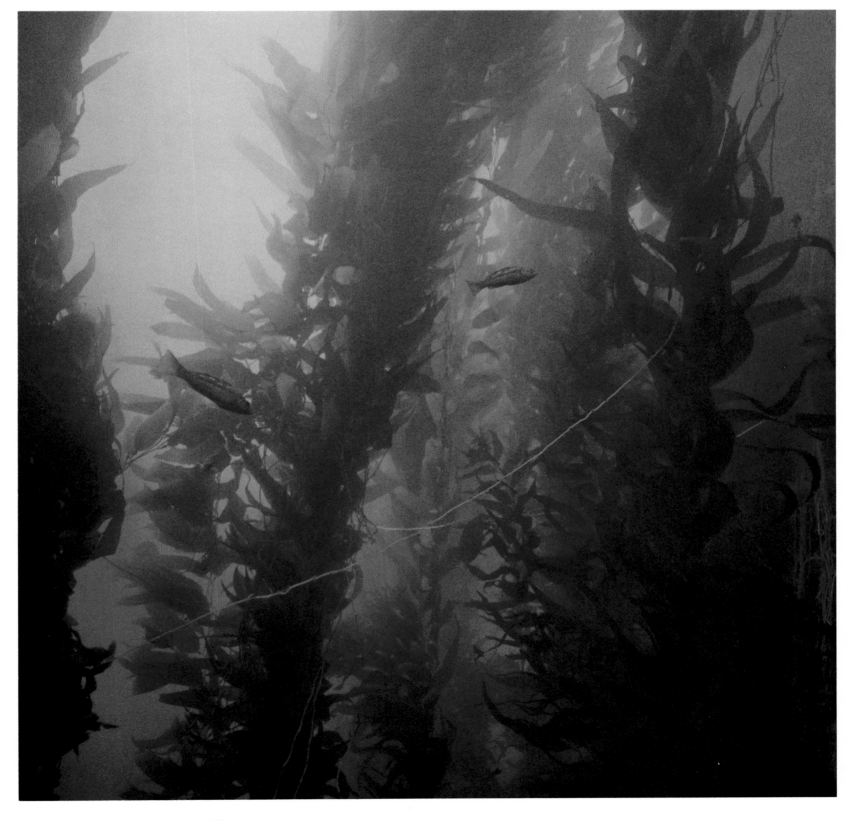

Fronds of the giant kelp, *Macrocystis pyrifera*, grow at the phenomenal rate of one or two feet a day. They grow from the apex, picking up speed as they reach the sunlight, so that their long, fast-growing tops trail out, floating, on top of the water, where the blades can photosynthesize in full, unfiltered sun. A frond of *Macrocystis* produces blades along its entire length, from the floor up, each with a swollen, pear-shaped bladder at its base. The kelp produces carbon monoxide to fill the bladders, and they act as floats to buoy the plant. At the base of the plant, near the floor, the light is dim and the blades large and far apart, the floats few and inconspicuous. Near its rapidly growing apex, however, the blades are much smaller and occur at much more frequent intervals. Crowds of pale, elegant little floats glow among the dark brown-green of the blades, holding the great plant upright and keeping its trailing top floating in the sun.

At Santa Cruz Island, we dive fairly shallow, at about twenty-five feet. The water is quite murky, and the bottom is crowded with low-growing kelp, its blades encrusted with chalk-white bryozoans. I am intrigued by the many small, strange-looking sharks: leopard sharks, angel sharks, horned sharks, and electric rays. There are purple urchins on the rocks, and purple coralline algae, and bright orange garibaldi damselfish punctuate the darkness of the kelp. Soon harbor seals come to join us, gentle, lovable creatures, endearingly inquisitive. They are shy to start with. They keep disappearing into the kelp, sneaking through the jungly vegetation to pop out and stare where I least expect them. As they grow increasingly courageous, they zoom back and forth, buzzing me as they pass. Some seals venture close and, cocking their heads, stare into my face. By the end of the dive, one particularly daring creature is balancing merrily on top of my electronic strobe.

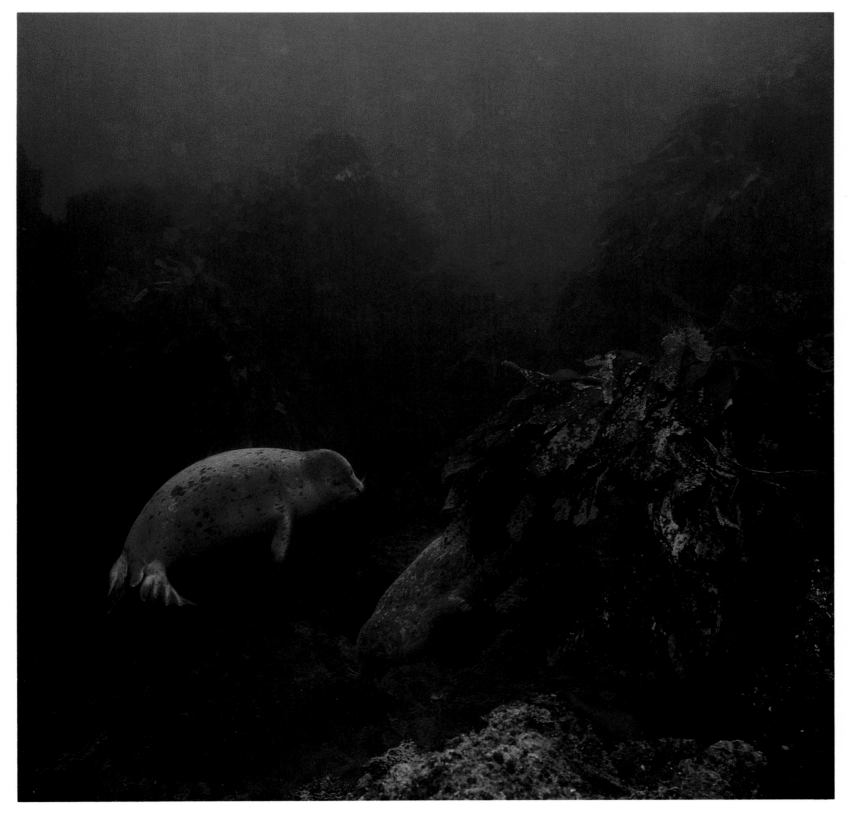

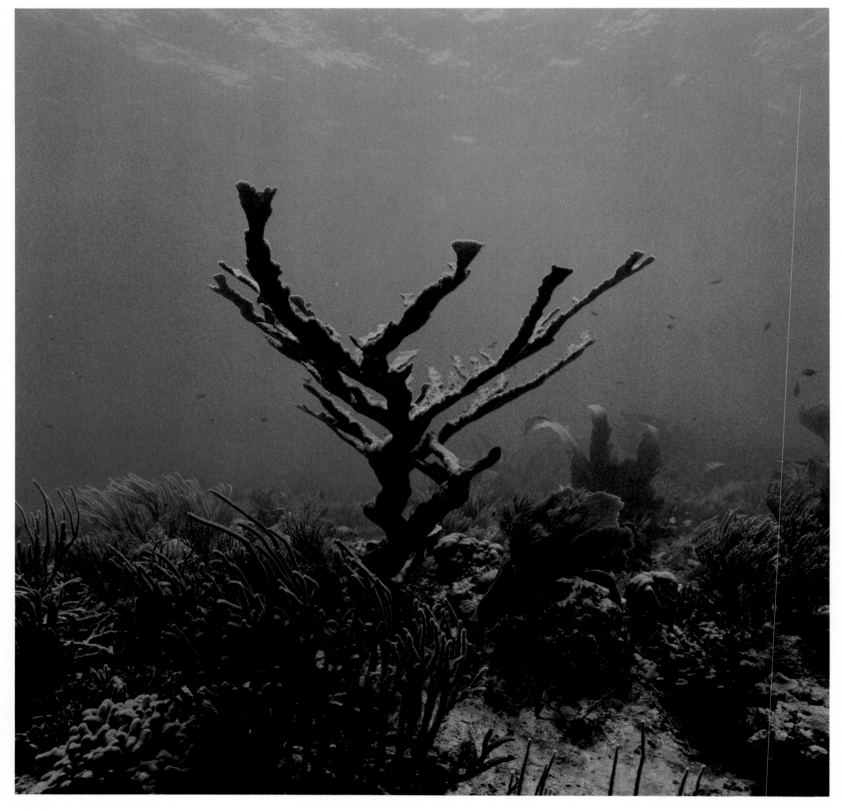

*Windward reef front,
East End, Grand Cayman*

The East End is the windward side of Grand Cayman, sometimes exposed to heavy waves and surge. Rollers sweep in and crash against the reef crest, but much of their energy is being absorbed on the shallow reef flat to the seaward, well below the surface. There, at forty feet, waves washing back to sea have cut a maze of sandy-floored canyons. Between channels, the reef rises in low coral mounds that have a windswept appearance, rather bare, with sea fans and gorgonians bowing beneath the surge. Only the sturdiest corals grow, mostly rounded forms that can maintain a low profile and deflect the waves' force. Yet elkhorn corals tower above the growth like great windblasted trees. They grow very fast, outstripping and shading any possible competitor. Standing tall above the substrate, they can spread their branches in uninterrupted sunlight, but their skeletons are exposed to the constant pounding of waves, and at times to the violence of storms and hurricanes. Only massive enough for mechanical strength, the flattened branches look vulnerable, but they are magnificently designed for their sunlit, high-energy environment. Presenting a fine cutting edge to the waves, they offer the least possible resistance, while their broad, flat surfaces are turned to the sky, holding countless zooxanthellae in the sun.

Shyness is not an outstanding trait of shy hamlets —they are sometimes quite inquisitive. They are, however, uncommon, which may have led men to think them reclusive; they are found at only a very few sites, one of them Grand Cayman. Hamlets, like most marine fish, broadcast their eggs in the currents, to drift in the plankton without parental care. Mortality is extremely high, and the fish must compensate by releasing great numbers of eggs. A fish invests a great deal of its energy in reproduction, both on behavior, such as courtship, and on producing eggs and sperm. In order to produce many eggs, pelagic spawners have evolved a variety of mating systems, each aimed at achieving the greatest possible fecundity at the least physio-logical cost. Seabass are often hermaphrodites. Some of them, like the *Anthias*, switch from female to male during the course of their lives. A hamlet is both male and female at the same time. Each fish produces both eggs and sperm, and in spawning, partners "trade eggs"—one gives up eggs to be fertilized in return for the opportunity to fertilize the other's. On the reef, multitudes of planktivores, from fish to sea fans, are ready to devour fish eggs, so the pair migrate to the edge of the reef, usually to a favorite spawning site above a coral head or gorgonian high enough that the eggs will not drift back to the reef, but will be carried away to face the severe but lesser dangers in the plankton.

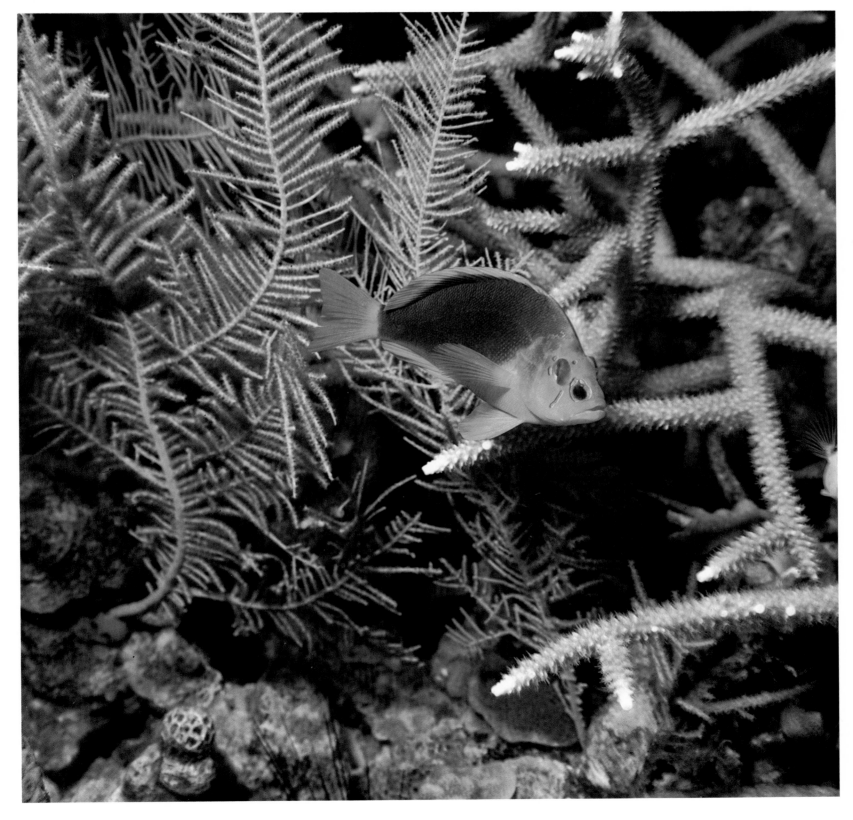

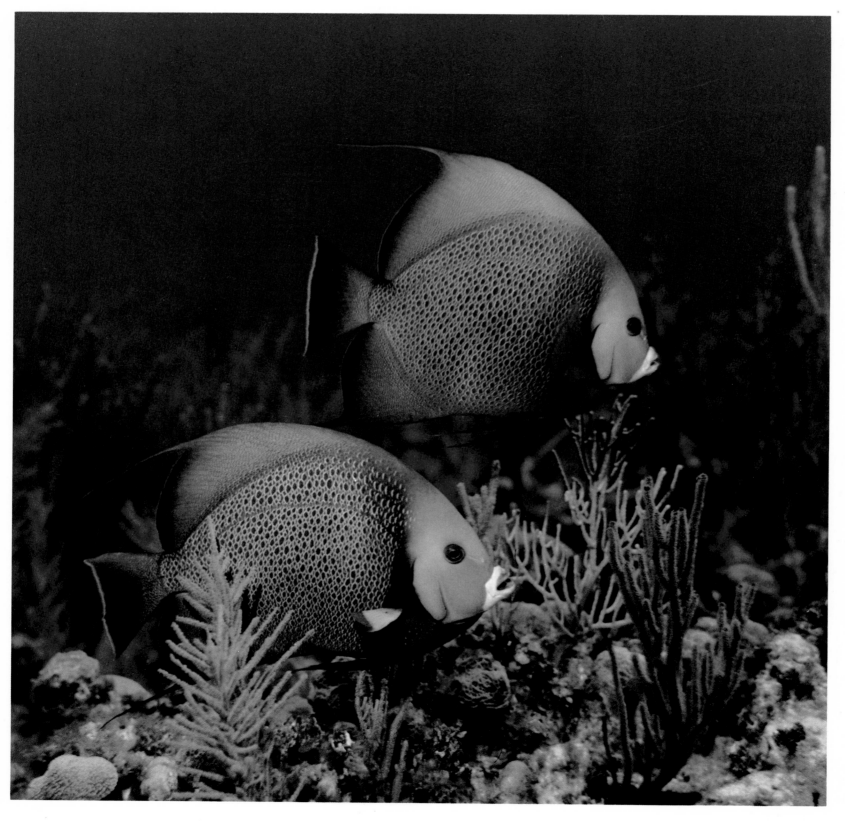

Large gray angelfish sail along the reef with a very stately air. Usually they are in pairs, male and female, for gray angels are monogamous, their pairs permanent. Male and female look very alike; they share a home range and forage there together, feeding primarily on sponges. Spawning is at dusk, just before or just after sunset. Swimming parallel and close together, the angelfish make long, horizontal sweeps of a hundred yards or more, then, with a slightly upward sweep, release the spawn into the currents. For the adults, dusk is the time of greatest peril, when predation is at a peak—and spawning fish are supremely vulnerable. For their eggs, however, dusk is the one time of safety. The plankton-feeders that would eat the eggs in daytime are becoming inactive, and the planktivores of the night have not yet begun to feed: in this narrow time slot, the eggs have the best chance of escaping the reef. Once in the plankton, however, mortality is still catastrophic. Fish that broadcast their eggs, like the angelfish, adopt various reproductive strategies for reducing their cost per egg in order to produce great numbers. Which mating system a species evolves is largely determined by its resources—food, space, and shelter. The ample resources of the gray angelfish make permanent pairs possible, with the advantage that, unlike many other mating systems, all the males have an equal opportunity to reproduce and are assured a mate during the narrow time frame of their spawning.

*Gorgonians on top of
North Wall,
Grand Cayman*

Until about five million years ago, the East Pacific Ocean and the Caribbean Sea were one, their marine fauna homogeneous. When the uplift of the Isthmus of Panama linked North and South America, the oceans were divided. For the last five million years, then, the Pacific and Caribbean fauna have been evolving separately. Sometimes the descendants of a common ancestor have differentiated very little, and form sister-pairs either side of the isthmus. In other instances, environmental factors have caused rapid divergence: the two oceans now share only four or five genera, and no species, of reef-building corals. The Caribbean, with less stable temperatures and a smaller area of suitable sea floor, has only half as many coral genera occur in the Indo-Pacific, and only a few soft corals, all in very deep water, in contrast to the Pacific's wide assortment. No sea in the world, however, can approach the magnificent array of sponges and gorgonians that bedeck the Caribbean reefs. Off Grand Cayman's north coast, sections of the wall top are thronged with gorgonians of every kind—sea fingers, feather plumes, sea rods three feet tall. Supple branches swaying with the currents, polyps shining in the sun, they make a very Caribbean seascape.

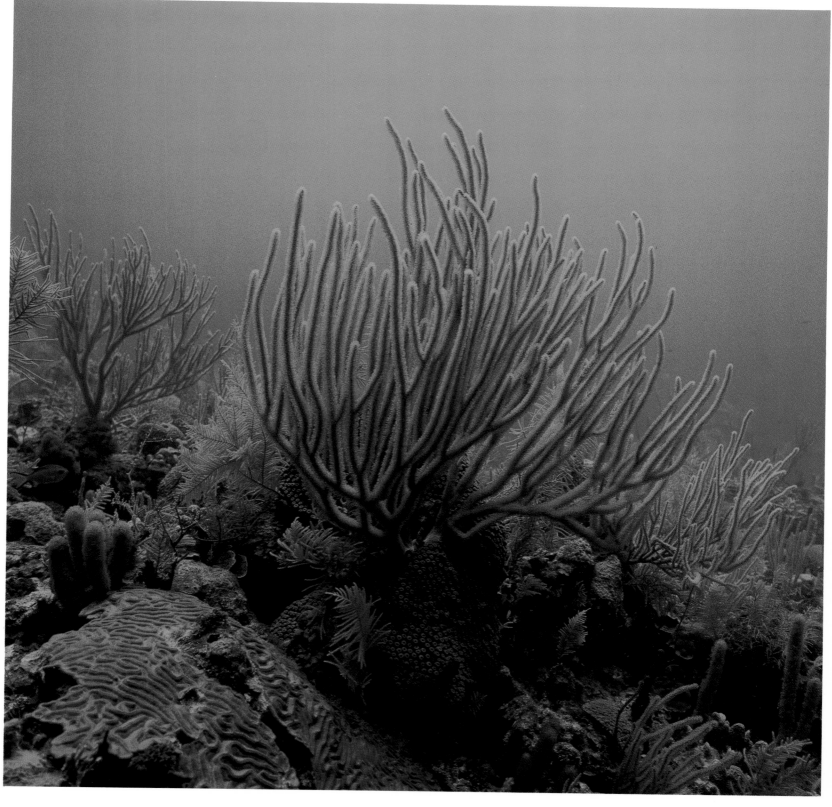

Not far from the harbor is a patch reef, rising from a forty-foot sand bottom to within a few feet of the surface. Its top is rich with life, its interior a labyrinth of tunnels and caves—it is a favorite "last dive of the day." Dropping to this reef one late afternoon, I head for a familiar roof-crack entrance into one of the caves, but when I reach it I look down and see the entire cave is roiling with fish. A school of dwarf herrings has taken refuge inside. Fish part before me as I drop to the floor. Fish spin around me, and flow along the contours of the cave; sun streams through the roof crack, glinting off their sides. I watch almost an hour. Then, abruptly, the pattern changes. Fish sweep up to the crack, and pour out into the sunlight. More and more fish swirl upward, like the spout of a tornado, and spill through the opening to join the mass milling outside. Such large, populous schools give the misleading impression of a highly fertile sea, but they form by day for protection, not feeding. In the evening, they move offshore and disperse, each fish feeding individually on the relatively sparse plankton of a tropical sea. At first light the schools re-form and move back to the safety of the reef and a shelter. Safety is relative. I return to the cave the next day: the herrings are back, but the predators have found them. A four-foot grouper is ensconced in one corner; several barjacks and some yellowtail snappers are busy feeding, swimming slowly through the school, then attacking in sudden surges of activity. Two tarpon hang just outside. There are noticeably fewer dwarf herrings.

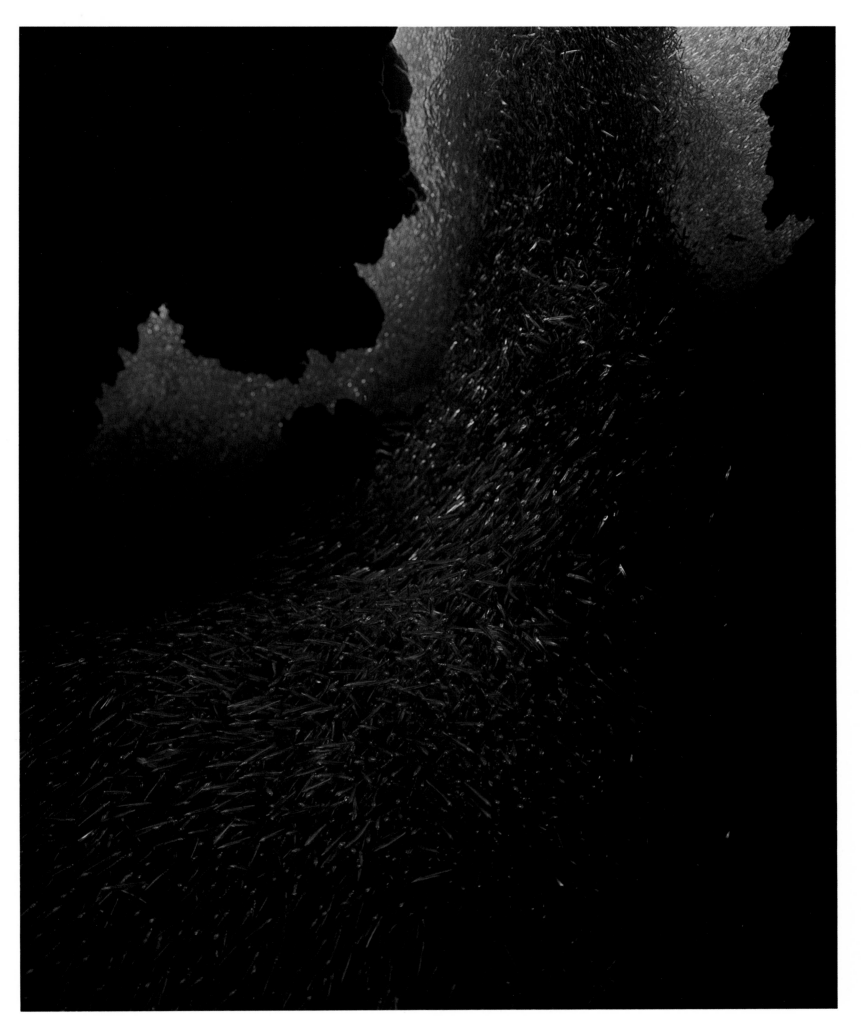

Queen angelfish
by barrel sponge,
West Bay, Grand Cayman

A barrel sponge grows very slowly, scarcely an inch a year. Some of the grand old giants on the Cayman reefs, six and seven feet high, have probably been growing a hundred years or more. These are very primitive animals. Despite their size, they have no organs, no gut, no nervous system, no sensory cells, only a loose aggregation of microscopic cells with an almost protozoan independence. They live by pumping water. The animal consists of a thick, barrel-shaped wall enclosing a central cavity. Its outer surface, crusted with minute spheres of silica, is stony rather than "spongy," but is perforated by countless tiny pores through which water is drawn into the sponge.

The wall itself is riddled by a complex, convoluted system of channels and chambers, all collecting into larger channels, and emptying into the central cavity, thence into the sea. Its chief living constituents are "collar cells"; they line every channel and chamber, and it is the beat of their flagellae that draws the water into the sponge and drives it out. It is their "collars" that filter out food, so efficiently that they retain particles as small as a bacterium. The larger the sponge, the more complex its channels and chambers, and the more numerous its collar cells. Billions of flagellae can move a lot of water, and a large sponge can pump its own volume in water every few seconds.

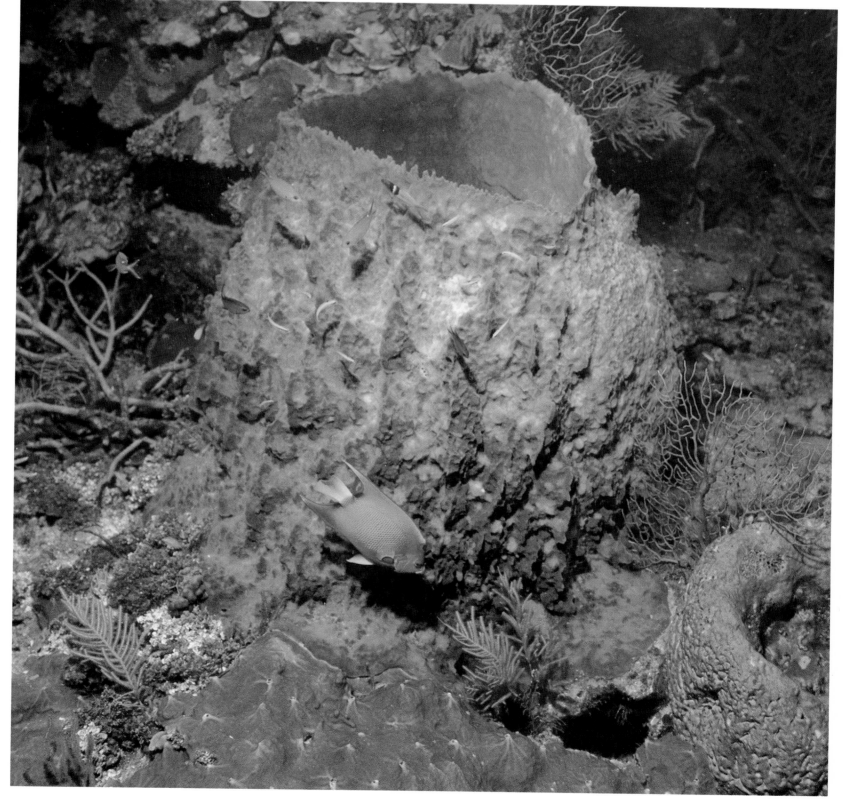

In the Caribbean, sponges become an important part of the seascape, more conspicuous, more varied, and more predominate by biomass than in any other sea on earth. At least part of the reason is the dearth of sponge predators in the Caribbean Sea. In the Indo-Pacific, by contrast, sponges suffer such intense predation that comparatively few can grow, and those mostly in cryptic habitats. In an evolutionary sense, sponges are a dead end—there is no evidence they have ever given rise to a higher form of life—but within the phylum, they have diversified widely. All sponges live attached to some submerged object. They may grow as a thin encrusting layer, as indefinite-shaped lumps, as ropes, or in a variety of vase shapes: cups, barrels, pipes, or tubes. The material of their skeletons also varies. Not all sponges are as soft and squeezable as the familiar bath sponge. Some are hard as stone, some are leathery, some bristly. A bath sponge is a sponge skeleton composed of "spongin," a fibrous protein related to horn or hair. Prettily patterned *Ircinia* also has a spongin skeleton. In *Ircinia*, however, the spongin fibers form a leathery membrane, pulled up into little raised cones all over the surface, embellished with a radiating network of fibers, and so tough it is almost impossible to cut. Unfortunately, the most memorable feature of this decorative sponge is its smell. Its foul, garlicky odor has earned it the common name of "stinker sponge."

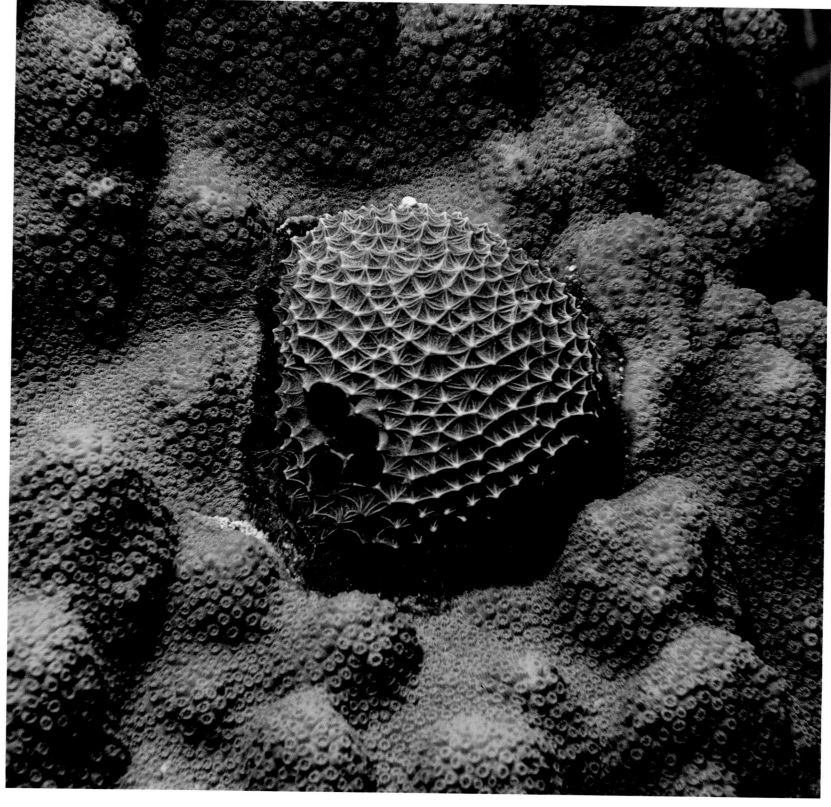

119

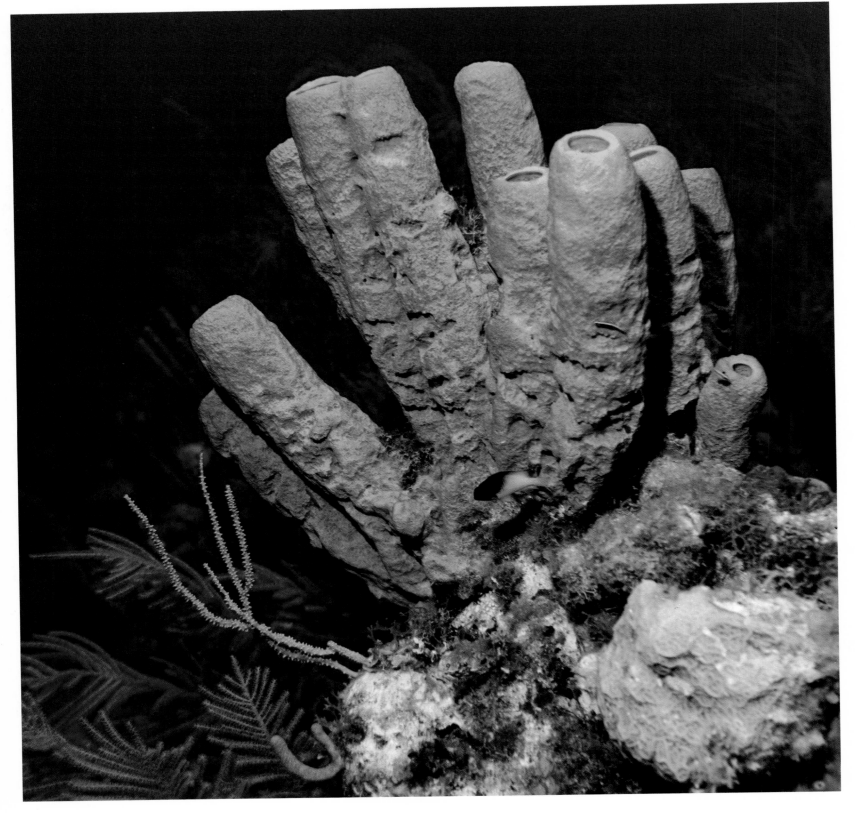

To us, the marigold hues of a stovepipe sponge are bright and beautiful. To a reef animal they spell danger, warning of noxious toxins, poisonous to all but the few evolved to eat that species. The height of a stovepipe sponge also has its purpose. Sponges in perfectly still water will circulate water through their passages, but will not thrive. Sponges in the ocean grow where currents will flow across the mouths of their cavities. Because water is viscous, the current entrains the water in the cavities, enhancing the flow through the sponge, increasing the amount of food and oxygen delivered, and carrying wastes away. The faster the flow, the more water is entrained. Immediately above the floor, currents are slowed by drag, so in quieter water the sponges grow tall, carrying their mouths up into a swifter stream. The stovepipe sponge, *Verongia fistularis*, and its close relatives are "bacteriosponges" that harbor such huge populations of symbiotic bacteria that half their living tissue is bacterial. Paradoxically, they are at the same time a source of potent antibacterial compounds.

Let the word sponge bring to mind, not only the pleasantly squeezable accompaniments to our bath, but the wonderfully colorful race of living creatures dotting the coral reefs of the world, much as clumps of violets and marigolds brighten our terrestrial gardens.

William Beebe,
Beneath Tropic Seas (1928)

The trunkfish is a very recently evolved, very sophisticated form of reef fish. The antithesis of streamlined, it is short, squat, triangular in cross-section, and encased in a rigid bone box. The bone, derived from elements of the internal skeleton, forms hexagonal plates, fused to enclose the entire fish except for small holes at the orifices and gills, and holes where the mouth, eyes, fins, and tail protrude. The bone is excellent armor, but in gaining armor, the fish sacrifices speed—the box restricts its movements like a bodycast. Most fish swim by rhythmic undulations of the body; the tightly-cased trunkfish employs a very different style. Most of the time it sculls along with its pectoral fins, aided by the anal and dorsal fins flapping from side to side. This suffices for puttering about the floor: smooth trunkfish forage for small invertebrates, such as shrimps, sponges, and worms, or they blow jets of water into the sand to uncover burrowing animals. None of this calls for speed. If circumstances require more rapid motion, the paddlelike tail can be brought into play. By contracting all the muscles on one side of its body, then on the other, the fish flexes the base of its tail and wags its caudal fin back and forth. It could not exist without armor.

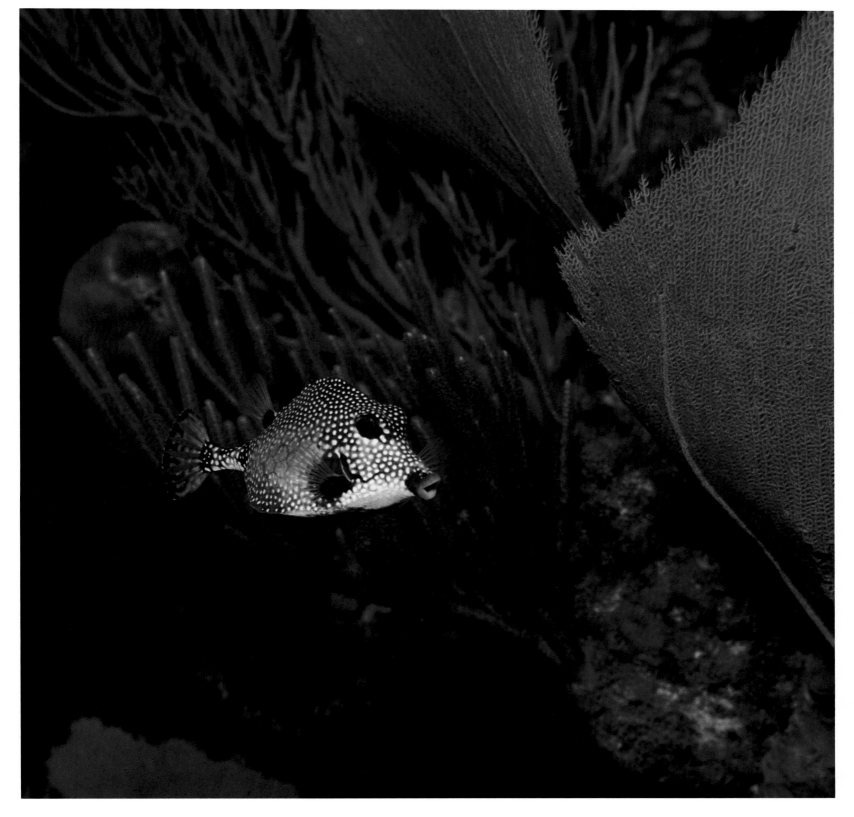

A large sound interrupts the north coast of Grand Cayman with the fringing reef continuing right across its mouth. Just inside is a shallow sand flats, and toward sunset we take our masks and snorkels, to explore. Reef squid are described as shy, but here they seek us out and stay with us; red-brown at first, they grow darkly iridescent in the gathering dusk. Squid are the most highly developed of all invertebrates. In them, the molluskan body plan has been adapted to an active, predatory life. The characteristic molluskan shell is reduced to a thin internal rod, and their bodies are torpedo-shaped and stream-lined. A squid has a large brain, encased in a protective cartilage like a vertebrate skull, and its big eyes are amazingly like ours, with an iris that contracts in bright light, and muscles to focus the lens. Many million years ago, squid ruled the seas. Then bony fish evolved, and they were more efficient. They swam instead of jetting through the water. While squid moved very fast—backward—fish could dart swiftly forward, to seize prey. Fish could regulate their buoyancy, maneuver vertically, and exploit many habitats. Squid were bound to the open water. The fish increased in numbers and species; the squid declined.

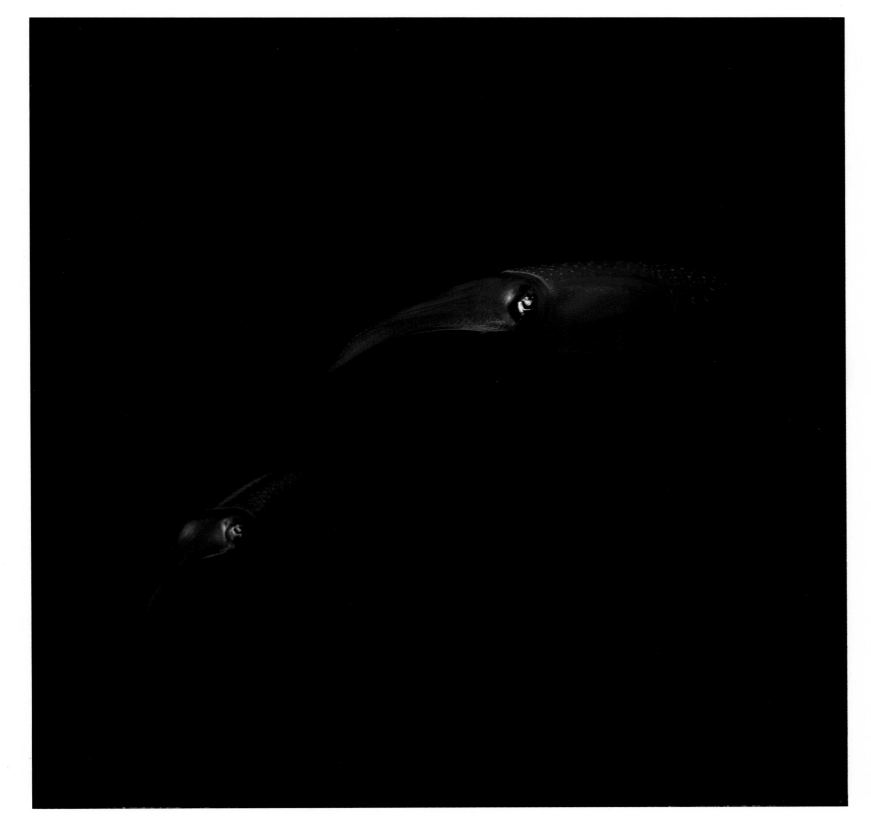

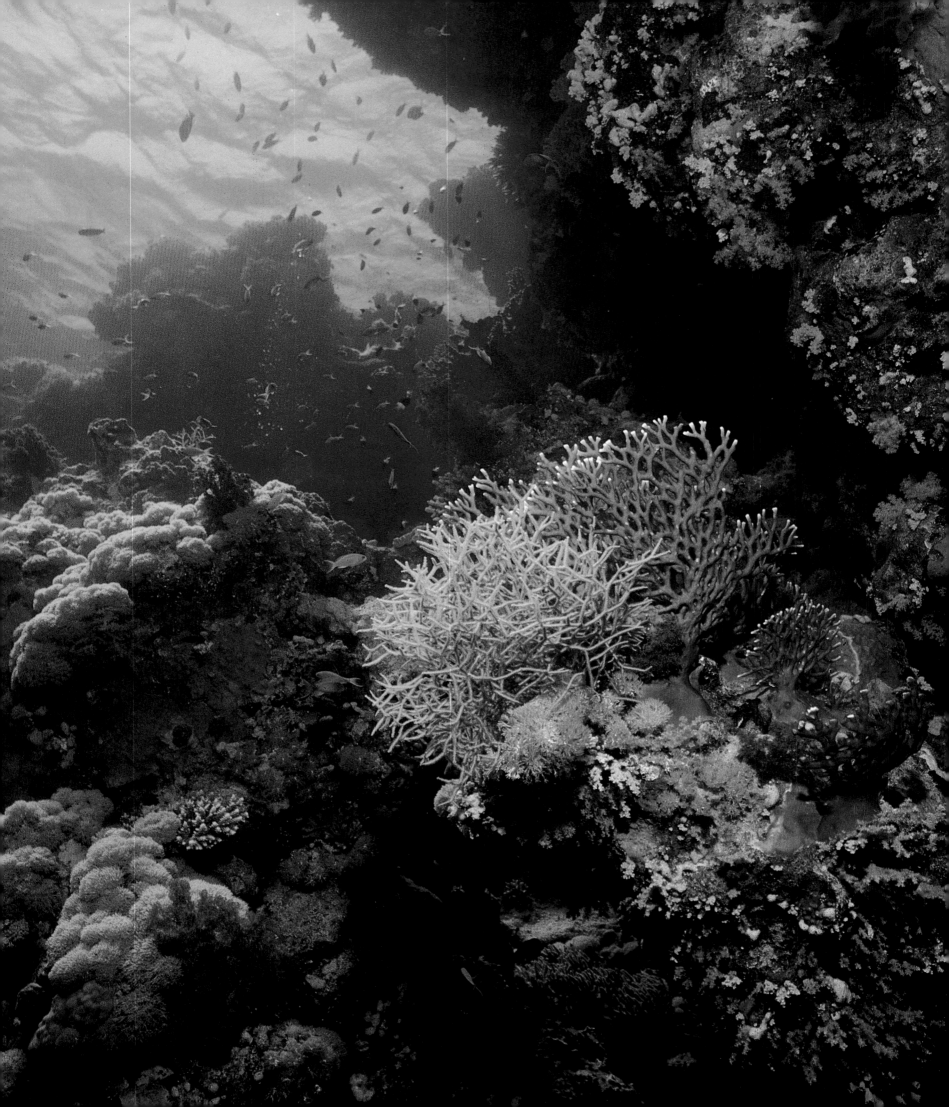

Earth's Young Seas

The photographs of the Red Sea taken from space show most clearly the fit of the African and Arabian coasts. Shove Arabia slightly south, then edge it west, slipping the tip of Yemen over Ethiopia's Afar Triangle—and the two continents mesh.

At the strange, volcanic Afar Triangle, three rifts meet. From the Indian Ocean, the midocean ridge turns and ends at the triangle. From the Afar Triangle south, the Great Rift Valley slashes almost the length of Africa, an ocean-in-the-making that will cut Africa in two. From the Afar Triangle north, a third rift splits Africa and Arabia apart. Its flooded valley is the Red Sea, a very young ocean, still long and narrow, but with magma rising in its depths, spreading its floor. In the north, the sea forks into two skinny fingers that hold the Sinai Peninsula between them. The shallow western gulf continues to the Suez Canal, but east of Sinai a transform fault cradles the deep, narrow, steep-sided Gulf of Aqaba, then, northward, the Dead Sea and the Sea of Galilee.

Deserts and near-deserts ring the Red Sea, barren lands supporting little life, but fringing the sea's shores are coral reefs that brim with life and color. The tip of the Sinai Peninsula is a mass of gnarled, bare rock, known as Ras Muhammad. All along the eastern coast of Sinai, gaunt, forbidding wilderness falls away to the lush coral reefs of the Gulf of Aqaba, and from Ras Muhammad to the Straits of Tiran are some of the Red Sea's richest reefs. In places, a series of barrier reefs lies a few

miles out to sea. Off Sudan, this system is fairly continuous. Sanganeb Reef lies outside Port Sudan, close enough that at night we could see the city's lights glowing across the water.

Until thirty million years ago, the North American Plate had been drifting west over the ancestral Pacific Plate. Then, when most of the plate had been consumed, the continent met the East Pacific Rise. The result of this collision is the San Andreas Fault, a system of transform faults between the North American and the present Pacific Plates.

With time, the trench along western North America consumed more and more of the rise until the northern end of the rise abutted the Mexican coast, and a strip of land, Baja California, was torn from the North American Plate and welded to the Pacific Plate. The interplate boundary now lay between Baja and the mainland, a hybrid of long transform faults and small spreading centers linking the rise with the San Andreas Fault system. Movement along these faults opened the Gulf of California. Now five million years old, it is the Earth's youngest sea.

The great swells of the Pacific crash on Baja's western shores, but east of the peninsula the Gulf of California lies protected. At the rocky headlands of Cabo San Lucas, gulf and ocean meet. Here, the gulf is tropical throughout the year, an oasis where corals build reefs, where migrants from the West Pacific can survive and colonize. Species live here that are not found again until the shores of Panama.

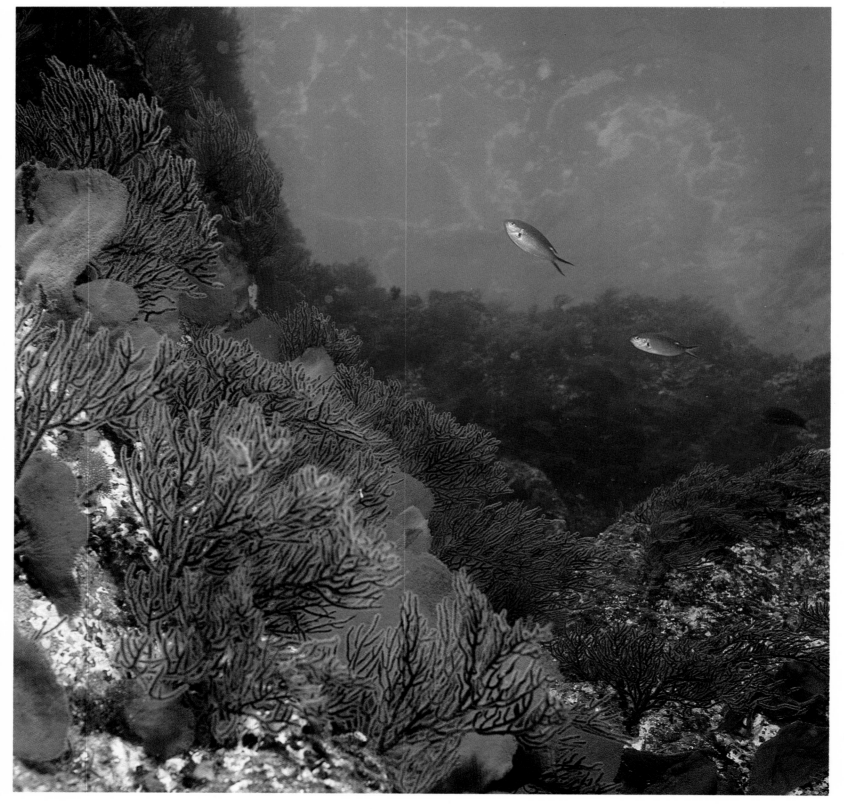

*At the base of
Roca Blanca,
Los Frailes, Baja California*

At Los Frailes, near the entrance to the Gulf of California, a number of large rocks rise just offshore. The tip of Roca Blanca scarcely clears the surface; then, under the water, the rock slopes away steeply, covered by a marvelous collection of sea fans. The sea is so clear that from a fifty-foot bottom we can see the patterns of the waves moving across the surface-sky, and the late afternoon sun shining through. A current sways the sea fans, and damselfish are feeding in it, following the contours of the slope as they swim—just high enough to capture plankton, just low enough to dive for cover. Toward the base of the slope two very different types of sea fans are growing together, beautifully intermingled. *Muricea* branches loosely; its sturdy dark branches, furred with white polyps, spread across the current more like a flat bush than a fan. The rust-brown branches of *Pacifigorgia* grow all in a single plane, anastamosing to form a delicate, lacy fan, fine-meshed and supple.

As I drop from the dinghy into a bright azure sea, panic-stricken fish explode past me; just beneath my feet a huge silver mass hangs in the surge—sardines. The school, as I enter, parts before me, streams past and forms again behind, and I swim, encapsulated, to twenty feet, breaking through above a rippled, sandy floor, with the wall sloping steeply beside me and the sardines just above. A large cave opens to the floor, and I settle just inside, watching the school, and marveling at its size. Cloud upon cloud of fish, in a dense, bellying canopy, stretches up and down the coast as far as I can see, and fish flow across the surface in wide, curling streams, making the great clouds roll, like the clouds of a gathering storm. So large is the school, so densely packed, that the floor is in dusk-blue twilight, the only brightness a pale blue strip that runs up the face of the wall, where the fish hold away from the rock. In this strip big groupers lie, sullen-jawed and predatory, staring at the multitude before them. The multitude swirls past, indifferent, as though secure in the safety of the many, and careless of the fate of a few.

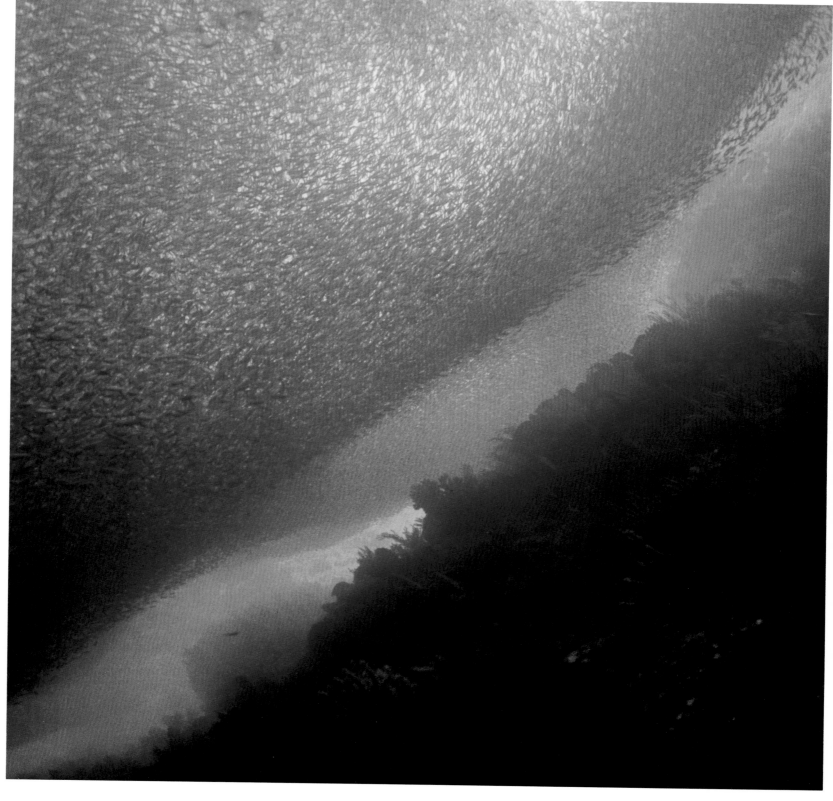

*Lionfish over sand floor,
Sinai, Red Sea*

In no other environment are there so many species of fish as on the coral reefs; at least a third of the world's fish species live on or about a reef. Dividing up the available resources, some feed on plankton, some on algae, while others are carnivores; the form of their bodies, the shape of their fins, are an expression of their mode of feeding. Most predators are generalists, generalized in form and feeding habits. They roam the reef looking out for vulnerable prey. Among the predators, however, are some that have become highly specialized to hunt one particular type of prey, in one particular manner, or in one particular habitat. Some are adapted to search out prey. A moray eel is a crevice predator with a smooth, snakelike body adapted to searching the crevices for fish at rest. Little trunkfish scull along the floor, blowing away sand in search of buried prey; eagle rays disturb the sand by beating powerful fins. Many fish are ambush hunters. Hidden by narrow, silvery bodies, barracuda can stalk their prey in open water until close enough to dart in. Kelp bass are sit-in-wait predators, skulking in the kelp. Lionfish are sit-and-wait predators of the night, hunting the shrimps and crabs that come out after dark, and probably stray fish as well. Formidably defended, they can lie with impunity on the open floor, resting motionless until some morsel wanders within range, and then, with a sudden lunge, seize it in a big, wide mouth.

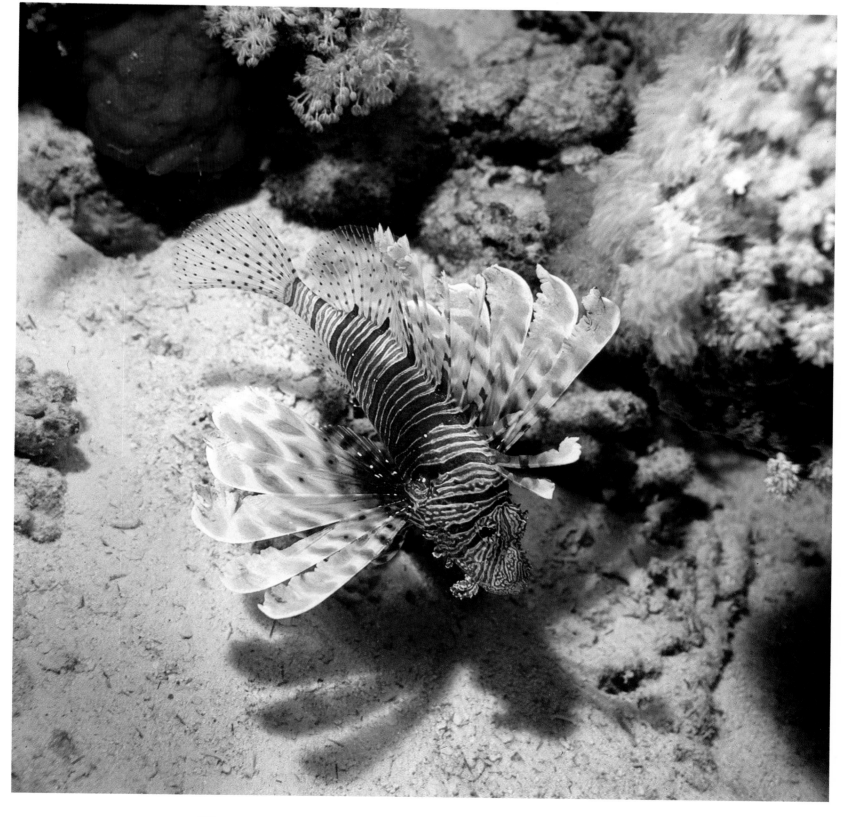

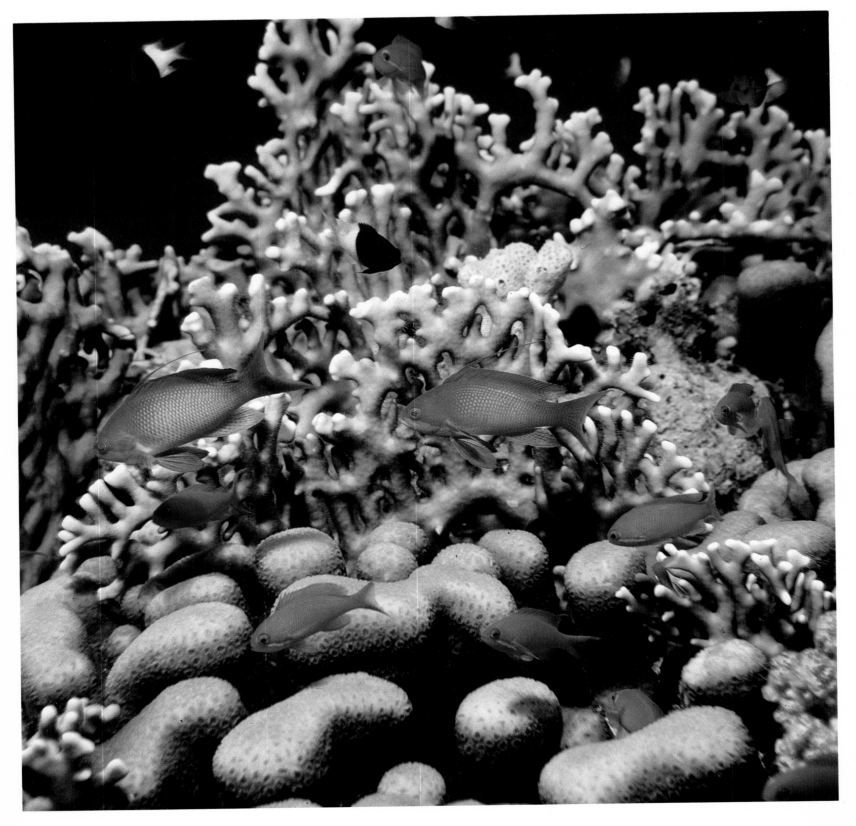

"Goldfish" and fire coral, Sinai, Red Sea

Little *Anthias*, or "goldfish," feed along the Red Sea reefs by the thousands, always hovering within inches of the coral, far enough out to harvest plankton from the current, close enough to reach refuge when threatened. The goldfish are hermaphrodites: they mature as females and change to males later in their lives. A male fish gets little opportunity to mate while small. When all the young are female, all can have some reproductive success early in their lives, and then, when they grow larger, can change their sex and reproduce more prolifically as males. The dominant male is about four inches long, with a long dorsal filament and lavender-red coloring that blanches to lavender-silver when displaying. He establishes a territory above a coral head, defends it against all other males, and recruits a harem of females. Eighty to ninety percent of the population are adult and subadult females, bright orange and smaller than the male. The male is kept so busy defending his territory and reproducing that he has little time to feed, and does not survive long. On the death or loss of the harem male, the dominant female becomes a male to replace him.

As I make my descent, I can see on the reef below me a strong splash of pink, looking implausibly like a filmy pink ruffle. When I reach it, I find eggs—tiny vivid-pink eggs embedded in a coil of gelatinous ribbon, slimy to the touch. It is the egg case of a nudibranch, or sea slug. Slugs on land are drab, disagreeable snails without shells, eating up the garden and leaving trails of slime. Nudibranches are shell-less marine snails, many of them exotically beautiful, and some with the most intense, startling colors in the sea. The colors are warning colors; the small, soft-bodied nudibranches protect themselves by concentrating noxious toxins, then advertising the fact. A nudibranch usually spawns at night, laying eggs embedded in gelatinous strings or ribbons. To build a coil, the spawning snail rotates slowly on its foot, while adding one vertical row after the other to the lengthening ribbon. The process may take hours—egg cases contain up to millions of eggs. In a few hours more, the eggs have hatched, and the swimming larvae have dispersed. In the meantime, with all the fish about, the eggs' position looks reckless, but as they come to no harm, it seems probable that their vivid pink, like the adults' vivid colors, is advertising the presence of toxins, and that the fish are taking heed.

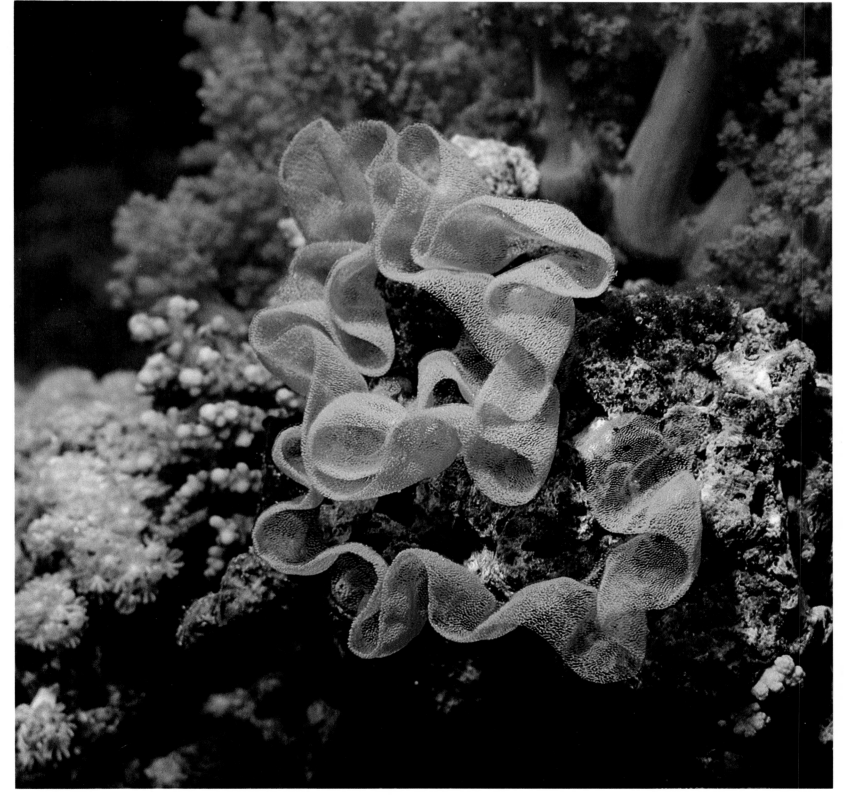

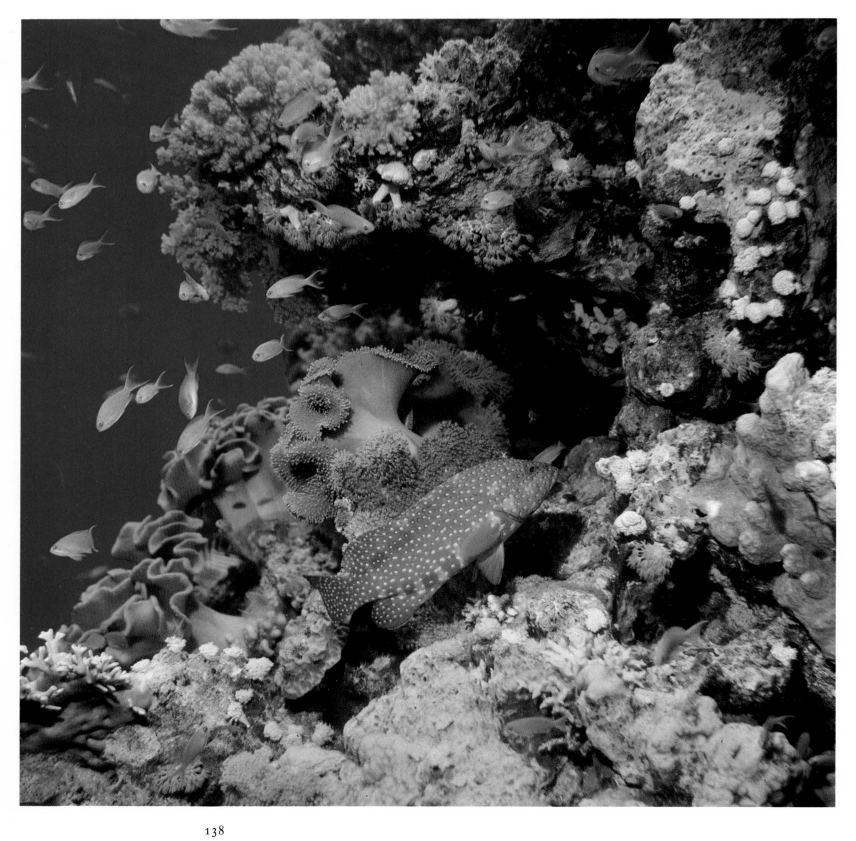

A big, fat red predatory grouper wends its arrogant way through the soft coral garden where a school of *Anthias* are feeding; the school goes about its business unperturbed. If alarmed, the *Anthias* would dive for the nearest shelter. Obviously they are not alarmed. They know the grouper is there, the grouper knows they know; both species know that should the grouper make a lunge, the *Anthias* are fast enough, and close enough to shelter, to escape. Rather than waste its energy on futile lunging, the grouper bides its time, patrolling the reef and watching—watching for the spawning pair whose guard is relaxed, for signs that a fish is injured or ill. The moment a prey fish shows weakness, the grouper moves in. In the long run, predator and prey maintain a balance. Prey evolve defensive mechanisms (a spine? a tougher shell?) and thereby gain an advantage, but only until the predator evolves some means of overcoming that defense (for example, a stronger jaw).

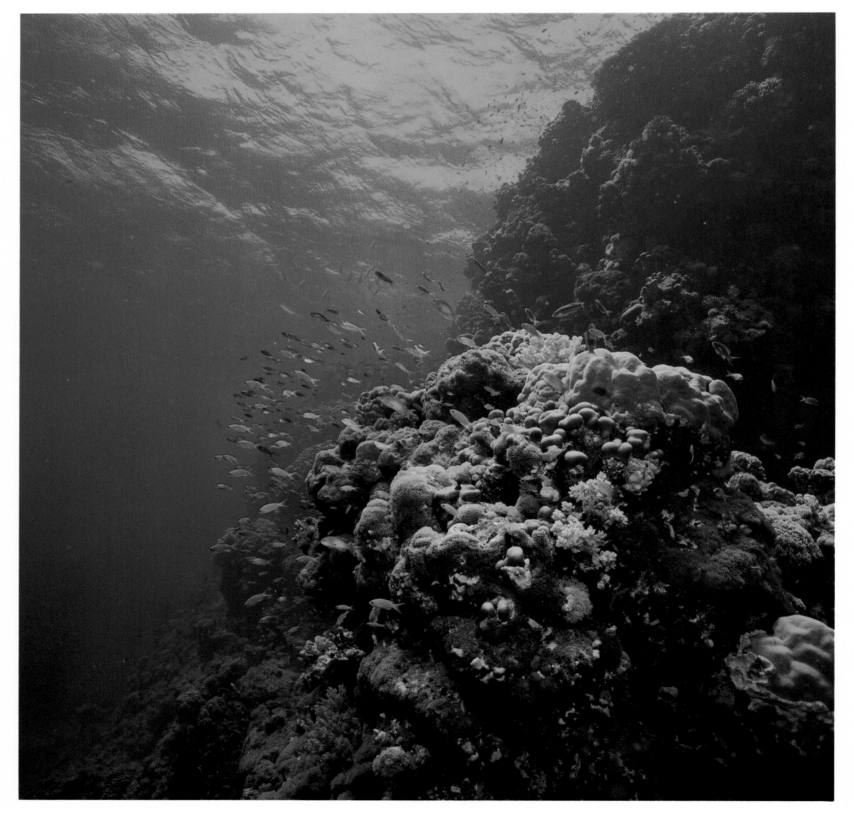

Midday at Sanganeb Reef
Sudan, Red Sea

The general impression of hours and days spent at the bottom of the sea is its fairylike unreality. It is an Alice's Wonderland, where our terrestrial experiences and terms are set at naught. The flowers are worms, and the boulders living creatures; here we weigh but a fraction of what we do on land; here distance is sheer color and the sky is a glory of rippling light. Here we can support ourselves with the crook of our little finger, and when we let go we fall too slowly for injury.

Until we have found our way to the surface of some other planet, the bottom of the sea will remain the loveliest and strangest place we can imagine.

William Beebe,
Beneath Tropic Seas (1928)

Biological Notes

Gerard M. Wellington,
University of Houston Marine Science Program

ii
A field of plating coral, *Turbinaria*.

2
The steep reef slope with numerous gorgonians, *Melithea squamata* (Nutting), reaching out into the current. The stony coral on the left is *Porites lutea* Milne Edwards and Haime. A school of Luna fusiliers, *Caesio lunaris* Cuvier, pass overhead.

10
See note for page 19.

13
A large school of barracuda, *Sphyraena jello* Cuvier and Valenciennes, hovering along a vertical drop-off on the reef slope.

14
A close-up of the gorgonian *Melithea squamata* (Nutting) showing the articulated stems.

Sheltering close to its branches are small purple serranids, *Mirolabrichthys* sp.

17
Found only in the lagoon waters of Palau is the jellyfish *Mastigias papua* (Lesson).

19
Perched atop a gorgonian, *Melithea squamata* (Nutting), the silver crinoid *Cenometra bella* Hartlaub uses its feathery arms to filter plankton.

20
A school of needlefish, *Strongylura* sp., feeding on plankton at the surface.

21
A sea snake, *Laticauda colubrina* (Schneider), prowling the reef in search of small crabs and fish.

22
The gorgonian *Melithea squamata* (Nutting) with a juvenile snapper, *Macolor* sp.

25
The expanded ectodermal vesicles of the bubble coral, *Plerogyra sinuosa* (Dana), serve to maximize exposure of endosymbiotic zooxanthellae to available light. At night elongated tentacles expand to capture zooplankton.

26
At the top of the reef slope, living space is crowded with competitors of every sort. In the center are colonial hydroids surrounded by various stony corals, *Acropora*, *Pocillopora*, *Goniastrea*, and soft corals, *Lobophytum*. At the base of the hydroids are numerous urn-shaped ascidians, *Didemnum ternatanum* (Gottschaldt).

27
The skunk clownfish, *Amphiprion perideraion* Bleeker, nestled within the tentacles of its host anemone, *Radianthus ritteri* (Kwietniewski).

29
The plating and coiling growth form of the stony coral *Turbinaria* gives the appearance of a field of cabbage heads. Peeking out beneath the "leaves" are squirrelfish, *Myripristis murdjan* (Forskal).

31
A trio of butterflyfish, *Heniochus acuminatus* (Linnaeus), with planktivorous damselfish (*Chromis*) in the background. In the foreground is the bright red soft coral *Dendronephthya* sp.

32
The battle for space is nowhere more intense than on the shallow forereef. Here species of stony coral, *Acropora* (left of center), battle with *Pocillopora* (center) to maintain a foothold.

35
Like many invertebrates that live out in the open on coral reefs, the very common cobalt blue sea star *Linckia laevigata* (Linnaeus) is conspicuously colored, perhaps an indication that its tissues concentrate compounds toxic to potential predators. Nearby is a yellow tunicate and a gray vase-shaped sponge.

36
Forming a tablelike growth morphology up to several meters across is the stony coral *Acropora hyacinthus* (Dana). In the foreground is a branching form of *Acropora*.

37
Staghorn coral, *Acropora*, probably *A. formosa* (Dana), with a school of *Chromis caeruleus* (Cuvier and Valenciennes) hovering close for protection.

38
Cuttlefish (probably *Sepia*) are commonly found schooling near shore on reefs during the day.

39
The clownfish, *Amphiprion melanopus* Bleeker, sheltering among the tentacles of the sea anemone, *Physobrachia douglasi* Kent.

40
See note for page 27.

43
A moray eel, *Gymnothorax meleagris* (Shaw and Nodder), in a defensive display with its jaws agape. The yellow encrusting coral is a species of *Turbinaria* sp.

45
Colonies of the leathery soft coral *Sarcophyton* sp. with their tentacles contracted.

47
A chalice coral, *Turbinaria* sp., apparently dislodged from the reef and tilted onto its side.

48
The Moorish idol, *Zanclus canescens* (Linnaeus).

51
A lionfish, *Pterois antennata* (Bloch).

53
A plating coral whose skeleton grows in the form of concentric ridges, *Pachyseris speciosa* (Dana). In the middle is a delicate yellow crinoid and a dark-finned chromis, *Chromis atripes* Fowler and Bean.

55
The yellow-faced butterflyfish, *Chaetodon flavirostris* Gunther, above the plating coral, probably *Mycetophyllia elephantotus* (Pallas).

56
The reticulated butterflyfish, *Chaetodon reticulatus* Cuvier, and a green encrusting coral, *Turbinaria* sp.

59
Two species of the giant clams sitting atop the coral *Lobophyllia hemprichii* (Ehrenberg).

60
Holes carved in the soft tuffstone at Cousin's Rock by the burrowing activity of the blunt-spined urchin, *Eucidaris thourasii* (Valenciennes). Also pictured is the smaller green urchin, *Lytechinus semituberculatus* Valenciennes. Upper right is a colony of the black coral, *Antipathes galapagensis*, and colonies of the cup coral, *Tubastraea coccinea* Lesson. Small wrasses, *Thalassoma lucasanum* (Gill), are in the upper left.

63
A playful Galapagos sea lion, *Zalophus californianus wollebaeki* Sivertsen.

65
The Pacific amberjack, *Seriola colburni* Evermann and Clark, can reach up to five feet in length.

66
The white-tipped reef shark, *Carcharhinus albimarginatus* (Jordan and Evermann), is very common in Galapagos waters. In the background is the Pacific green turtle, *Chelonia mydas* (Linnaeus).

69
The spotted eagle ray, *Aetobatus narinari* (Euphrasen).

71
Outstretched over a black tunicate is the sea star, *Mithrodia claverigera*. Adjacent are clusters of one of its main prey items, *Megabalanus galapaganus* (Pilsbry).

73
The endemic Galapagos black coral, *Antipathes galapagensis*. The tentacles are pigmented yellow.

74
To the left is the endemic cup coral, *Tubastraea tagusensis* Wells. Attempting to overgrow the coral is a red colonial tunicate.

77
The prey, *Paranthias colonus* Valenciennes (small seabass known locally as "gringos"), and the predator, the Pacific amberjack, *Seriola colburni* Evermann and Clark.

78
Clinging to the bottom, the marine iguana, *Amblyrhynchus cristatus* Bell, grazes on the red algal turf.

81
The mirrored pompano, *Trachinotus stilbe* (Jordan and McGregor).

82, 83
In spite of its ominous size—it is the largest of all fishes—the whale shark, *Rhincodon typus* Smith, is quite benign. It makes its living by filtering minute zooplankton.

85
Although it has the appearance of a stony coral, soft coral carpets the bottom. Mingling about are the brightly colored reef fish *Anthias squamipinnis* Peters.

86
Competing for space are soft coral (left) and stony corals (right), which include tabular *Acropora* and massive forms. The curious squirrelfish, *Adioryx spinifer* (Forskal), stays close to the shelter of nearby crevices.

89
A reef wall with a multicolored covering of invertebrates: upper left is the cup coral, *Dendrophyllia gracilis* Milne Edwards and Haime. In the center is a speckled hawkfish, *Paracirrhites forsteri* (Bloch and Schneider), resting above an oyster, *Ostrea*. The various splashes of red and orange are encrusting sponges.

90
A common rock-dwelling sea anemone of the Pacific northwest, *Tealia coriacea* (Cuvier). Individuals come in a variety of different color patterns.

93
Expanded, partially expanded, and retracted individuals of the sea anemone, *Metridium senile* (Linnaeus).

94
A sea star abundant in British Columbian waters, Stimpson's Sun Star, *Solaster stimpsoni* Verrill, makes its living by feeding mainly on sea cucumbers. In turn, it constitutes the main diet of its congener, *S. dawsoni* Verrill.

97
Related to the brittle star is the plankton-feeding basket star, *Gorgonocephalus eucnemis* (Muller and Troschel). This species reaches over half a meter in diameter and is one of the largest known basket stars.

98
A voracious predator of sea urchins is the multirayed sun sea star, *Pycnopodia helianthoides* (Brandt). To the lower right is a smaller red sea star, *Henricia leviuscula* (Stimpson). Numerous cup corals, *Balanophyllia elegans* Verrill, cover the surrounding rocks.

99
The sea anemone *Tealia coriacea* (Cuvier), in the center surrounded by numerous orange solitary cup corals, *Balanophyllia elegans* Verrill, and a yellow sponge, *Haliclona* sp. (?).

100
The classic jellyfish, *Aurelia aurita* (Linnaeus). The tentacles of this jellyfish are quite small and occur along the very edge of the bell.

101
A view of the elongated column and finely branched tentacles of *Metridium senile* (Linnaeus). Encroaching at the base is the red sea urchin, *Strongylocentrotus franciscanus* (A. Agassiz).

103
The kelp bass, *Paralabrax clathratus* (Girard), stalk smaller fish prey under cover of the giant brown kelp, *Macrocystis*.

104
A close-up of the giant brown kelp, *Macrocystis*, showing the stipes, or branches, which give rise to gas bladders, or pneumatocysts, which act to float the blade upward into the light.

105
Two curious harbor seals, *Phoca vitulina* Linnaeus, posing in a forest of giant brown kelp, *Macrocystis pyrifera* (Linnaeus) Agardh.

106
Shaped by the strong surge of passing waves, the elkhorn coral, *Acropora palmata* (Lamarck), reaches upward toward the lighted surface. The surrounding sea floor is covered by wave-resistant gorgonians.

109
Member of the bass, or serranid, family, the shy hamlet, *Hypoplectrus guttavarius* (Poey), is a simultaneous hermaphrodite, with fully functional ovaries and testes. Individuals pair-spawn to exchange gametes. The branching stony coral is *Acropora cervicornis* (Lamarck) and the feathery gorgonian is *Pseudopterogorgia acerosa* (Pallas).

110
A pair of gray angelfish, *Pomacanthus arcuatus* Linnaeus. The lower animal shows the bright yellow color on the inside of its pectoral fin. The gorgonian left of center is *Pseudopterogorgia* sp., while the one on the right is probably *Plexaura flexosa* Lamouroux.

113
A gorgonian, probably *Plexurella dichotoma* (Esper), growing between the stony coral *Montastrea cavernosa* (Linnaeus). At the base and to the left is the feathery gorgonian *Pseudopterogorgia acerosa* (Pallas), while the knobby gorgonian farther to the left is *Briareum asbestinum* (Pallas). The brain coral (lower left) is *Colpophyllia natans* (Houttuyn).

115
A tornado of herring.

117
The central sponge pictured is *Xestospongia muta* (Schmidt), the largest of the barrel sponges in the Caribbean (up to two meters diameter). The encrusting sponge in the center right foreground is probably *Anthosigmella varians* (Duchassaing and Michelotti). The globular sponge in the left foreground is *Geodia neptuni* (Sollas). In the background is the gorgonian *Iciligorgia schrammi* Duchassaing. The fish just in front of the central sponge are the bluehead wrasse, *Thalassoma bifasciatum* (Bloch), blue chromis, *Chromis cyanea* (Poey), brown chromis, *Chromis multilineatus* (Guichenot), and the queen angelfish, *Holacanthus ciliaris* (Linnaeus).

White sea fans,
Moore Reef, Coral Sea

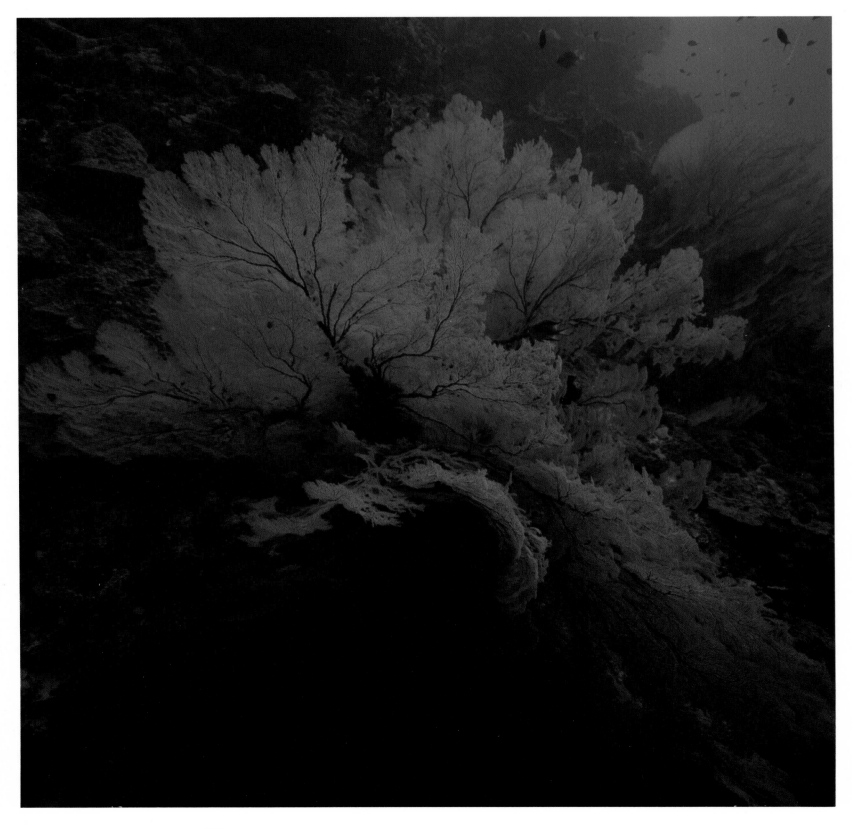

119
The star coral, *Montastrea annularis* (Ellis and Solander). Establishing on a dead area of the coral is the stinker sponge, *Ircinia strobilina* (Lamarck).

120
Red tube sponge, *Verongia (=Aplysina) fistularis forma fistularis* (Pallas). At its base is the bicolored damselfish, *Pomacentrus partitus* (Poey).

123
The smooth trunkfish, *Lactophrys triqueter* (Linnaeus). In the background are various gorgonians.

125
The squid *Sepioteuthis sepioidea* Blainville is frequently seen in shallow reef habitats, particularly over grass beds.

126
Perched on a ledge along the reef slope, two corals, *Millepora tenera* Boschma (brownish) and *Acropora* sp. (whitish), vie for space.

128
Gorgonians, *Muricea californica* Aurivillus, and the sea fan *Pacifigorgia*, share space along the sides of an isolated rocky outcropping in the Gulf of California. The fuzzy white appearance of the colonies is caused by the fully expanded tentacles. Above is the planktivore *Chromis atrilobata* Gill.

131
A school of sardines (engraulids).

133
A lionfish, *Pterois volitans* Linnaeus, hovering at the base of the reef. At the upper right is a bright red sponge.

134
Sex-changing serranids, *Anthias squamipinnis* Peters. In the background is the fire coral, *Millepora tenera* Boschma; in the foreground, a species of stony coral, *Favia*, with the bicolored damselfish, *Chromis dimidiatus* (Klunzinger).

137
The delicate egg case of a nudibranch. Thousands of individual eggs are imbedded in a gelatinous matrix. Within hours or days swimming larvae emerge to join the plankton before eventually returning to the reef.

138
A grouper, *Cephalopholis miniatus* (Forskal). In the background are large colonies of the leathery soft corals *Sarcophyton* and swimming above are the anthias, *Anthias squamipinnis* Peters.

140
A school of "goldfish," *Anthias squamipinnis* Peters, hovering close to a coral buttress along the reef slope. The reef provides a refuge from predators while *Anthias* searches for plankton carried onto the reef by the passing currents.

145
Ambient light highlights the delicate branching of the sea fan, *Melithea squamata* (Nutting).

Designed by Thomas Sumida

Copyedited by Jean Crockett Ritchie

Composition in Monotype Bembo by The Stinehour Press

Printed by Princeton Polychrome Press

Bound by A. Horowitz and Sons